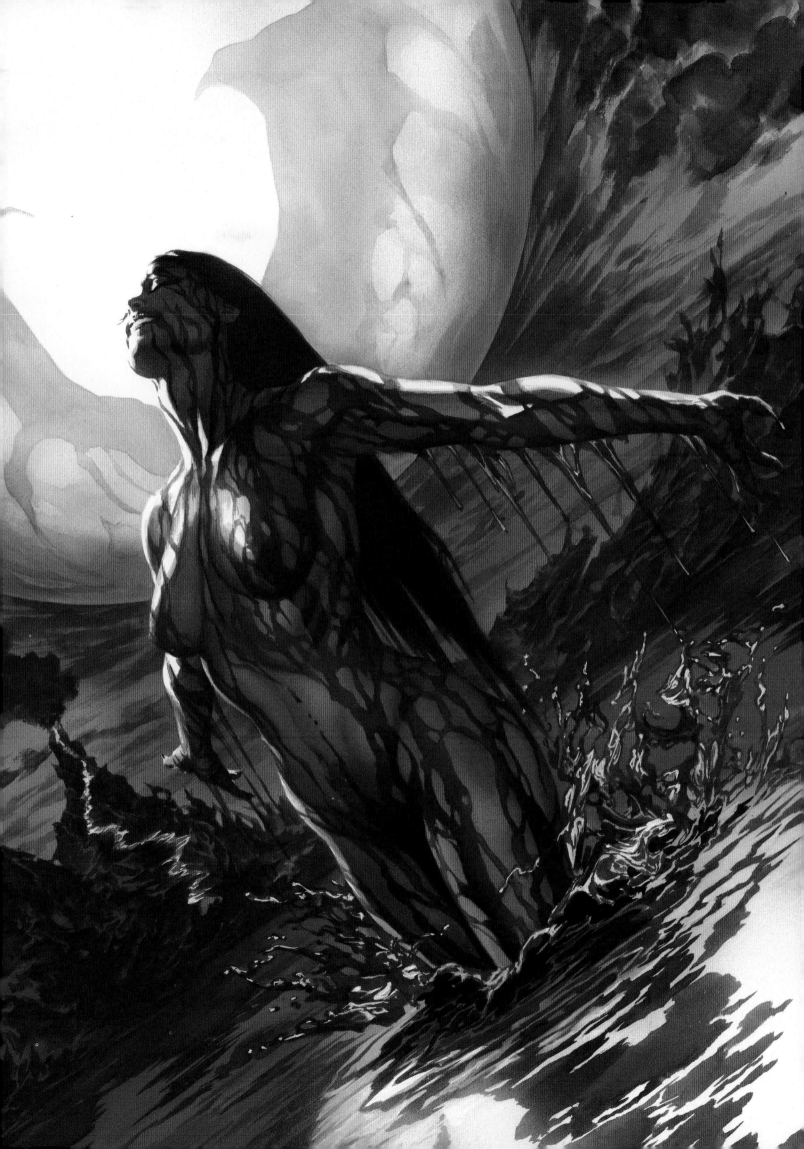

Collection Design by Katie Hidalgo
Edited by Hannah Gorfinkel

DYNAMITE®

Nick Barrucci, CEO / Publisher
Juan Collado, President / COO
Rich Young, Director Business of Development
Keith Davidsen, Marketing Manager

Joe Rybandt, Senior Editor
Hannah Gorfinkel, Associate Editor
Josh Green, Traffic Coordinator
Molly Mahan, Assistant Editor

Josh Johnson, Art Director
Jason Ullmeyer, Senior Graphic Designer
Katie Hidalgo, Graphic Designer
Chris Caniano, Production Assistant

Visit us online at www.DYNAMITE.com
Follow us on Twitter @dynamitecomics
Like us on Facebook /Dynamitecomics
Watch us on YouTube /Dynamitecomics

ISBN-10: 1-60690-513-9
ISBN-13: 978-1-60690-513-5

10 9 8 7 6 5 4 3 2 1

THE ART OF
VAMPIRELLA

THE DYNAMITE YEARS

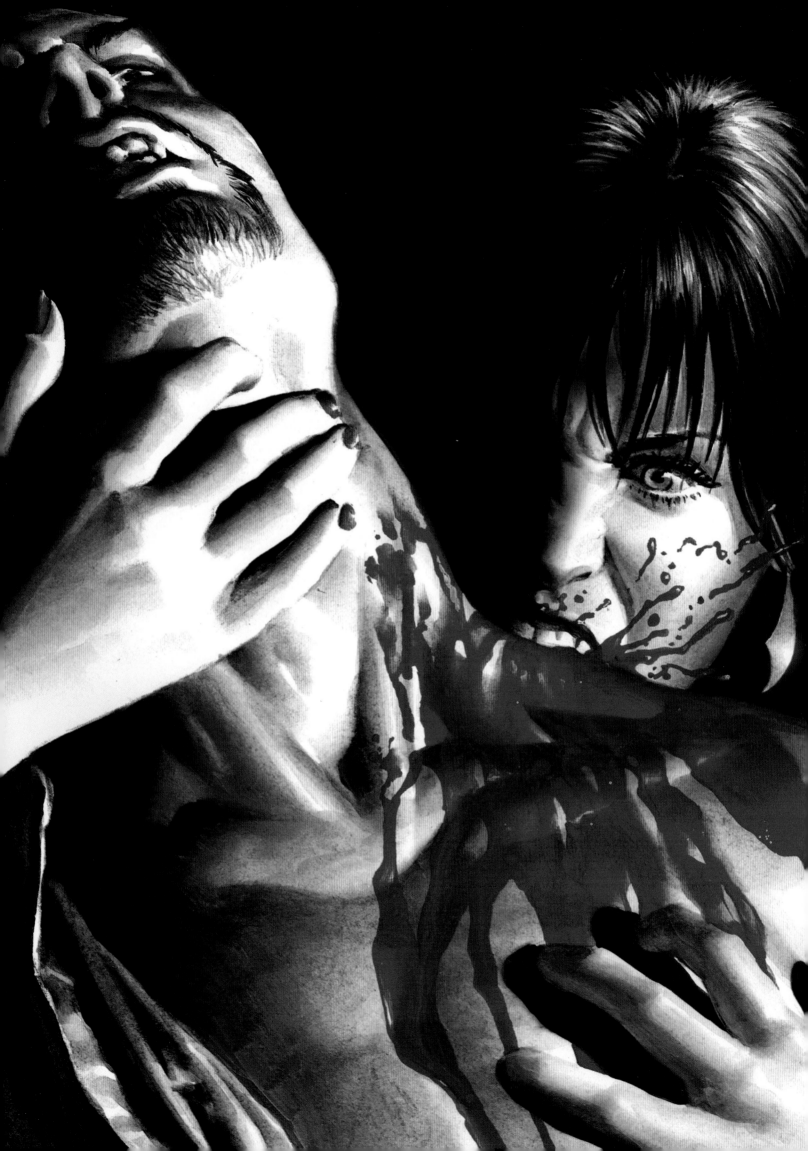

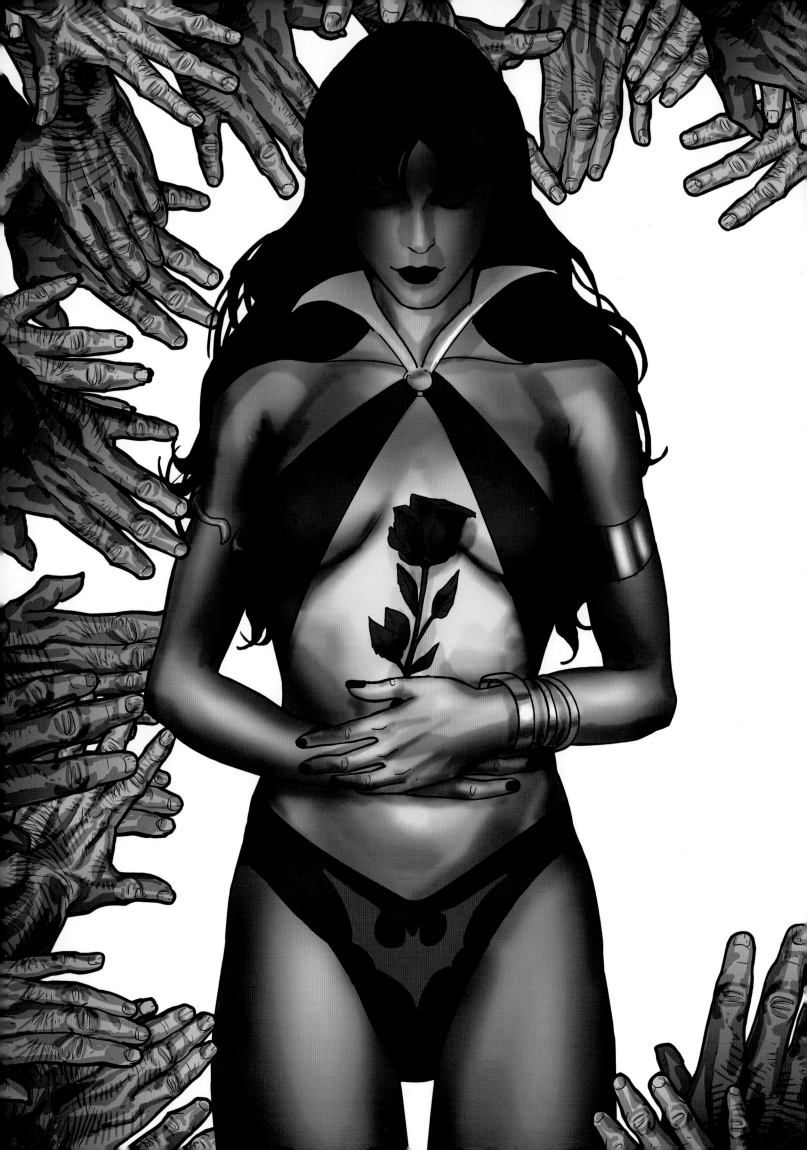

FOREWORD

BY DAVID ROACH

Fittingly for the comic world's most successful vampire, Vampirella has risen from the grave not once, but twice. Through a career spanning several decades and three publishers, the character has beguiled and captivated generations of readers: from Warren comics in the 70s, to Harris in the 90s and now Dynamite in the 21st century. With stories and art by some of the industry's greatest creators, Vampirella has become one of today's truly iconic characters, transcending her humble beginnings. Today she is an ever-present favorite of cosplayers, art collectors, horror aficionados and comic book readers. From the San Diego Comic Con, to Playboy, and even Archie comics, Vampirella has become a part of popular culture across the world. However, comic books were where she started and where her evolution as a character continues to emerge.

Vampirella's roots lie in both the 1960s of her birth and the creative ferment of the comics industry in the 1950s. Horror was one of the last important genres to be exploited by comic publishers, initially with ACG's ground breaking *Adventures Into the Unknown* in 1948, and then in the 50s by the legendary EC comics. EC built up a roster of exceptionally talented artists including Jack Davis, Wally Wood and Frank Frazetta, gave them intelligently written, viscerally intense scripts and set them free to express themselves. The results were both compelling and transgressive, inspiring the writers, artists and filmmakers of the coming decades, but also incurring the wrath of parents, politicians and self-appointed guardians of the nation's morality.

Following the collapse of the comics industry in the late 50s, the two biggest publishing phenomena were EC's *Mad Magazine* and Hugh Hefner's *Playboy*. James Warren was an ambitious young publisher looking for a way to make his mark on the world; inspired by *Playboy's* enormous success, he decided to launch his own version: *After Hours*, in 1957. That magazine was a flop, but his next effort established the company as a great maverick publishing house and created an entirely new genre— the monster movie magazine. Its first issue hit the stands in 1958 and sold out its 200,000 print run, inspiring a small industry of competitors. Under editor and writer Forrest J. Ackerman, the magazine featured in depth articles on a wide range of horror and science fiction titles written with an anarchic, punning style, creating a great sense of loyalty and belonging in its readership. Warren soon expanded his line with the humor magazine *Help* and another movie magazine; *Monster World*, but neither truly caught on. Remembering his fondness for the EC comics of his youth, he decided to create a new horror comic of his own, in the magazine format, which could sit next to *Famous Monsters* and *Mad* on the Newsstand— *Creepy*.

The first issue of *Creepy* appeared in late 1964 and was such a success that a companion title called *Eerie* was launched a year later. Under the inspired editing and writing of Archie Goodwin, the two magazines recaptured the wit and intelligence of EC's heyday in strips drawn by many of the company's finest artists. Frank Frazetta provided most of the covers with a series of astonishing paintings, which effectively laid the foundations for the whole fantasy artwork genre. Within a few years, however, despite the quality of its magazines, Warren publishing was in trouble. Beset by cash flow problems, the comics lost most of their artists and reprints began to appear with alarming regularity. However, out of this troubled period, Warren decided to launch a third comic in a bid to turn around his company's ailing fortunes. That comic was *Vampirella* and, despite an uncertain first few issues, it was indeed the life-saving catalyst Warren had gambled on.

Vampirella was the brainchild of Jim Warren, but it took the involvement of several other creators over the course of several years for the feature to fully coalesce into the strip we know today. Talking to the *Warren Companion* in 2001, Warren recalled her creation: "Of all the writers to pick from I chose Forrest [J. Ackerman]. He had never done anything for comics and doesn't even read them. I said 'Forry, I know you can do this'. We had both seen the movie Barbarella together and had loved it. I carefully outlined exactly what I wanted: a modern day setting but something with a mystique of Vampires, Transylvania, something legendary— and Vampirella was born." The first issue appeared in September 1969 with a Frazetta cover that has now become legendary, as has its creation. Underground comic artist Trina Robbins was visiting the office while Jim Warren was trying unsuccessfully to describe his vision of Vampirella's costume over the phone to Frazetta. While this was going on, Robbins sketched out her interpretation and showed it to Warren who loved it so much he asked her to speak directly to Frazetta. The resulting costume, a tightly stretched, curving red swimsuit topped off with a collar and high heeled boots was startlingly provocative and is doubtlessly a big part of the strip's appeal. As Warren himself admitted, the comic sold because of its mix of sex and horror, the perfect combination of *Creepy* and *Playboy*, but it was to be two more years before the strip as we know it was fully formed.

The first Vampirella strip in issue #1 was set on the planet Drakulon and was clearly indebted to Barbarella, with its jokey script and cheesecake artwork from Tom Sutton. In issue #2, she came to earth, but the story was even more inconsequential and there were to be no more Vampirella strips until #8, a year later. With that issue, Archie Goodwin effectively created the Vampirella we recognize today, with a supporting cast of Adam and Conrad Van Helsing, the tipsy Magician Pendragon (introduced in #11) and villains such as the Cult of Chaos and Dracula. Visually, however, something was still missing and it was purely by chance that Vampirella finally got the artist she needed when Josep Toutain walked through Jim Warren's door in 1971. Toutain represented a studio of artists in Barcelona, Spain, who were hoping to find work in America after many years of drawing romance comics in the UK. Here at last was the artist Warren had been looking for; Toutain's artists were all highly talented, but it was Jose "Pepe" Gonzalez that caught the eye. Gonzalez was particularly gifted at drawing beautiful girls with just the hint of European sophistication and glamour the strip needed. His first strip appeared in issue #12 behind a striking cover by another Spaniard: Sanjulian. Frazetta had painted four memorable covers for the comic, but only the first had featured Vampirella herself; Sanjulian could match Frazetta's rich painting technique and had a dramatic sense of the macabre that was all his own. A few months later, in issue #17, another Spanish artist, Enric Torres-Prat, better known simply as Enrich, painted the first of many covers for the comic and soon became the title's main cover artist. Enrich was able to paint with extraordinary realism and, like Gonzalez, his artwork was suffused with a powerful erotic charge. Many of Enrich's covers have become legendary with several appearing as posters, book covers, calendars and trading cards over the years.

To announce the arrival of his star artist, Jim Warren commissioned Gonzalez to paint a portrait of Vampirella that could be used to promote the strip around the world. Gonzalez had always struggled with paint and finally turned to his friend Enrich to paint, anonymously, over his penciled drawing. The resulting painting of Vampi standing with a bat balanced on her outstretched arm was released as a life-size poster and did indeed go on to become one of the comics industry's most iconic images. Throughout the 70s, Vampirella was a big success both at home and abroad, being published in 19 countries. Gonzalez was joined by Gonzalo Mayo as an artist, but came and went from the title with some regularity. Warren had reintroduced horror to American comics and the genre was a big success for both him and his rival publishers throughout the decade. But by the early 80s tastes were changing, and with declining sales the industry was shrinking back to its core superhero titles. Vampirella was experiencing something of an artistic renaissance, with Gonzalez and Enrich both back on the title after lengthy absences, but sadly the readers were looking elsewhere. In March 1983, after 112 issues, one annual, a color special, and six novels, Vampirella was cancelled, seemingly forever.

The 80s were a dark time for Vampi and for many years it appeared that she would be lost forever, a footnote in comics history. However, soon after Warren's collapse, the rights to Vampirella had been bought by publisher Stanley Harris, and after the false start of an all reprint one-off magazine in 1988, she was reborn

as the star of a color comic book in 1991. Under Harris, *Vampirella* became a leading title in the emerging "Bad Girl" craze that was one of the 90s defining genres; comics sold largely on the scantily clad, top-heavy charm of their alluring heroines. In some respects, Vampirella had been the forerunner of this genre, but she was always so much more than just a pretty face (and figure). As the most successful female character since the creation of Wonder Woman, and a strong, confident, independent woman, it has been suggested that she could be seen as a feminist icon, despite that costume. Harris also helped popularize the use of mini-series, teams-ups, one-shots, collections and spin-offs, releasing a staggering 87 different Vampirella titles over the course of nearly 20 years. Many of these issues also featured numerous cover variants; making collecting their entire output a truly daunting task.

As each generation gets its own Vampirella, so it also falls to a new generation of creators to guide her path. Harris called upon such writers as Kurt Busiek, Mark Millar and Grant Morrison; and artists including Amanda Connor, Mike Mayhew, Bruce Timm and Louis Small Jr. The company was particularly strong in its choice of cover artists, drawing upon the talents of Adam Hughes, Jim Silke, Dan Brereton and Mike Kaluta among many others. Amazingly, Harris was also able to entice back both Frank Frazetta and Jose Gonzalez for one last cover each. Dave Stevens only contributed two covers, but both are now widely regarded as classic Vampi images. However, it was Joe Jusko who came to personify the Harris era over the course of his many paintings for the company. Jusko possessed the strong design sense and natural artistic ability of the greats of the 70s, combined with a great love for the character, making him the natural heir to Enrich.

Since 2010, Vampirella has been published by Dynamite, who are creating their own classic strips and adding new images to Vampirella's pantheon. Written by Eric Trautmann and drawn by Wagner Reis and Fabiano Neves, among others, this reimagining of the character expands and updates the strip as we know it while remaining true to its horror roots. Like Harris, Dynamite has offered readers a choice of cover variants to suit their individual tastes. Typically, each comic has presented four different covers, with the first issue boasting six; including new illustrations from J. Scott Campbell and Joe Madureira, as well as two from Alex Ross. Long-time fans were delighted to see that one of Ross' paintings paid tribute to Frank Frazetta's original 1969 cover, presenting his version of the same scene, though seen from behind. Among other cover artists, standouts must include such modern stars as Billy Tucci, Sean Chen and Joseph Michael Linsner, while fans were amazed to see European legend Milo Manara's take on the character.

Each of Dynamite's regular cover artists has had their own unique interpretation of Vampirella and it has been fascinating to see their unique visions emerge. Jelena Kevic-Djurdjevic has been the closest to Joe Jusko's tradition, with her richly painted, strongly designed covers, albeit with a modern, digital twist. By Contrast, Ale Garza's Vampi is sexy, cute and kittenish, drawn in what you might call the Image comics tradition. Fabiano Neves presents yet another Vampi; a dangerously powerful, statuesque Amazonian who could snap you in two like a twig. French artist Paul Renaud has drawn most of his American artwork for Dynamite and brings a cool, stylish approach to his covers. In Renaud's world, Vampirella is seen in cold, stark, snow-laden forests surrounded by skulls, wolves and demons, suffused with an atmosphere of mystery and suspense. In time, however, it might very well be Lucio Parrillo's Vampirella that defines this era, just as Enrich, Gonzalez and Jusko defined theirs. Parrillo is that rarity in the 21st Century: a young traditional painter working in the digital age who has matched his extraordinary technical ability with a disturbing, erotic, contemporary sensibility. Parrillo's covers are near to the knuckle explorations of violence and sexuality featuring fetishistic imagery, body horror, blood, piercings and gore. They also feature that indefinable stroke of genius that can create a truly iconic image— and his covers to issues #26 and #38 are surely already classic images.

There is a richness and depth to Vampirella's character that has inspired many of comics' greatest artists to create some of their finest works. As the comic strip enters its fifth decade, it shows no signs of ending and her fans can look forward to exciting new interpretations for years to come.

David A. Roach, March 2014

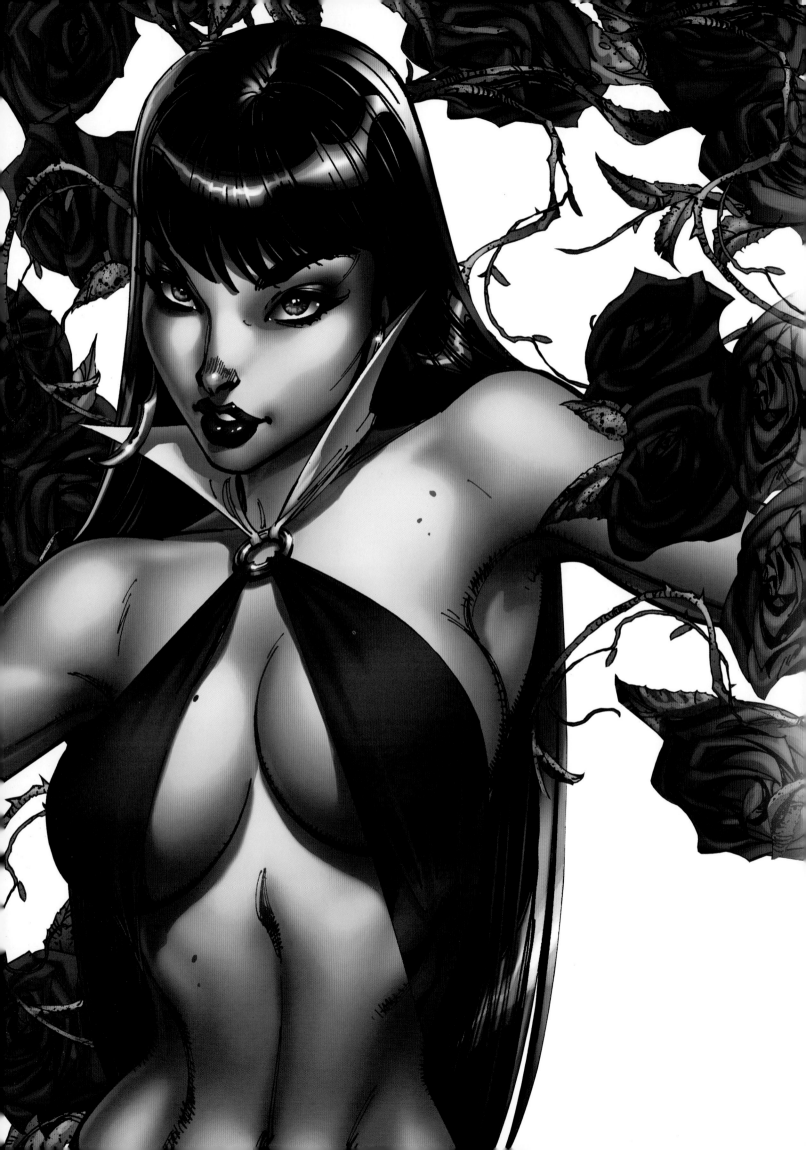

INTRODUCTION
BY ERIC TRAUTMANN

Worth A Thousand Words

or, a writer talking about pictures and wishing desperately he could draw....

So, let's get this out of the way right now: I'm basically *screwed*.

This is the part where I'm supposed to hook you, Dear Reader. The moment where I'm required to dazzle you with cleverness and wit and fabulous yarns of lost and forgotten comics lore, to entice you into the pages that follow with a blazing display of linguistic legerdemain. Creep closer to the campfire, kids, there's a story to be told.

But, come *on*.

How am I supposed to blind you with the pale moonlight of my feeble words when, with the flick of your index finger, you're going to be stunned by page after page of lush, evocative images in a bewildering array of styles—from the slickest, most modern of comic art to paintings of subtle hue and undeniable power.

Thanks a *bunch*, Dynamite. How am I supposed to compete with all *that*? I'm just the word monkey.

This is just how my luck goes, I guess, especially when it comes to Vampirella.

<p style="text-align:center">***</p>

Let's roll back the clock a bit, shall we?

It was somewhere around August or September 2010, I think, when Dynamite's Editor Emeritus, Joe Rybandt, e-mailed me and said "So, yeah, you need to write me a Vampirella pitch."

(Joe isn't one for a big wind-up.)

I was hip-deep in scripting *Red Sonja*—a series I was *very* content writing—and finishing up some DC Comics work. At the same time, I was also writing a rather long, rather challenging original graphic novel for Vertigo, and it was absolutely *devouring* my time.

I told Joe that my dance card was a little full. (It is the freelancer's automatic response to never quite say "no" to anything an editor asks.)

And, to tell the truth, I wasn't a *huge* fan of the character. Don't get me wrong—I was familiar with her exploits, but I'd never been a die-hard, completist devotee.

I mean, sure, I *loved* the old black & white Warren magazines, and of course those fantastic Frazetta covers

were pretty great, and that lovely, lovely José Gonzalez artwork always struck a chord, but... no, I said, I'm probably not your guy. Vampirella stories just weren't in my bag of tricks.

"I'll need that pitch in a week or so," Joe said.

(The mark of being a good editor is *listening*, I'm told.)

But, I argued, I really don't write that kind of thing. I'm not a horror writer. I'm best known for writing about soldiers and superspies, not the grand canvas of the war against order and chaos. Writing Red Sonja was a huge stretch for me, I thought, but I have no idea how to write a bikini-clad paranormal monster fighter. At best, I said, I could maybe — *maybe* — apply some of my espionage mojo to the setting, but I'd have to take some serious liberties.

"So do that. It's a clean slate. You've got a week or so."

(The mark of being a good editor is also not listening to your flaky, insecure writer and pushing him past his comfort zone. Joe is a *very* good editor.)

I was still reluctant, but less so. If I had some freedom, some opportunity to really get into her head and see what makes her tick, if I could use that drama—in this case, the fact that she has two completely valid and yet contradictory sets of memories which, let's face it, would drive anyone (pardon the pun) batty—as the primary engine and over time build a consistent status quo for her, well... that'd be a lot of fun.

It occurred to me that treating the series as more of an espionage or investigation procedural against the backdrop of dark forces at the fringe of our world, hungry to destroy us all, would also be an interesting exercise. It would require some real setup—a recurring sidekick to give new readers a window on the character and her history, and to underscore the weird things that were going to be happening. A longer plot that slowly revealed where Vampirella had been for the long hiatus she'd been on in the comics world. A secret organization within the Vatican that employed monsters to fight monsters.

All of that sounded great to me, but as I said, I still had reservations. *Lots of them*. About two dozen Eisner award winners worth. Because:

Alan Moore took a crack at writing her. Roll that around for a second, and then contemplate following *that* opening act.

Oh, and then there was Grant Morrison.

And also Warren Ellis.

And Mark Millar.

And Kurt Busiek.

And James Robinson...

And. And. And.

Cue panic attack.

But, I wrote the pitch, and it became the first volume of Dynamite Entertainment's refurbished *Vampirella* line, "Crown of Worms." I like to think it was a fun run—I did almost 20 issues before handing the reins to my good friend, and *Vampirella* scribe, Brandon Jerwa—that played with a lot of the same toys as the Warren

and Harris books, but recast the character and setting into something more grounded and realistic, with plenty of room for the glorious, operatic insanity of the prior iterations.

But every step of the way, we chased ghosts.

Every time I sat at the keyboard to start another script, I'd seize up.

I've written characters with storied histories before—I put words in Superman's mouth in *Checkmate*, I pitted Red Sonja against legions of foes, and on and on—but with Vampirella it was particularly nerve-wracking.

One need only look at the legendary talent that transformed the character from a Crypt-Keeper-Rod-Serling-Elvira carnival barker—prefacing ironic twist-ending stories—into an alien (or hellborn, you decide) warrior woman bent on saving humanity in the face of an ever-escalating tide of chaos and insanity. If you can look at that trajectory and the roster of creators who navigated her through it and not be a bit awestruck, I submit you're not paying enough attention to our medium's history.

In addition to the character's creators—Forrest J. Ackerman, Trina Robbins and the aforementioned Frazetta (just a small pantheon of genre *legends*, not daunting at all)—you had the likes of Archie Goodwin. Tom Sutton. Esteban Maroto. Rudy Nebres. Gonzalo Mayo. Pablo Marcos. Dozens more. A who's who of comics in the heady days of the 1970s and 1980s.

And more modern luminaries like Bruce Timm, Amanda Conner, Joe Jusko, Ed McGuinness, Adam Hughes, Joe Quesada, Colleen Doran, Kelley Jones, Alan Davis, John Bolton, Arthur Suydam, David Mack and more than I can possibly remember here all contributing signature visuals—covers, interiors, posters—along the way.

So there we were, looking at the impending deadlines ahead of us, and the staggering list of comics creators who preceded us. Hundreds of brilliant covers. Thousands of creepy, inky-shadowed and blood-drenched story pages.

It was a little unnerving, to say the least—and by unnerving I mean *terrifying*.

Then, the cover images started rolling in and I at last breathed a sigh of relief.

Maybe this would work out okay after all...

There's a lot of history associated with Vampirella to be sure, and the Dynamite series has always been mindful of that. But there's a refreshing modern sensibility to the cover art that has graced each issue since Dynamite Entertainment's relaunch of the character.

Right from the start, Dynamite pulled no punches—issue 1 had covers by a widely disparate group of artists.

There was the hyperrealistic painted work of Alex Ross (who graced issue #1 with *two* different covers), to the vibrant, manga-inflected, pure pop-comics dynamism of Joe Madureira and J. Scott Campbell, to the atmospheric, moody painted work of Jelena Kevic-Djurdjevic.

Ms. Kevic-Djurdjevic's work is perhaps the darkest of those who contributed covers to the title during this period. Her Vampirella, leaning on a cairn of skulls, smiling a half-mocking, half-playful smile at the reader is a favorite of mine. And her spotlighting of supporting character Sofia for the issue #7 cover is simply

sublime, a knowing, deliberate and skilled homage to Michelangelo's *Pietà*. Setting the bar at Michelangelo is, if nothing else, audacious.

As the series progressed, so too did the cover images, adding material from French illustrator Paul Renaud (who's work shines brightly on such disparate titles as *Vampirella*, *Flash Gordon: Zeitgeist*, *Dejah Thoris*, *Spider-Man*, *Ms. Marvel*, various *X-Men* titles... the list goes on and on...). Under Renaud's pen, you'll find a Vampirella of icy composure—strong and confident, but aloof, a perfect note to hit given the character's outsider status. Renaud's compositions hearken back to the best of movie poster designs—collages of figures and color, but above all a keen sense of structure. His pages combine crisp line work, vibrant color, and a draftsman's sense of how a page is constructed.

Fabiano Neves contributed a staggering number of covers as well, in addition to his last-minute recruitment to illustrate the "Vampirella vs. Herself" dream sequences in the "Crown of Worms" arc. His Vampirella burns, rarely smiling, as if combatting an inner monster as well as the more obvious demons in her midst. There's a dusty quality to the work, evoking the feeling of ancient crypts and forgotten tombs, through which strides a powerful Vampirella.

Italian painter and illustrator Lucio Parrillo brings a muscular Boris Vallejo/Julie Bell influence to his work on the covers, as well as highlighting the character's more overtly sexual trappings. His is a romantic Vampirella, drowning in blood and horror but underscoring that, despite the monsters and demons and sinister Lovecraftian conspiracies, she exists in a world that she wouldn't trade for normalcy. There's something supernaturally attractive amidst the death and destruction.

Each of these illustrators employed their prodigious talents to craft cover artwork to attract the eye, to be sure, and each has a modern master's command of the medium. But, to me, the collection of influences, the sense of history each manages to bring to bear, is in part what honors Vampirella's history and preserves her legacy.

<p align="center">***</p>

So here's the dirty secret: virtually every professional writer I know has spent years honing their skills, perfecting their craft to the best of their ability.

I've been fortunate to become friends with writers who constantly strive to improve, who never quit learning, who know that the only thing in your career you really control is how much you are willing to commit to the art and craft of writing.

But deep down, each of us wishes like hell we could *draw*.

We want to create those pictures, those images that move only when viewed through the reader's eyes, when you, the person holding this book, can "see" the swirl of the vampire's cape, or the sudden gleam from the dark when torchlight strikes the werewolf's eyes.

And what happens to those of us who can't draw?

We end up writing the introduction, trying to distract you for a moment before you charge through the fun house doors and into a colorful, bizarre new world.

Maybe you'll spare us a pitying thought before the *real* fun begins...

Eric Trautmann is a writer, editor and graphic designer based in the Pacific Northwest. His Vertigo graphic novel, *Shooters* (co-written by *Vampirella* scribe Brandon Jerwa and illustrated by Eisner award-winner Steve Lieber) won the PRISM award in 2013. Eric has written the monthly adventures of *Red Sonja, Flash Gordon,* and *Vampirella* for Dynamite Entertainment.

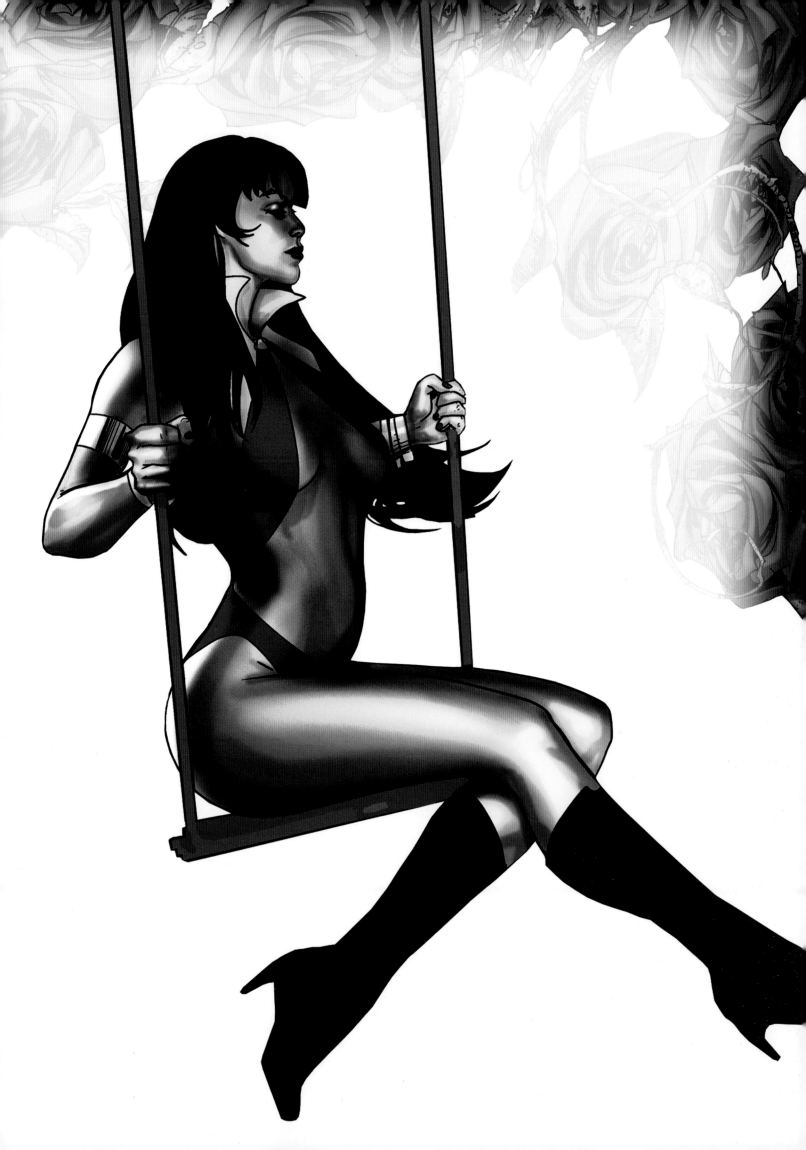

CROWN OF WORMS

She's back! And she's all that stands between us and the end of the world! It's a new era for Vampirella— a corpse-strewn maelstrom of intrigue and violence as she pursues her nemesis, Vlad Dracula, through the beating heart of Seattle. Dracula's latest scheme is his deadliest yet, and it places Vampirella directly in the path of an ancient and terrible evil, one that seeks to devour all life... perhaps even something Dracula himself has cause to fear.

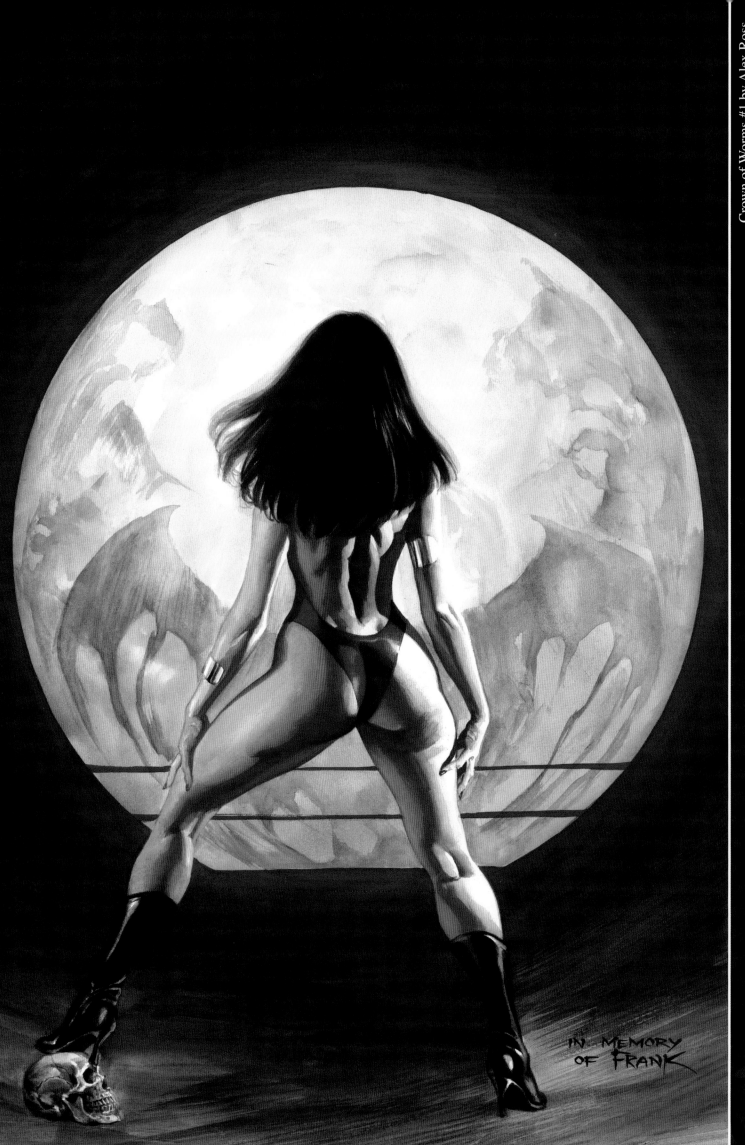

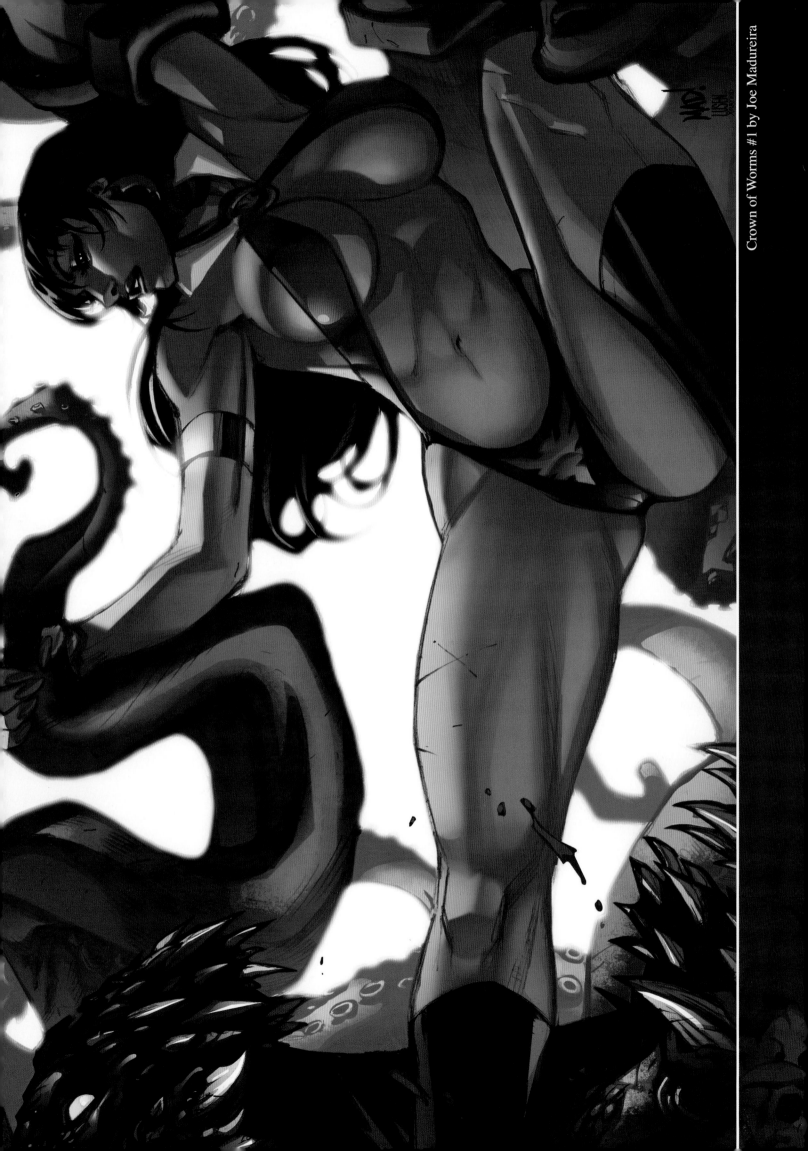

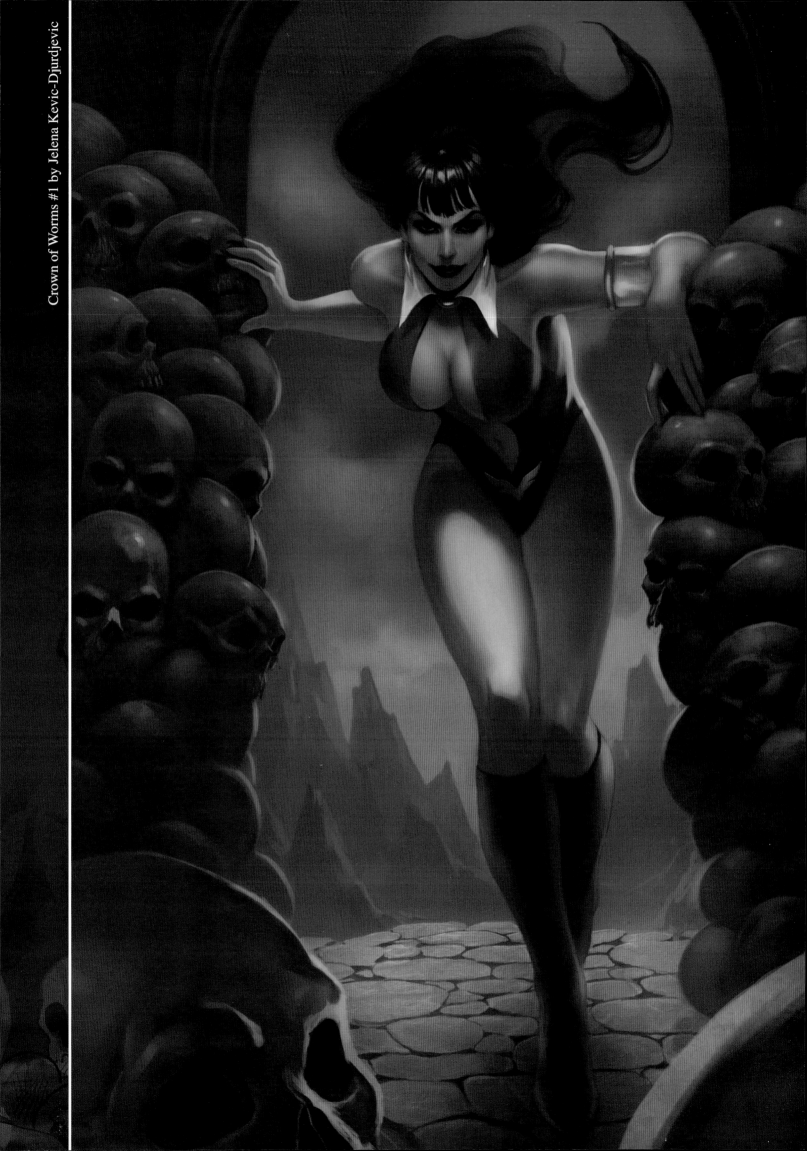

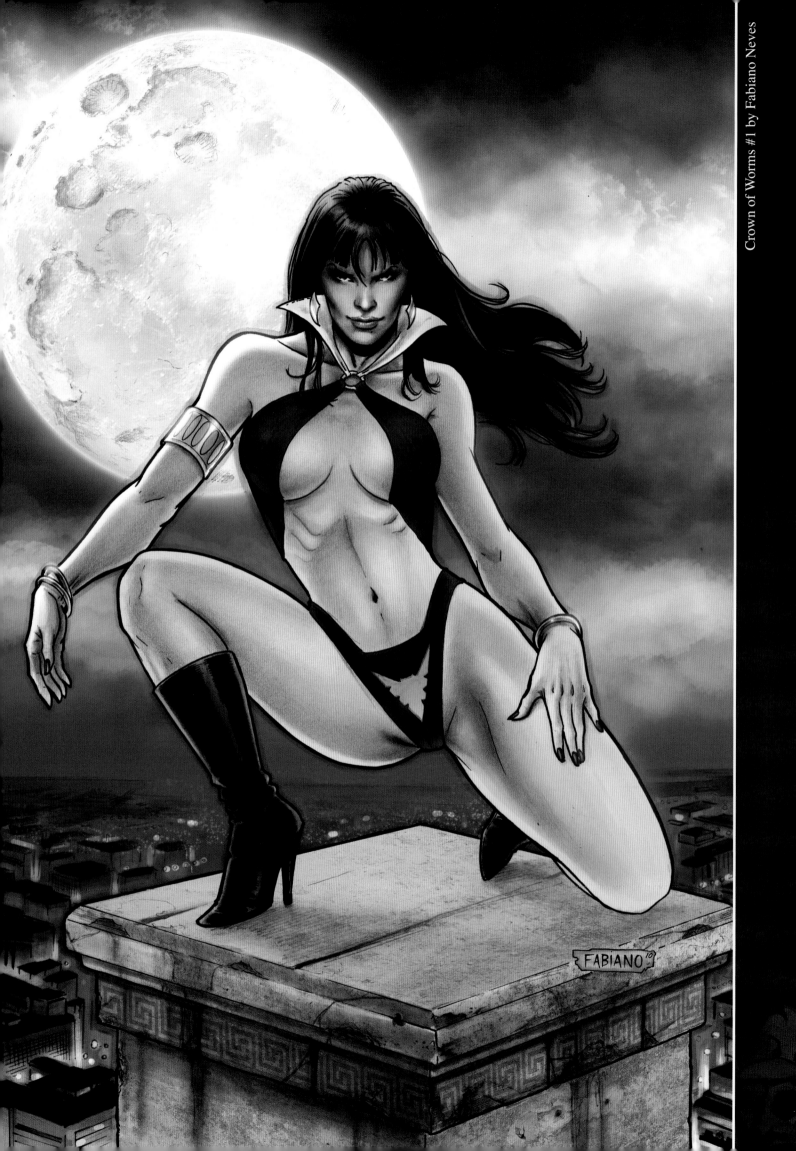

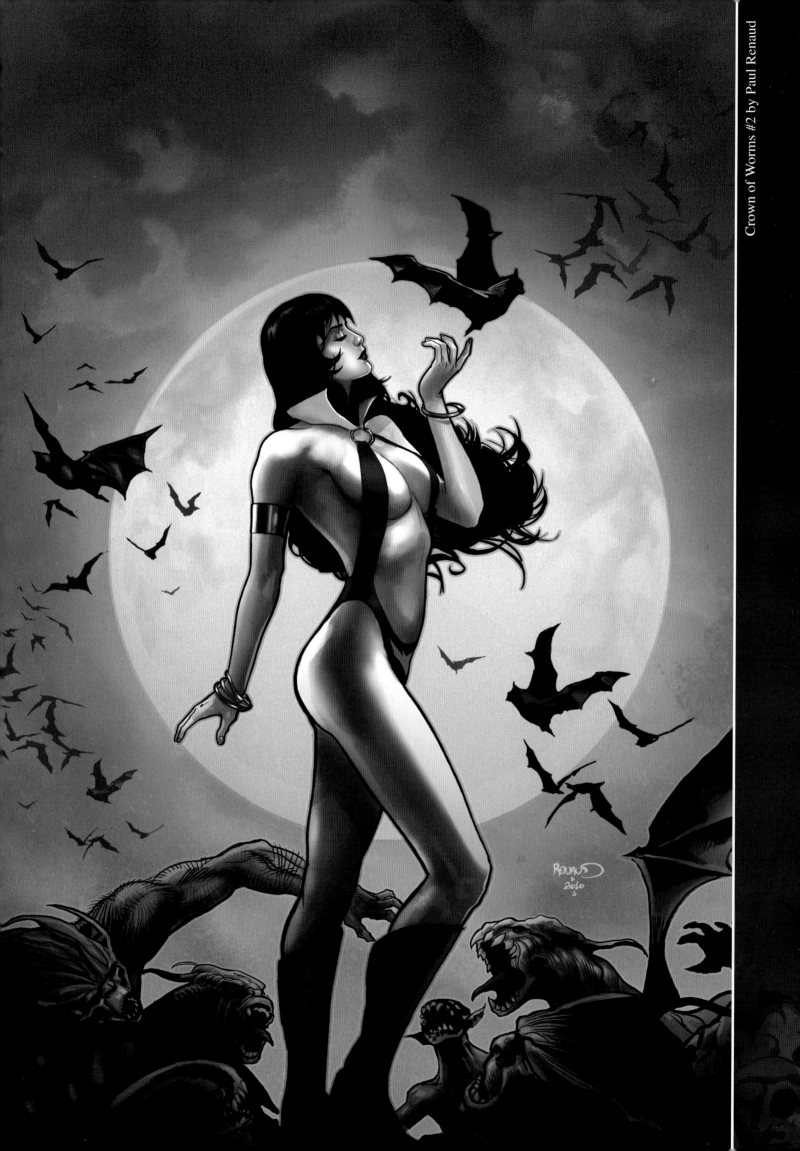

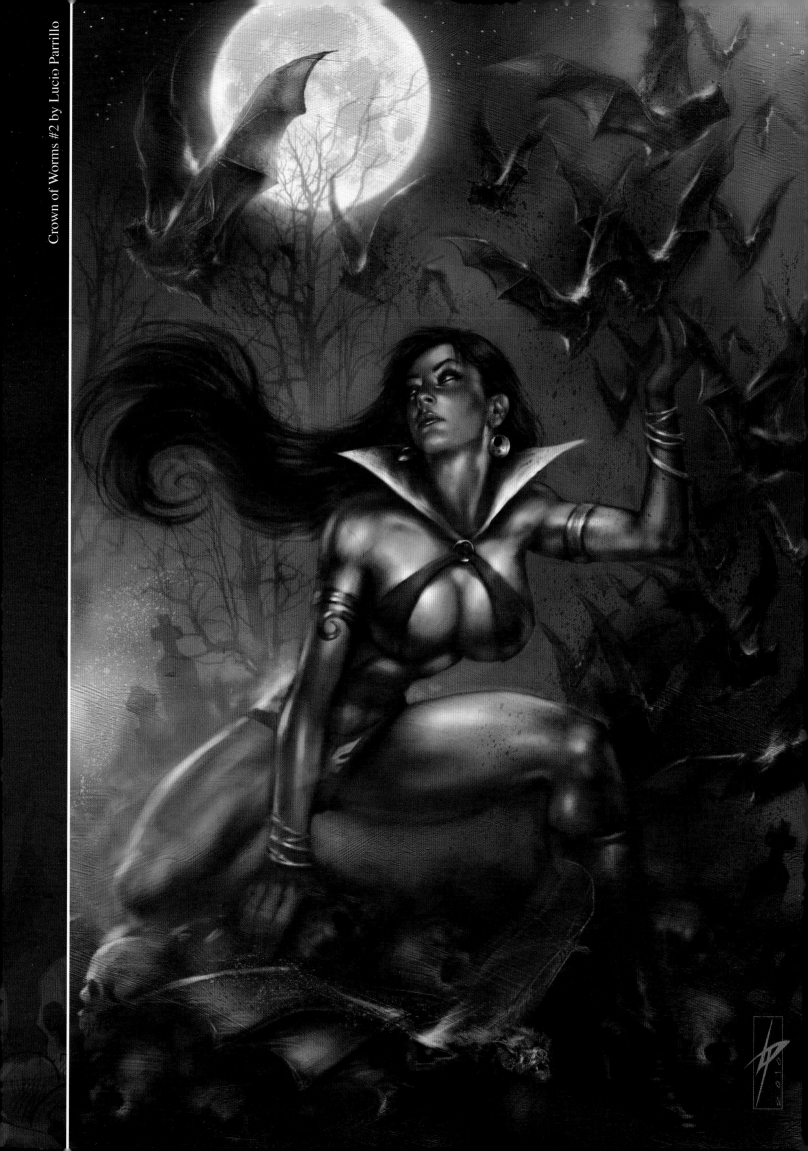

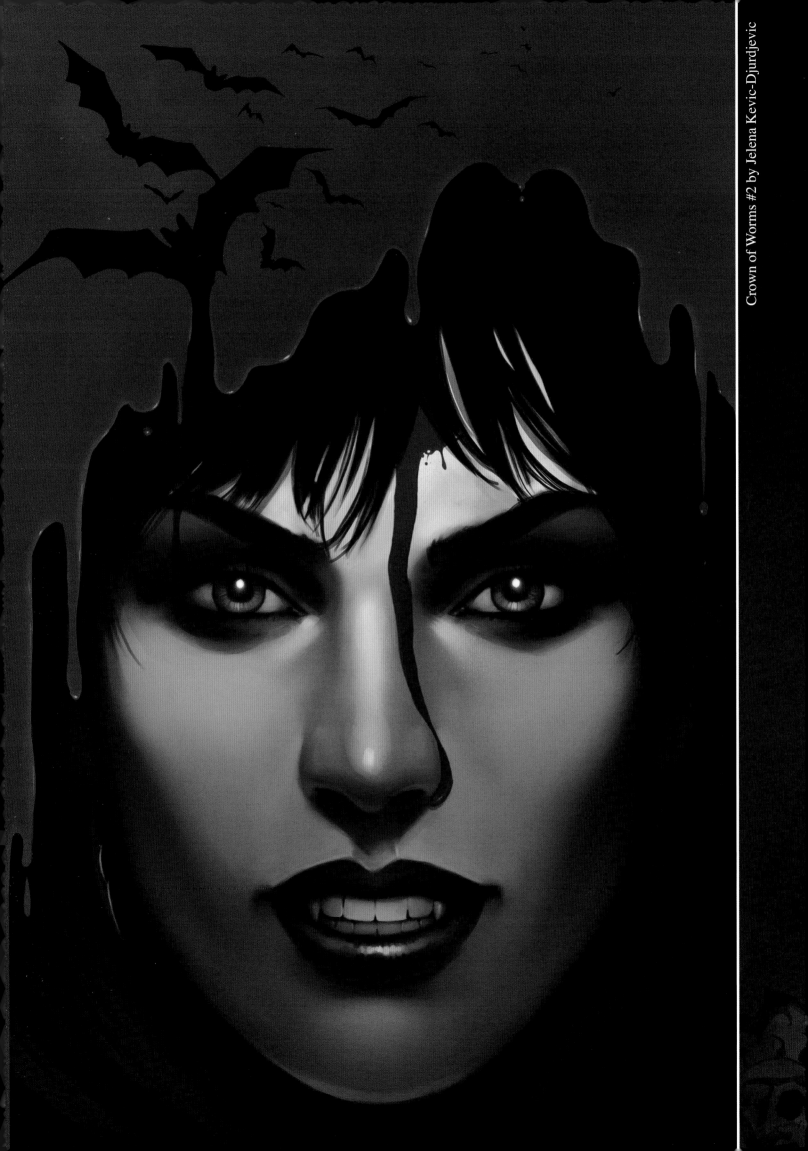

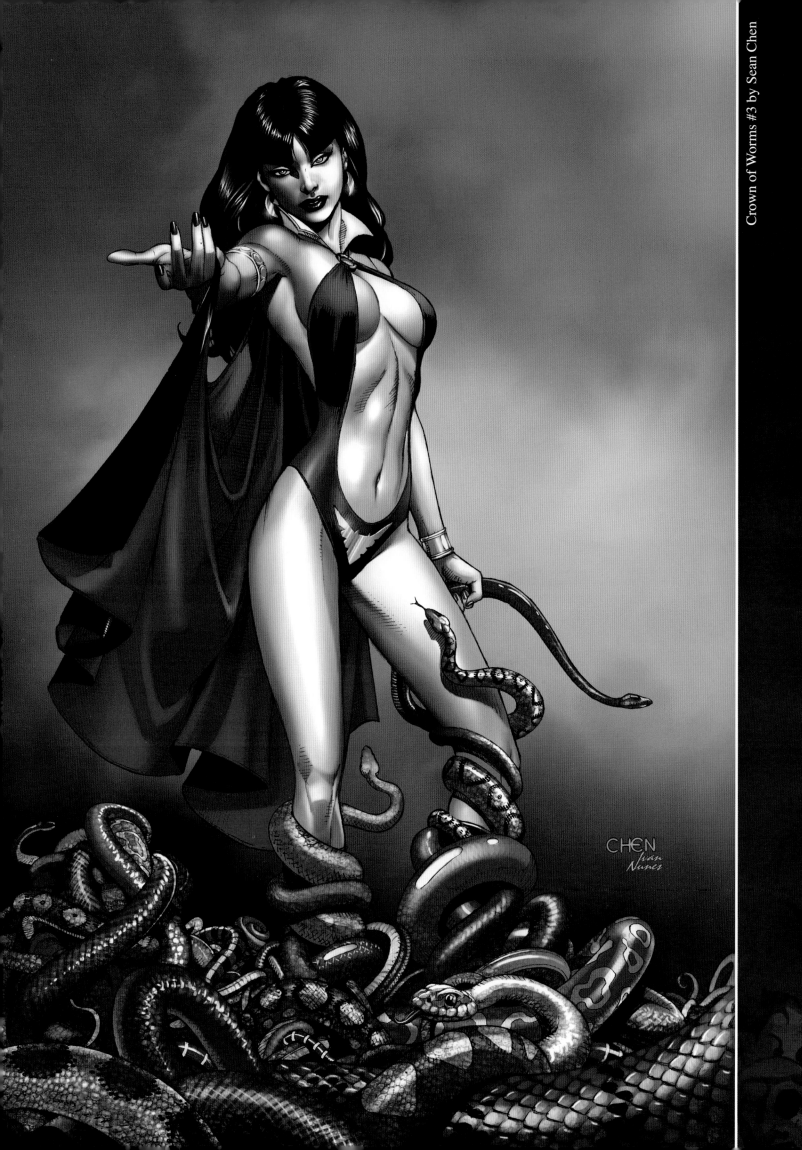

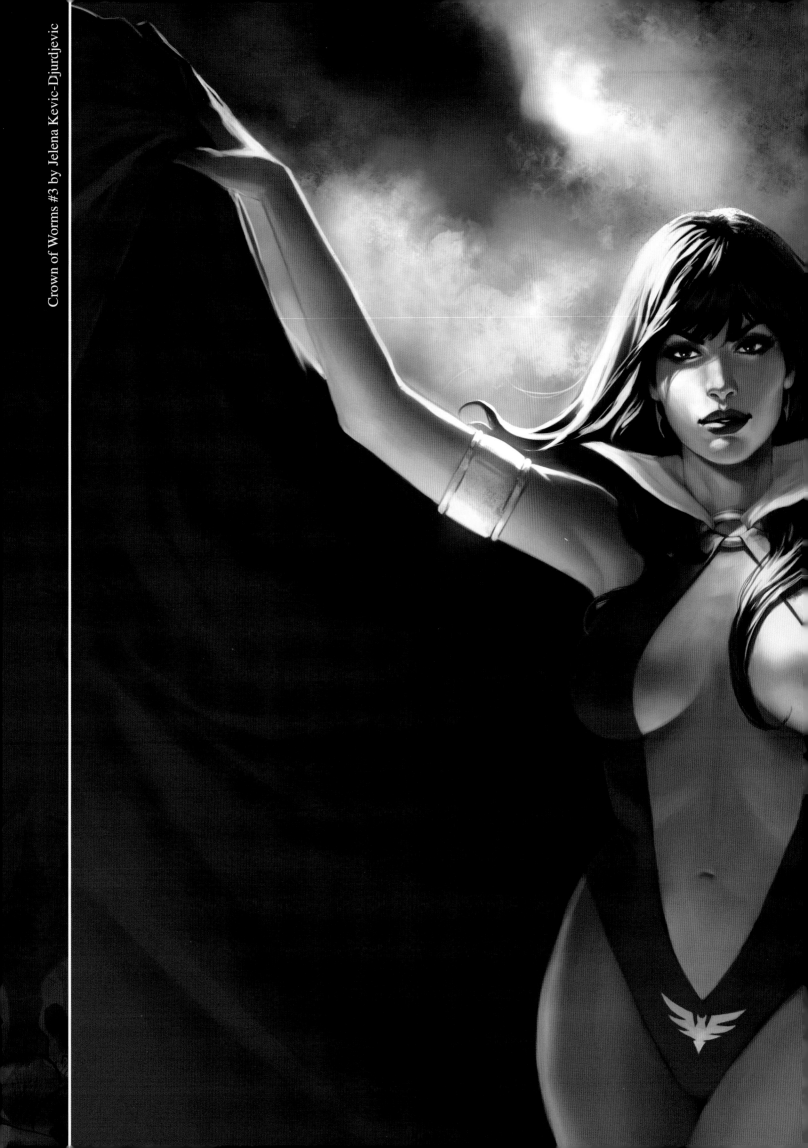

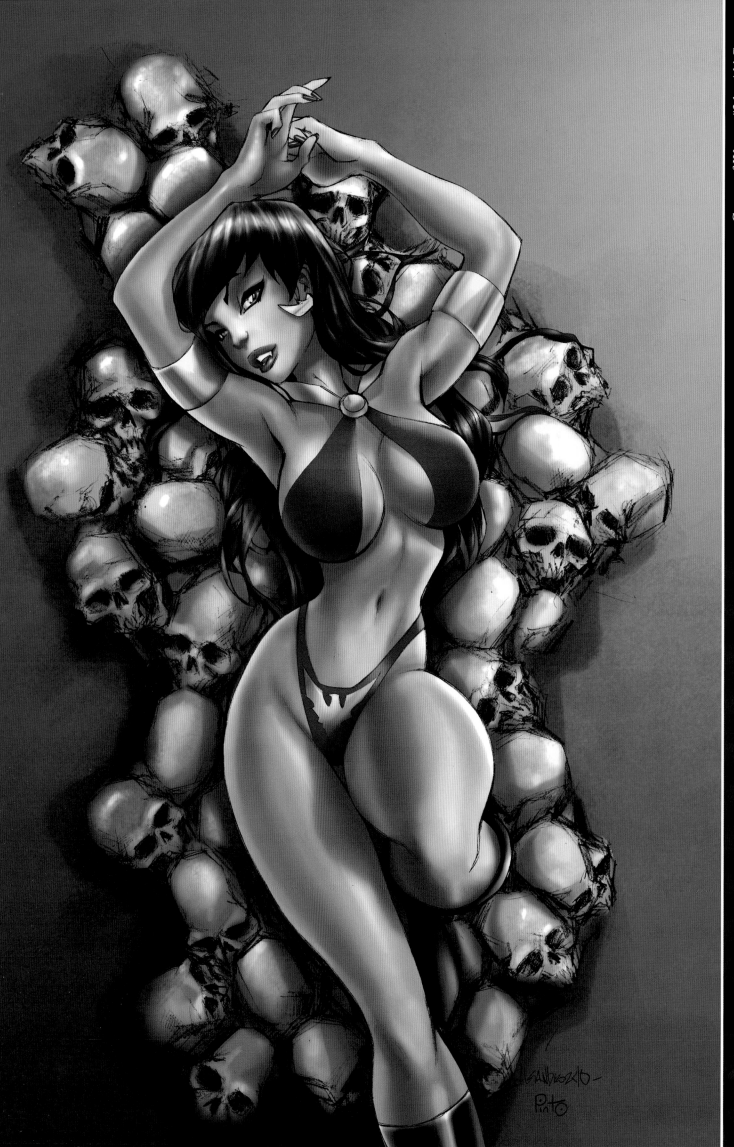

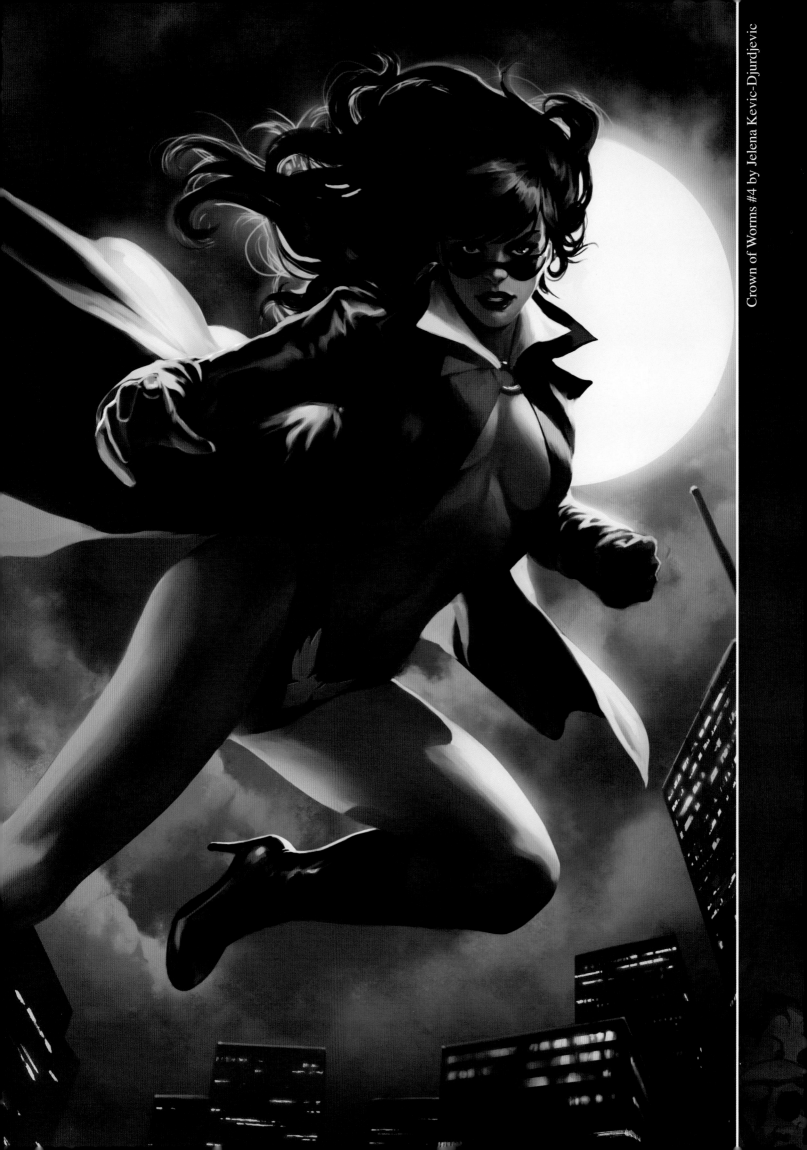

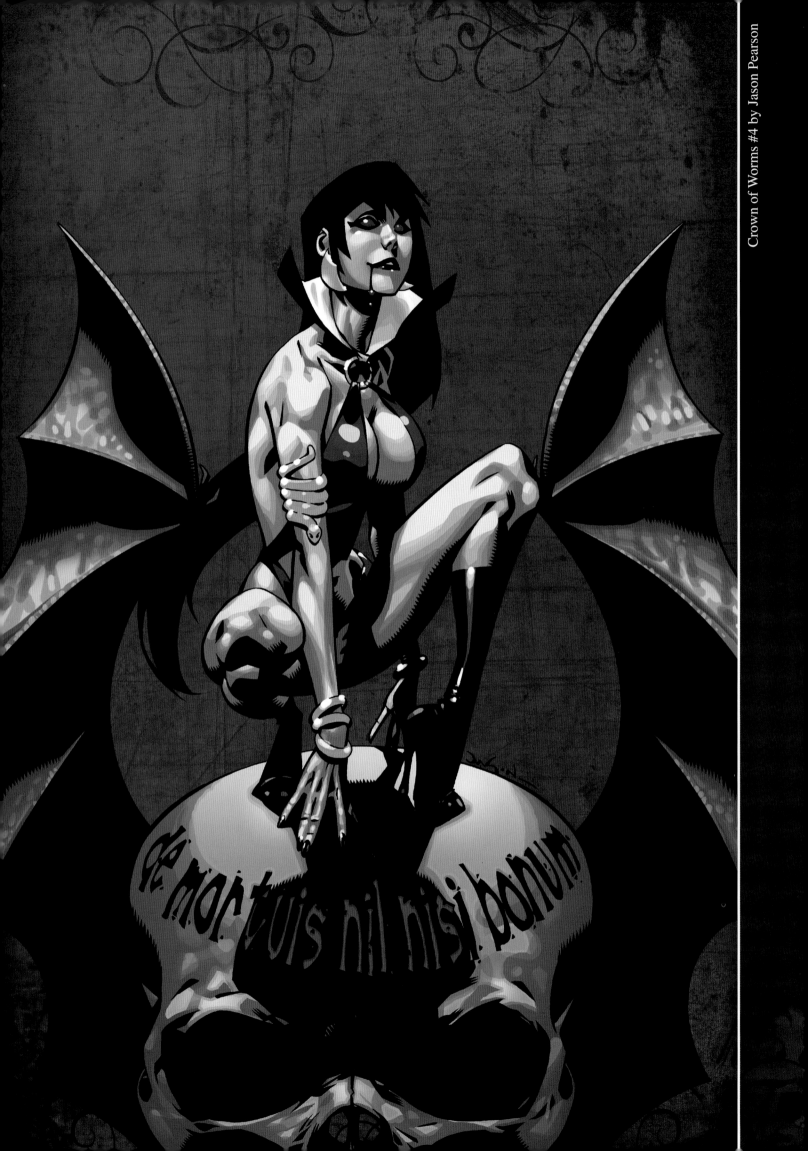

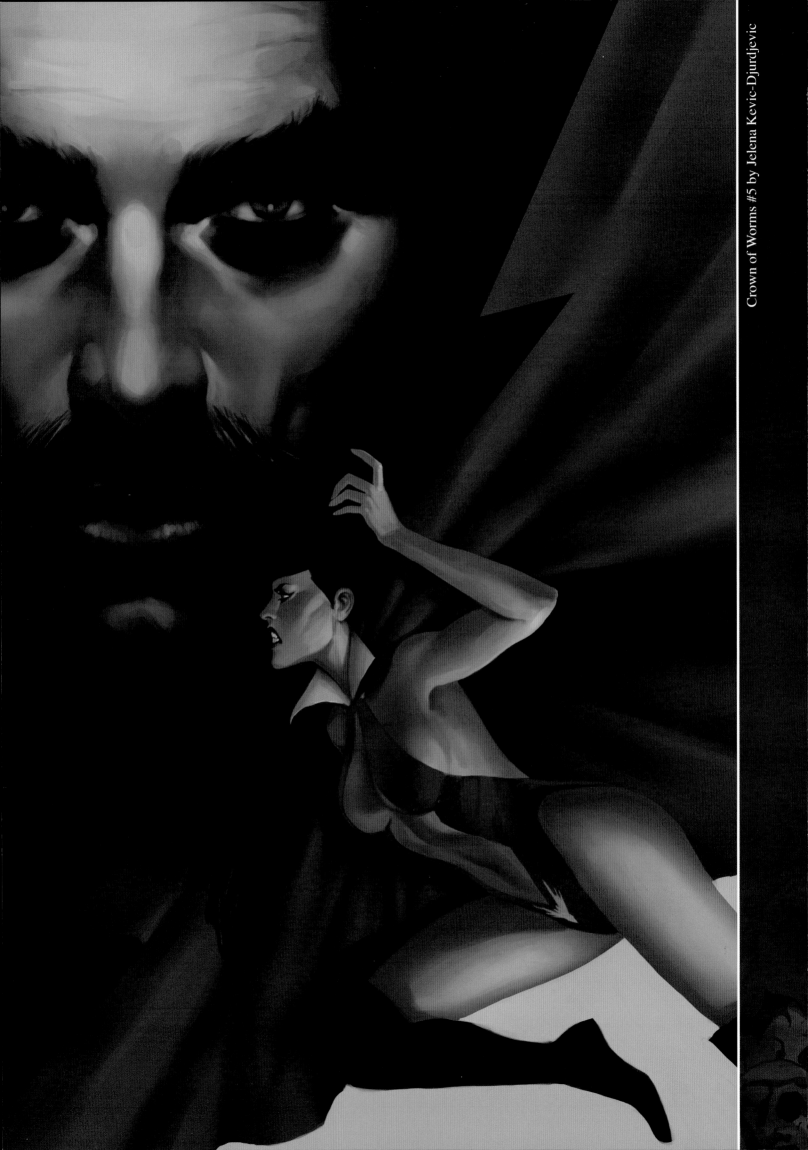

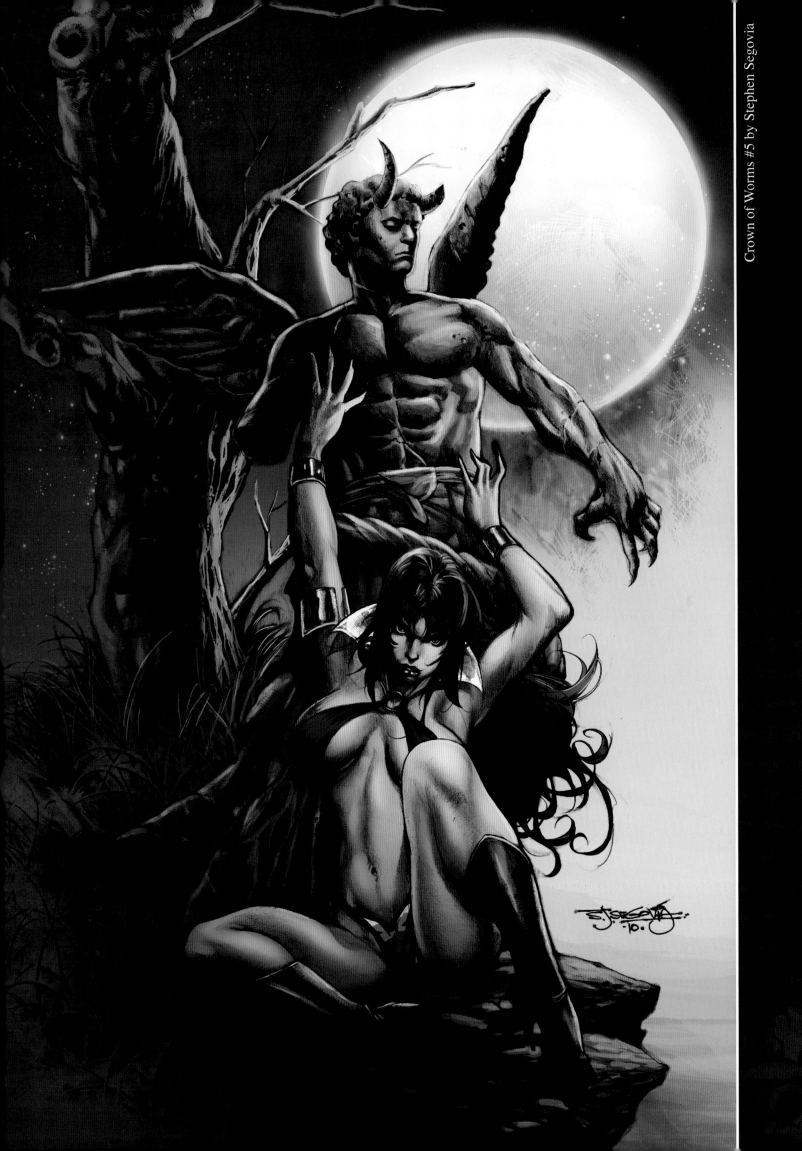

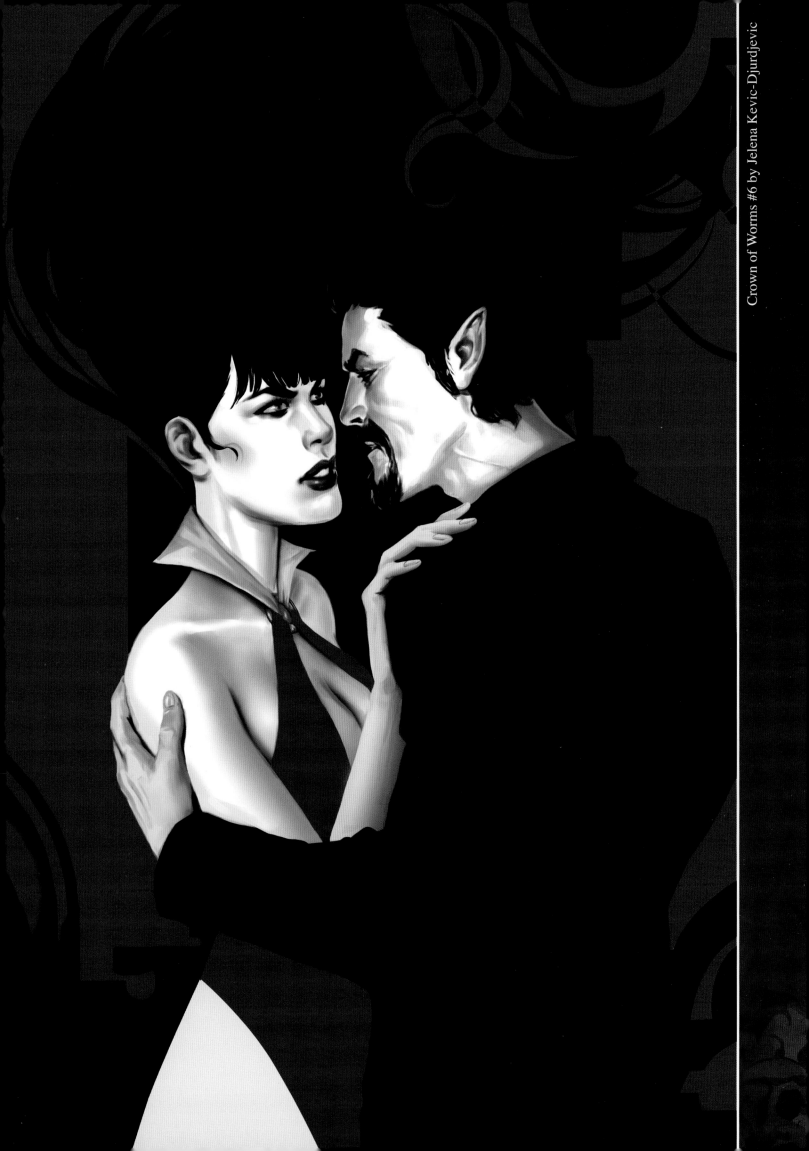

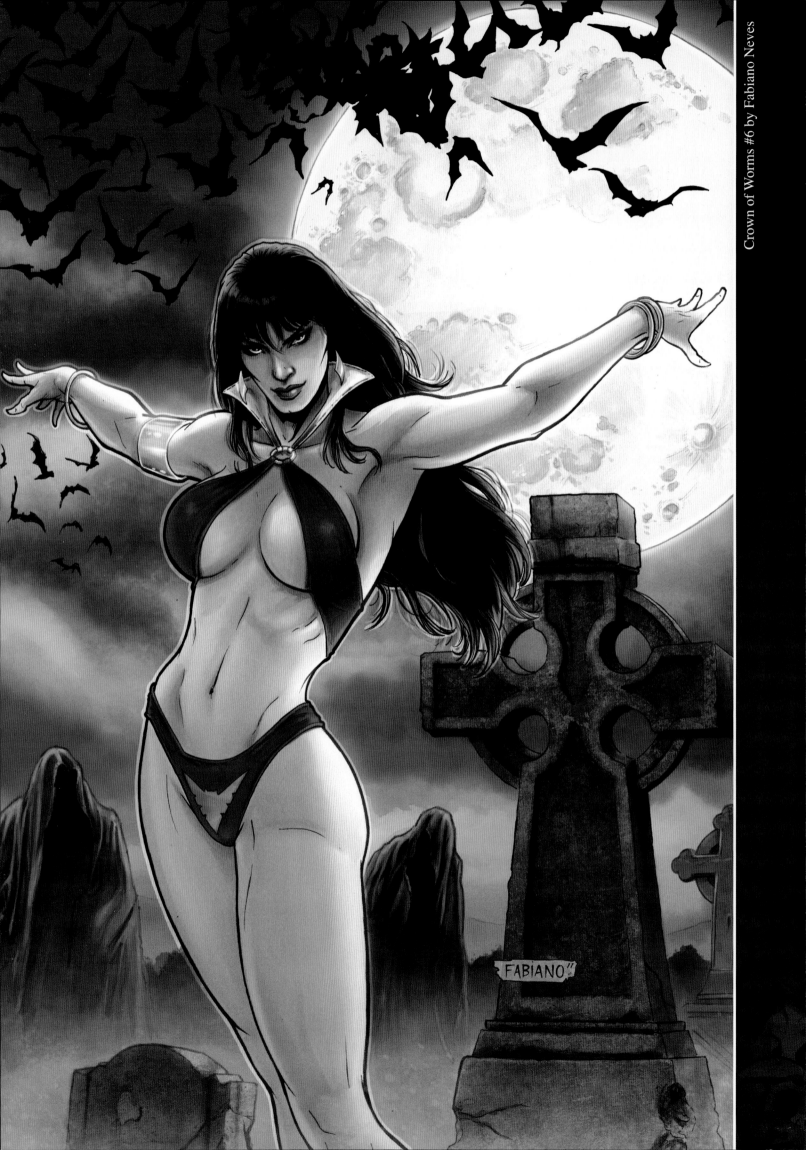

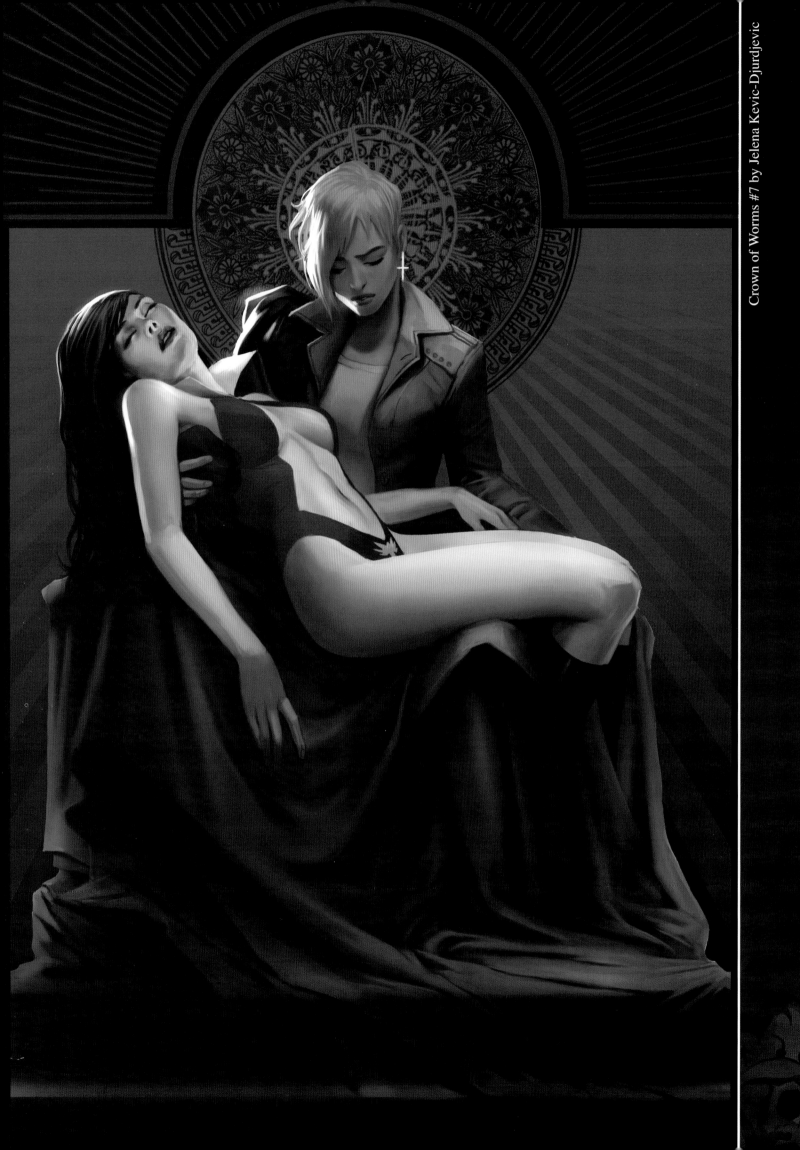

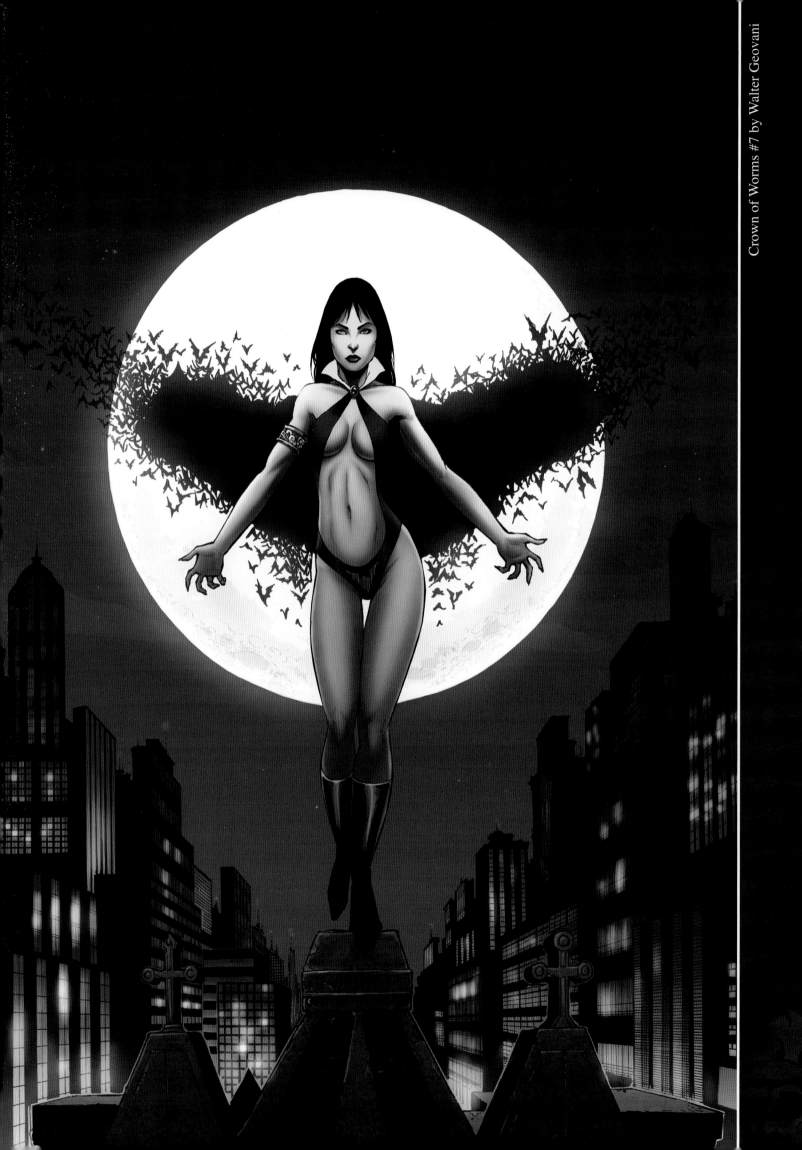

Crown of Worms #7 by Walter Geovani

A MURDER OF CROWS

THE MISTRESS OF THE DARK CONTINUES HER SUPERNATURAL ADVENTURES, RUNNING A GAUNTLET OF MURDER AND DESPAIR ACROSS AN INCREASINGLY IMPERILED GLOBE. A TRIO OF DEMONESS ASSASSINS - THE KERASU SHIMEI (THE "CROW SISTERS") - HAVE CLAWED THEIR WAY INTO OUR WORLD AND ARE INTENT ON BUILDING A BLOODY MONUMENT TO MURDER, SIN AND MAYHEM, AND IT WILL TAKE ALL OF VAMPIRELLA'S CONSIDERABLE SKILL TO SEND THEM SCREAMING BACK TO HELL...AND IN A SPECIAL GUEST STORY, A TERRIFYING EXORCISM AWAITS VAMPIRELLA AND HER COMPANION, SOFIA MURRAY, IN GERMANY. BUT THIS PARTICULAR DEMON ISN'T READY FOR EVICTION JUST YET...

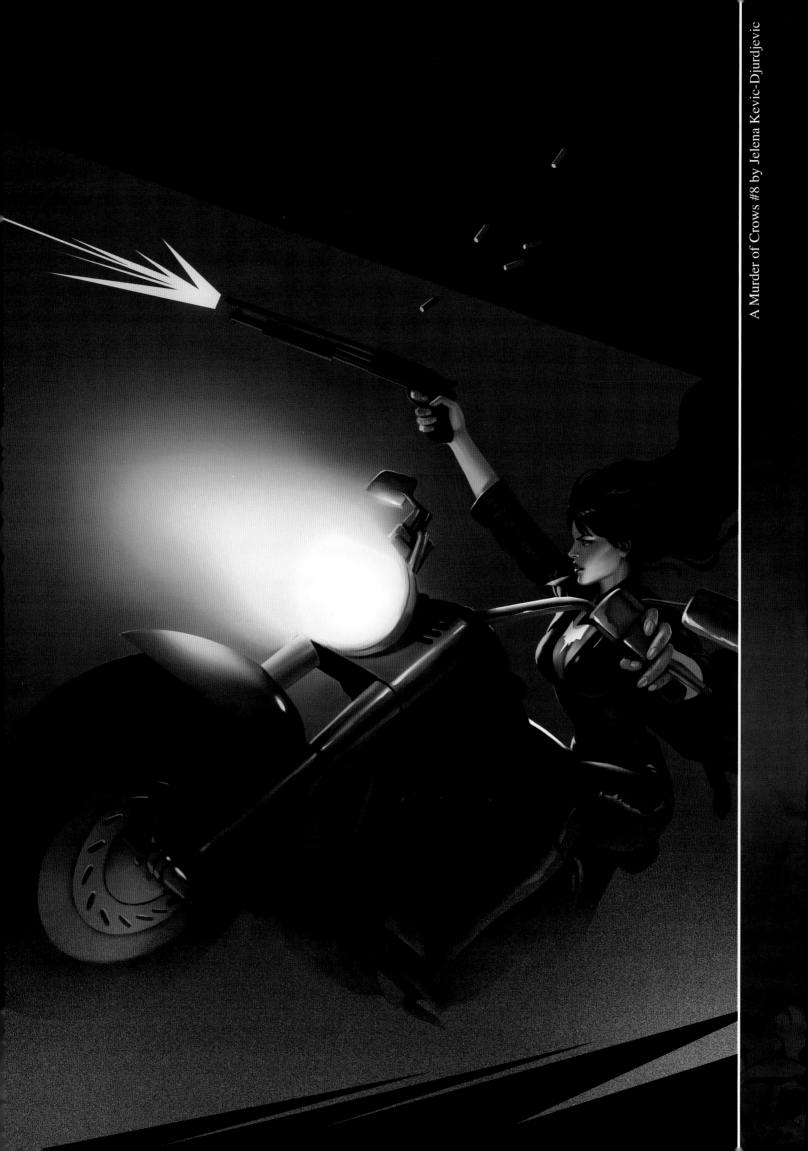

A Murder of Crows #8 by Jelena Kevic-Djurdjevic

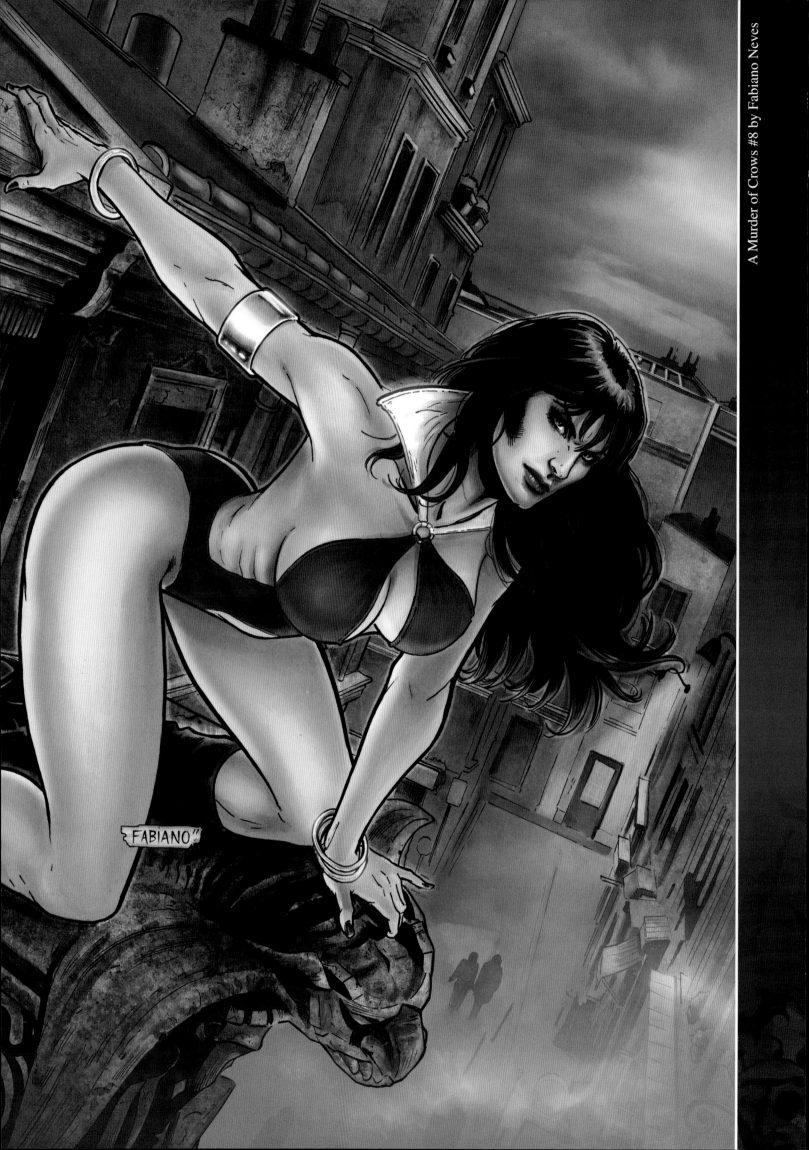

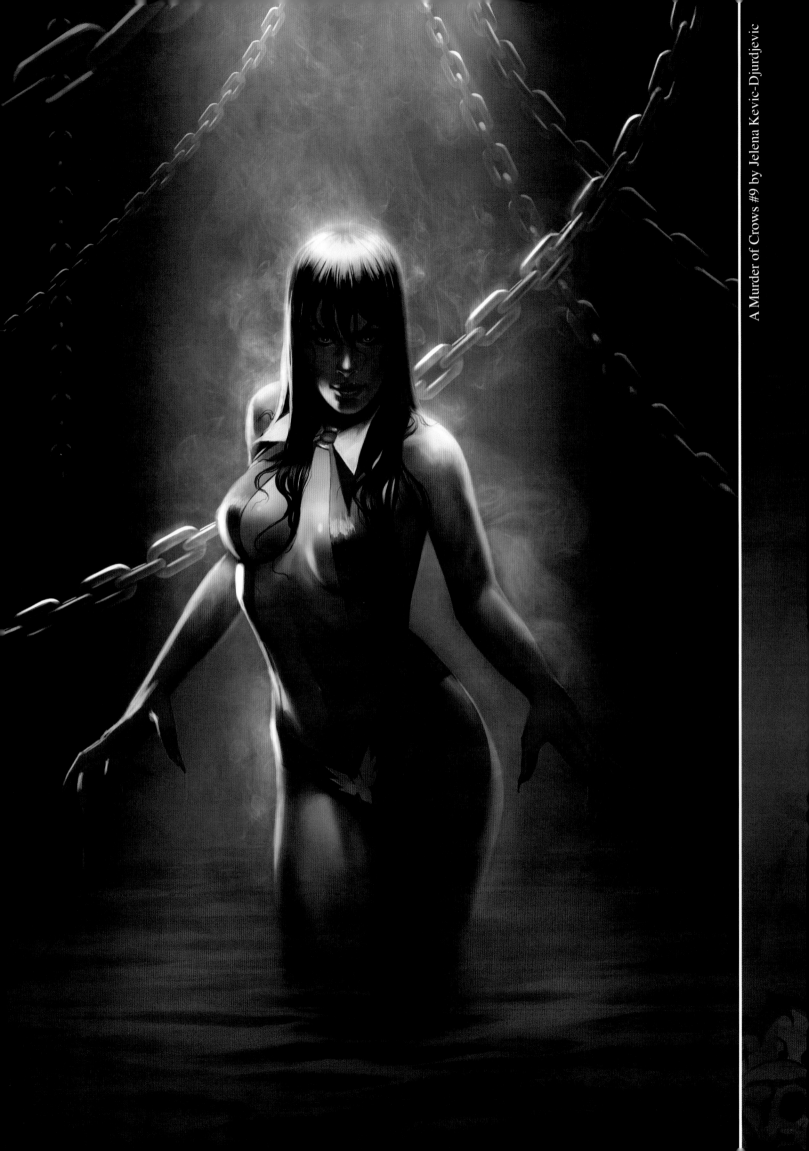

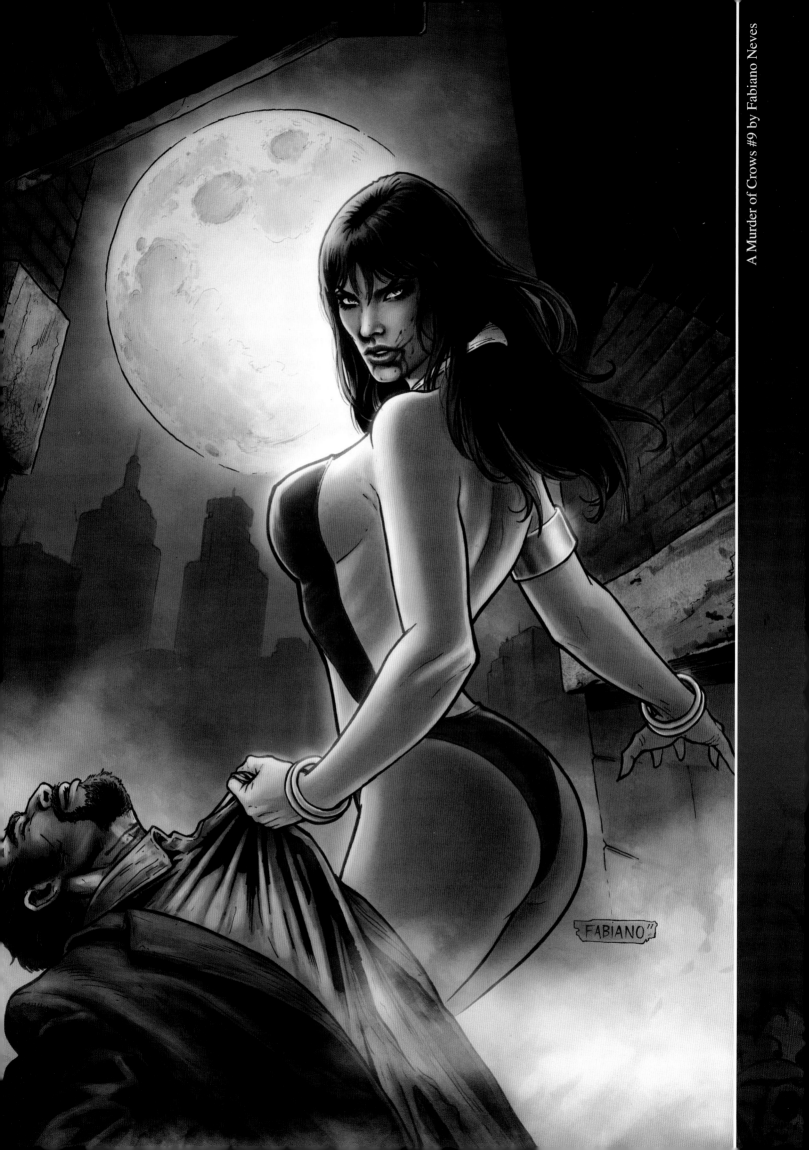

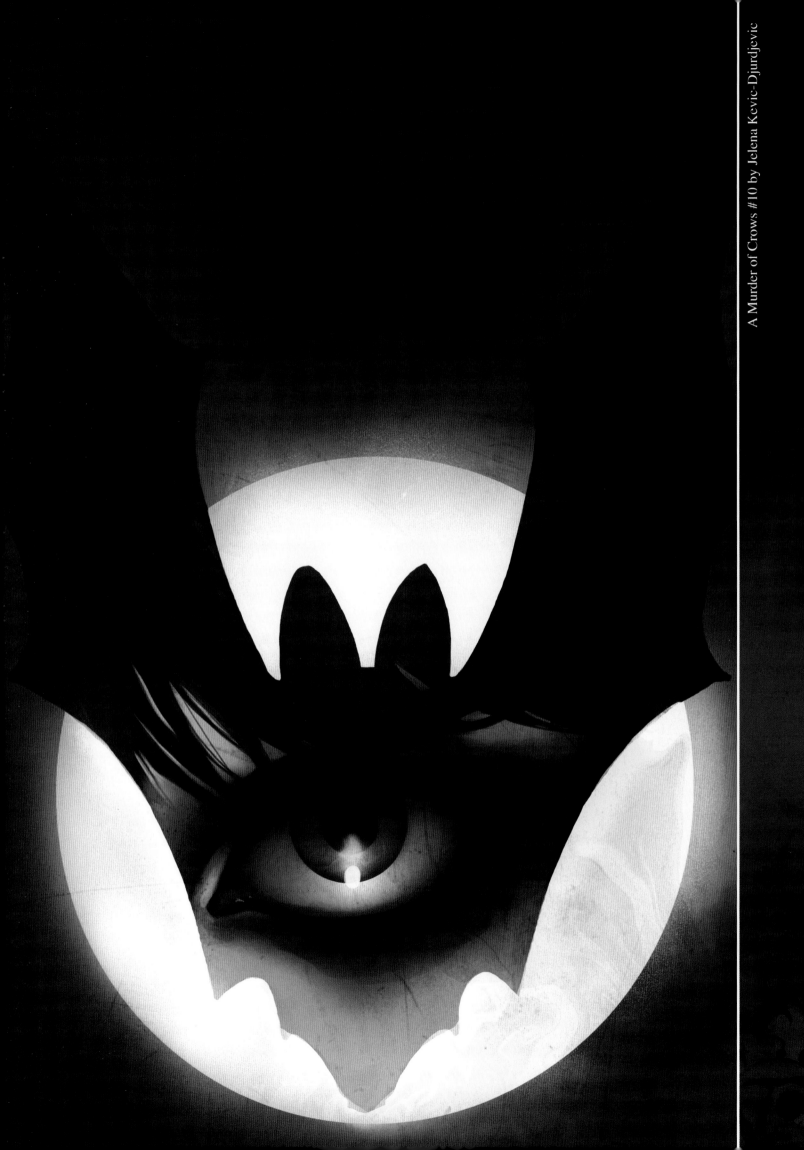

Vinicius
Andrade

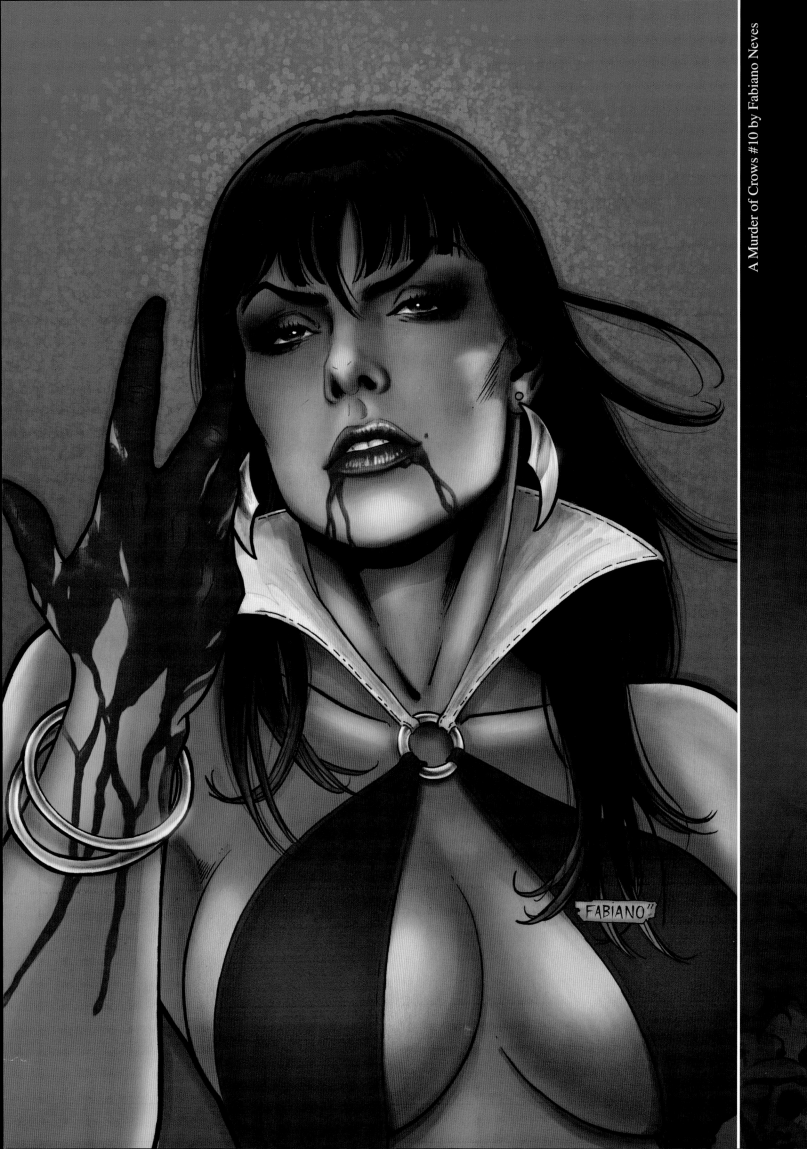

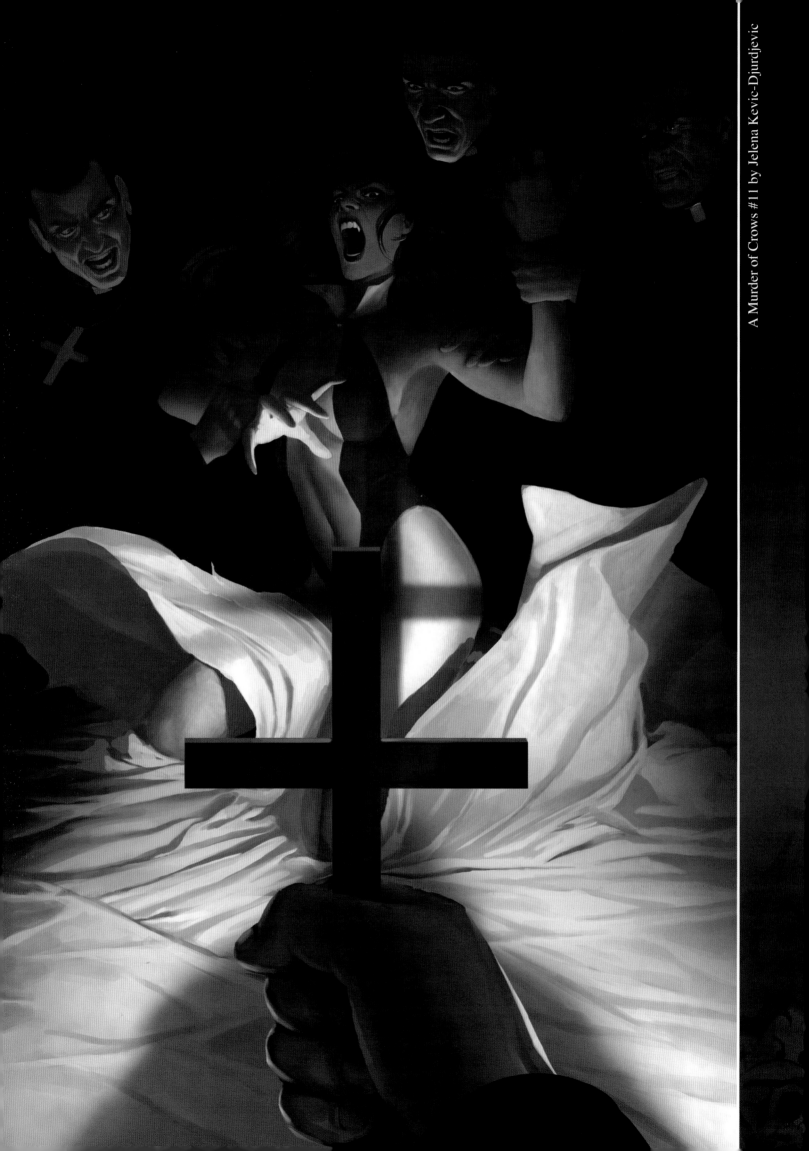

A Murder of Crows #11 by Jelena Kevic-Djurdjevic

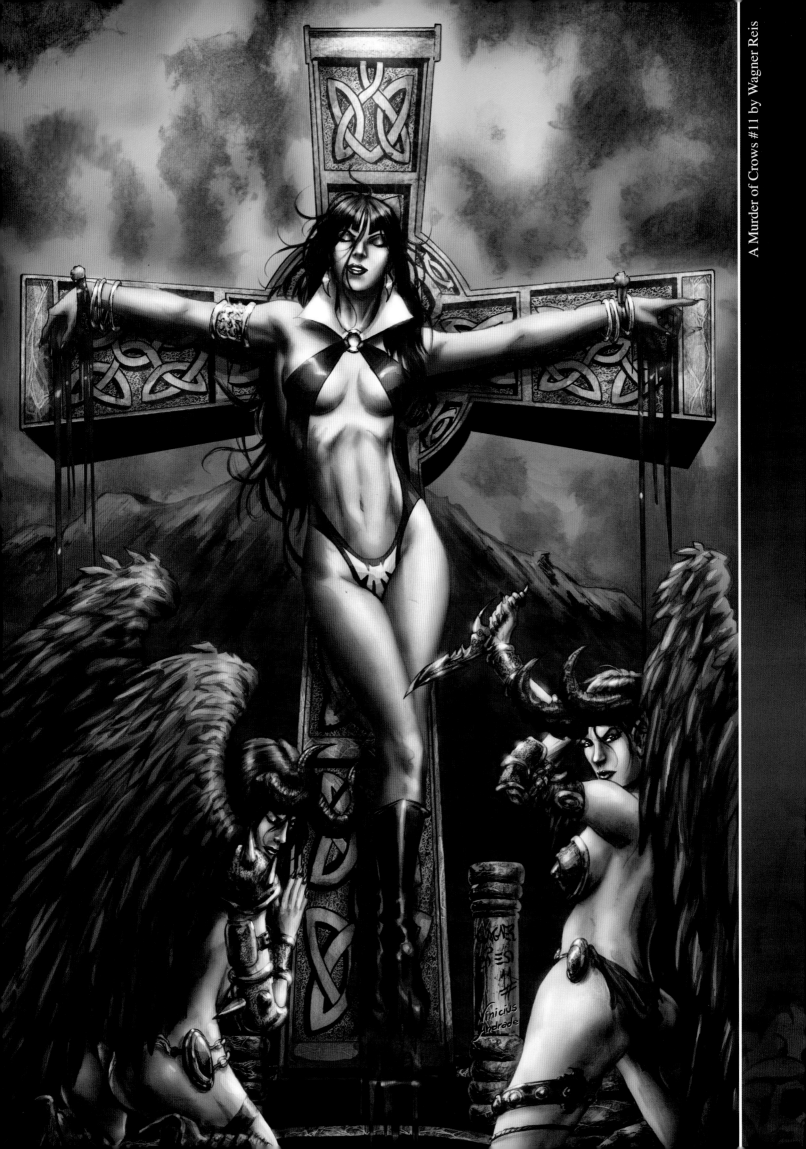

THRONE OF SKULLS

AT THE REQUEST OF VAMPIRELLA'S ALLIES— THE VATICAN'S PARANORMAL COVERT STRIKE FORCE, CESTUS DEI— THE BLOOD-DRINKING SCOURGE OF THE SUPERNATURAL TRAVELS TO RUSSIA, ON THE HUNT FOR A TERRIFYING KILLER WITH A GIFT FOR MURDER. BUT THERE'S MORE AT PLAY THAN A SIMPLE SEARCH-AND-DESTROY MISSION. COMPLICATING MATTERS IS THE RETURN OF THE KING OF THE VAMPIRES, DRACULA— MORE POWERFUL THAN EVER BEFORE, AND DETERMINED TO CONSECRATE AN UNHOLY PACT WITH ANCIENT, UNKNOWABLE FORCES THAT EVEN THE LORDS OF CHAOS AND ORDER WISELY FEAR. WAR IS ON THE HORIZON, AND ONLY ONE WHO HAS WORN THE CROWN OF WORMS CAN SIT UPON A THRONE OF SKULLS.

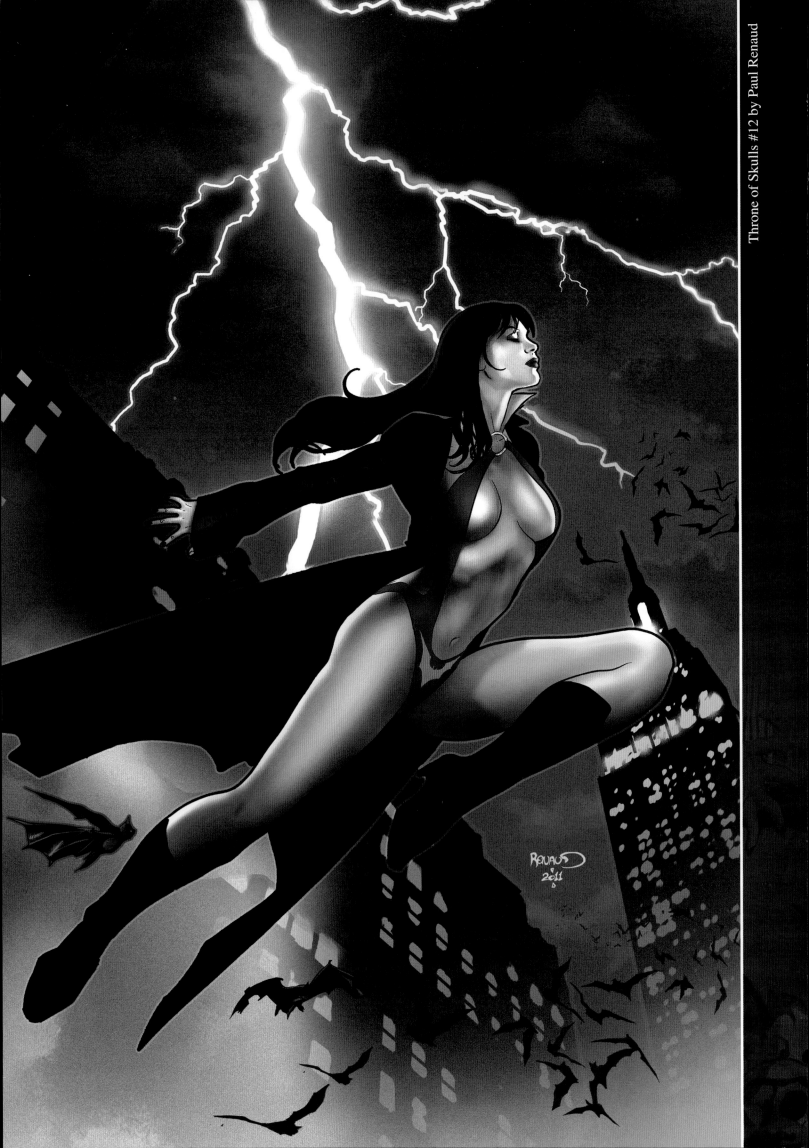

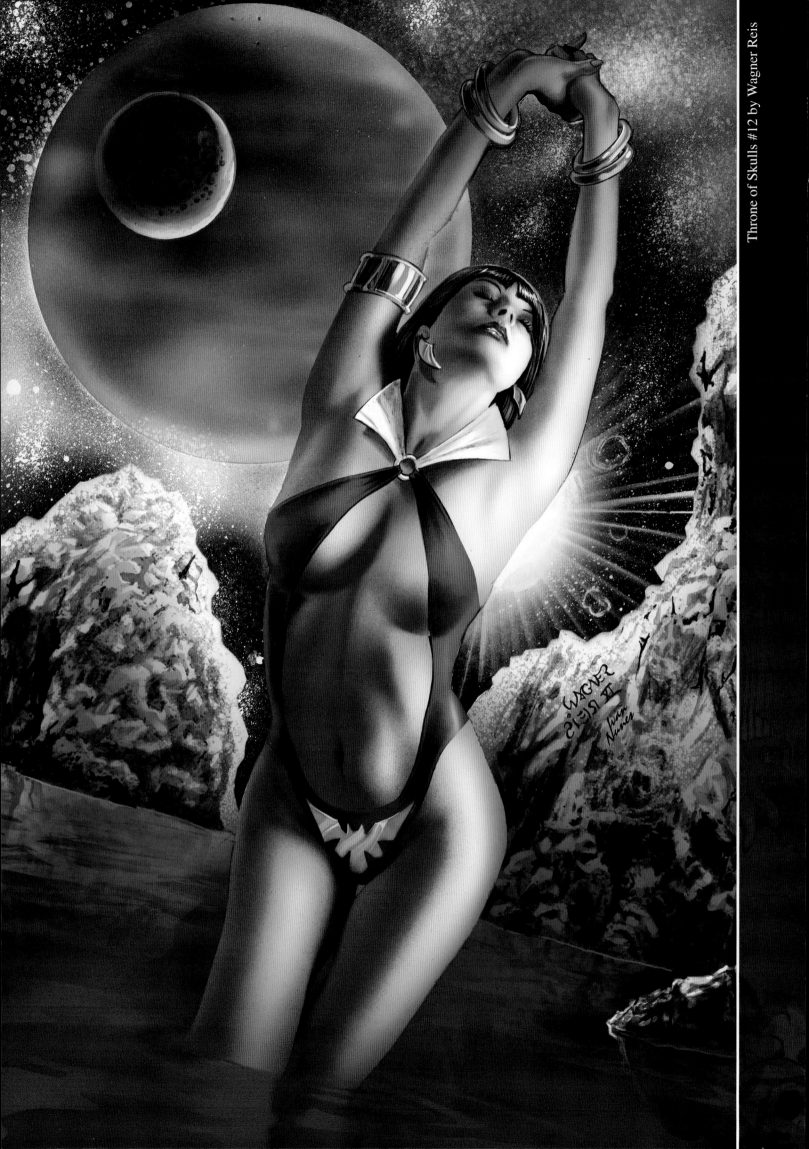

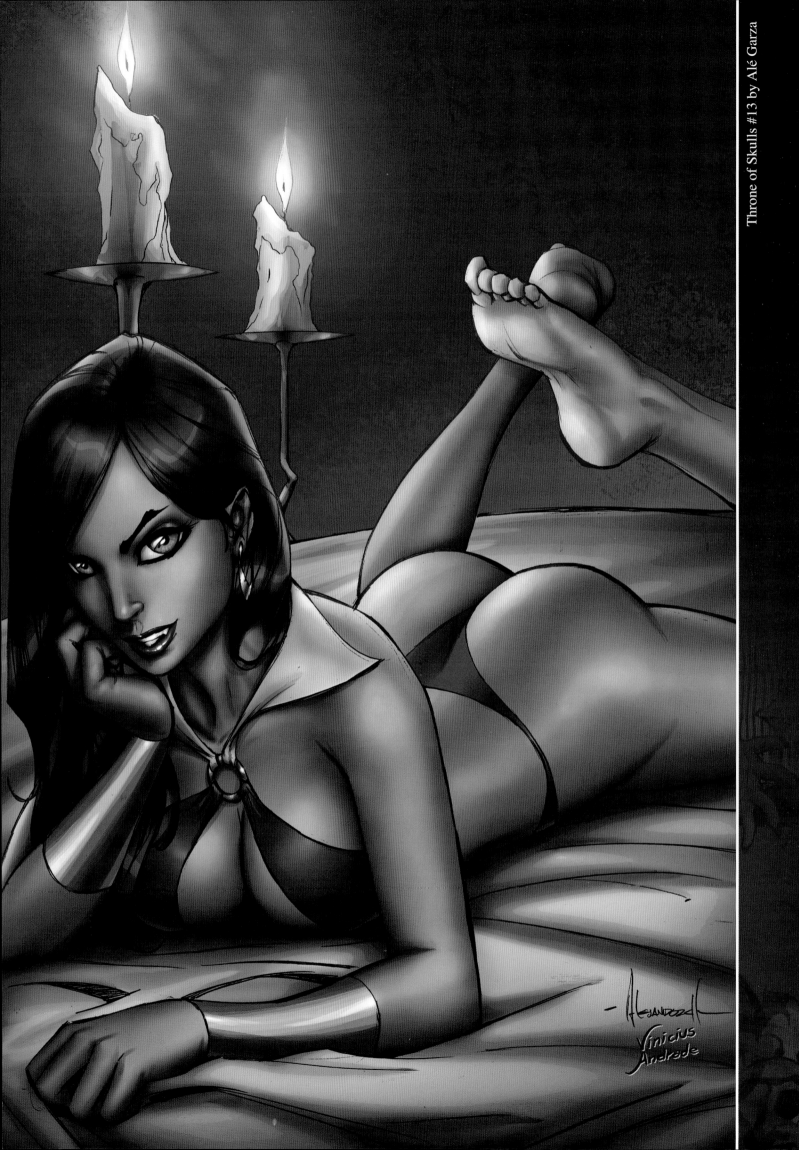

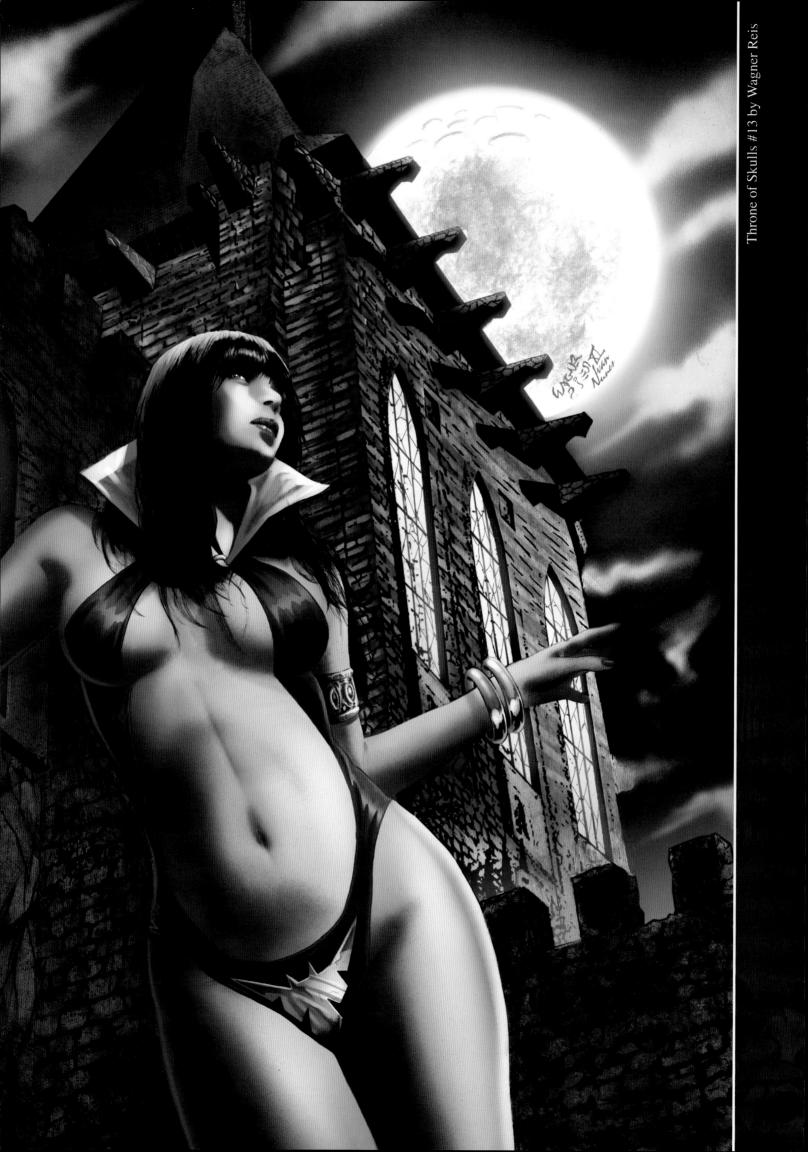

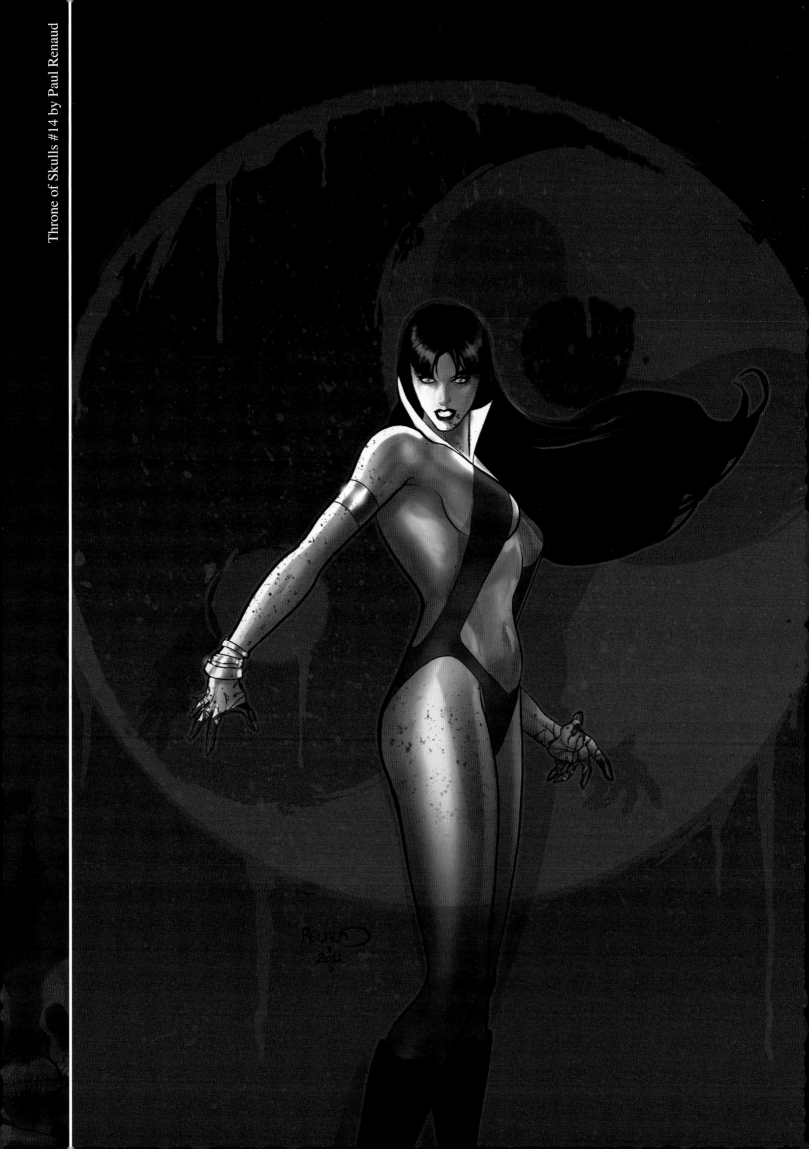

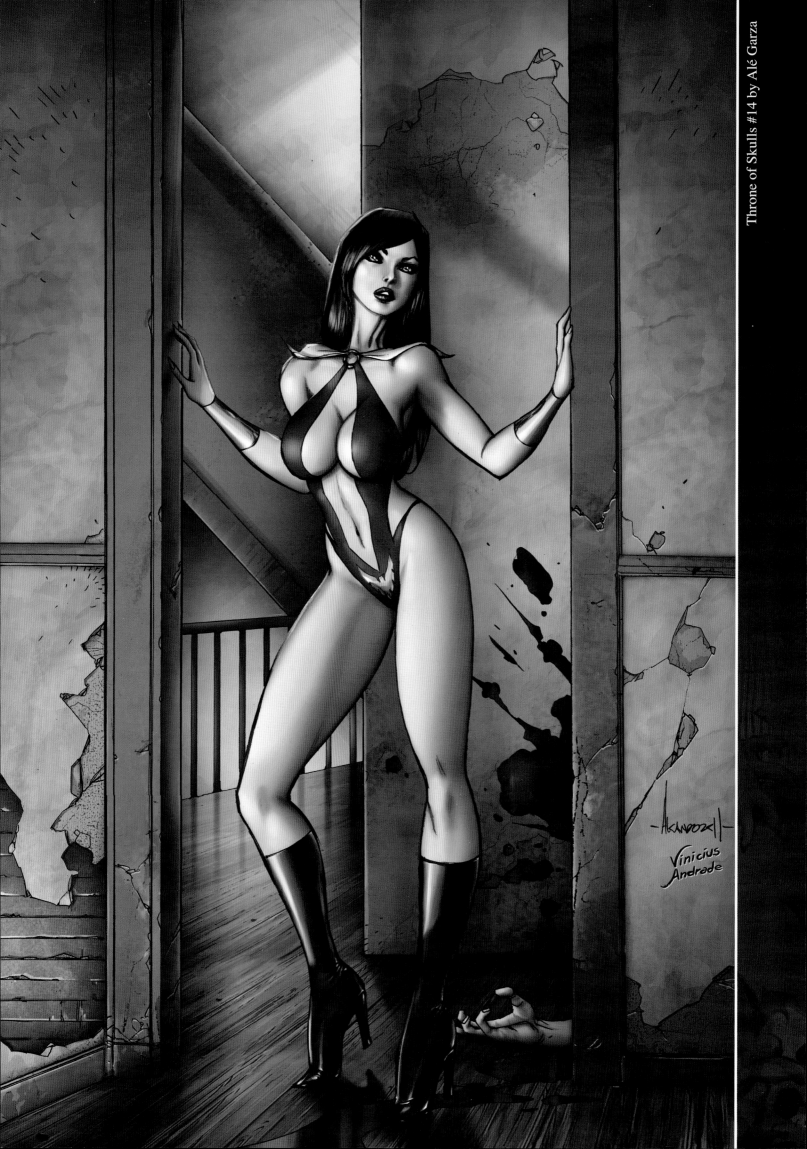

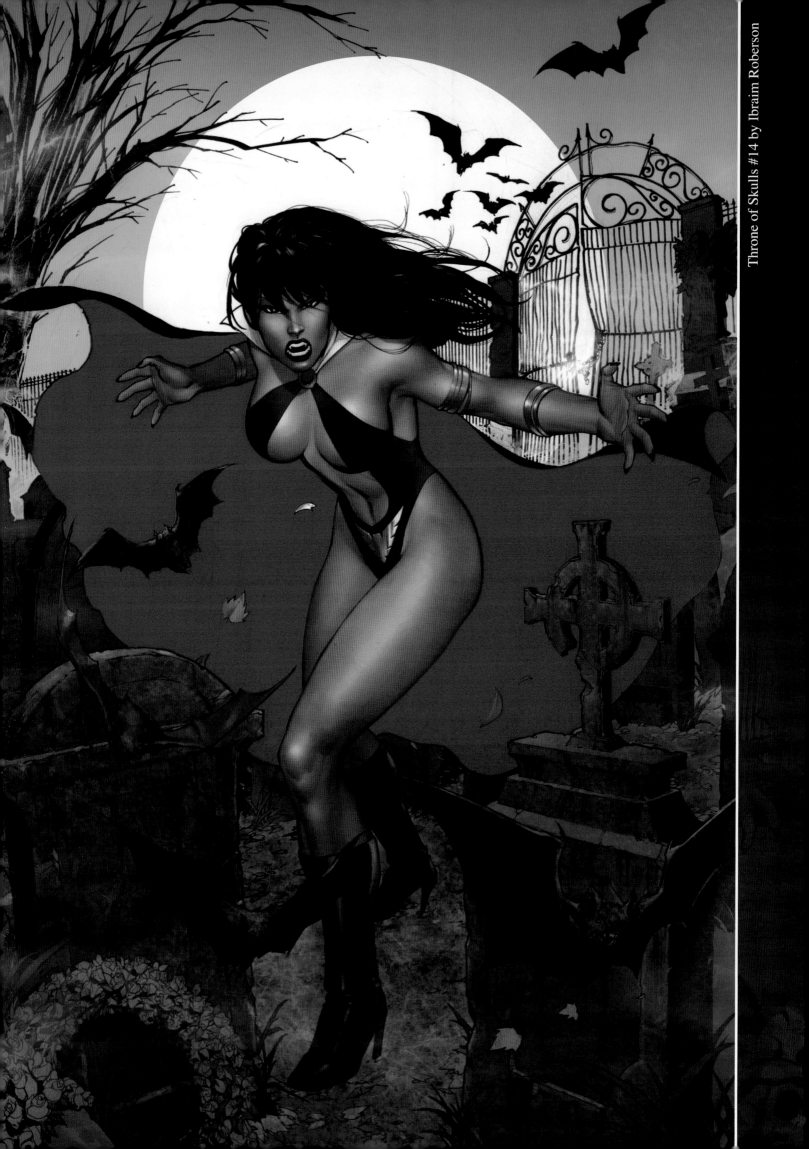

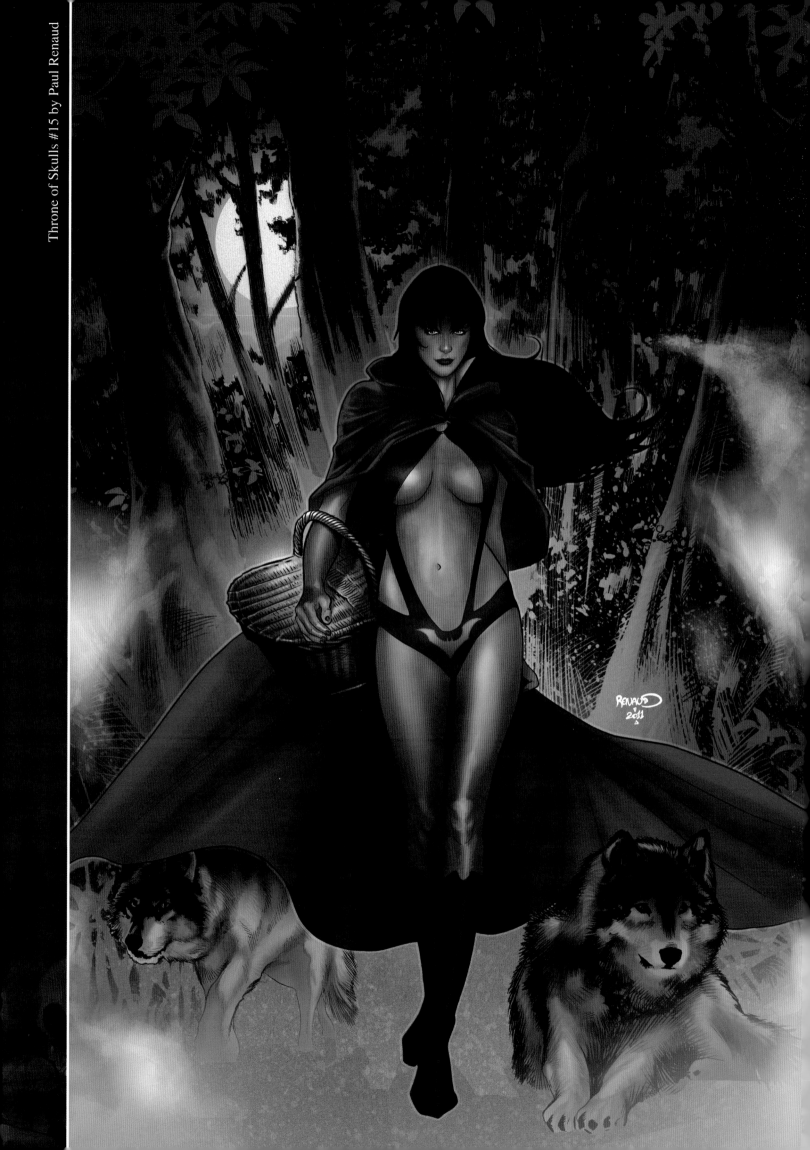

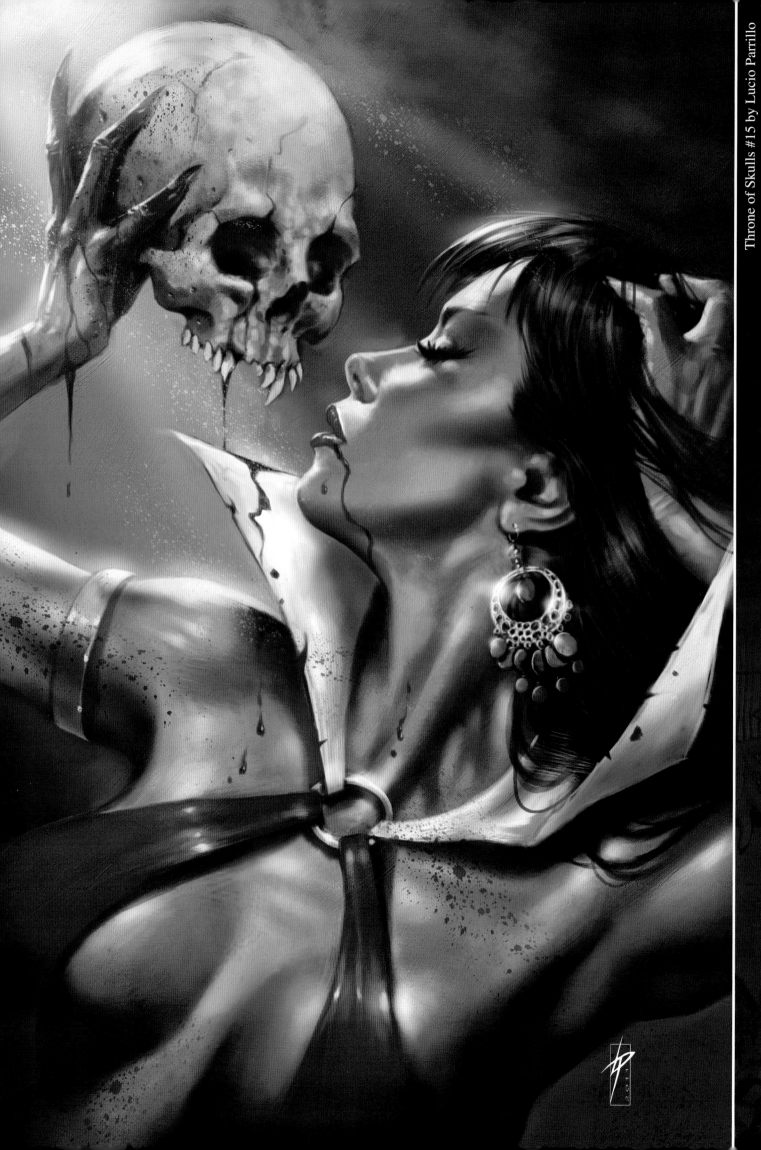

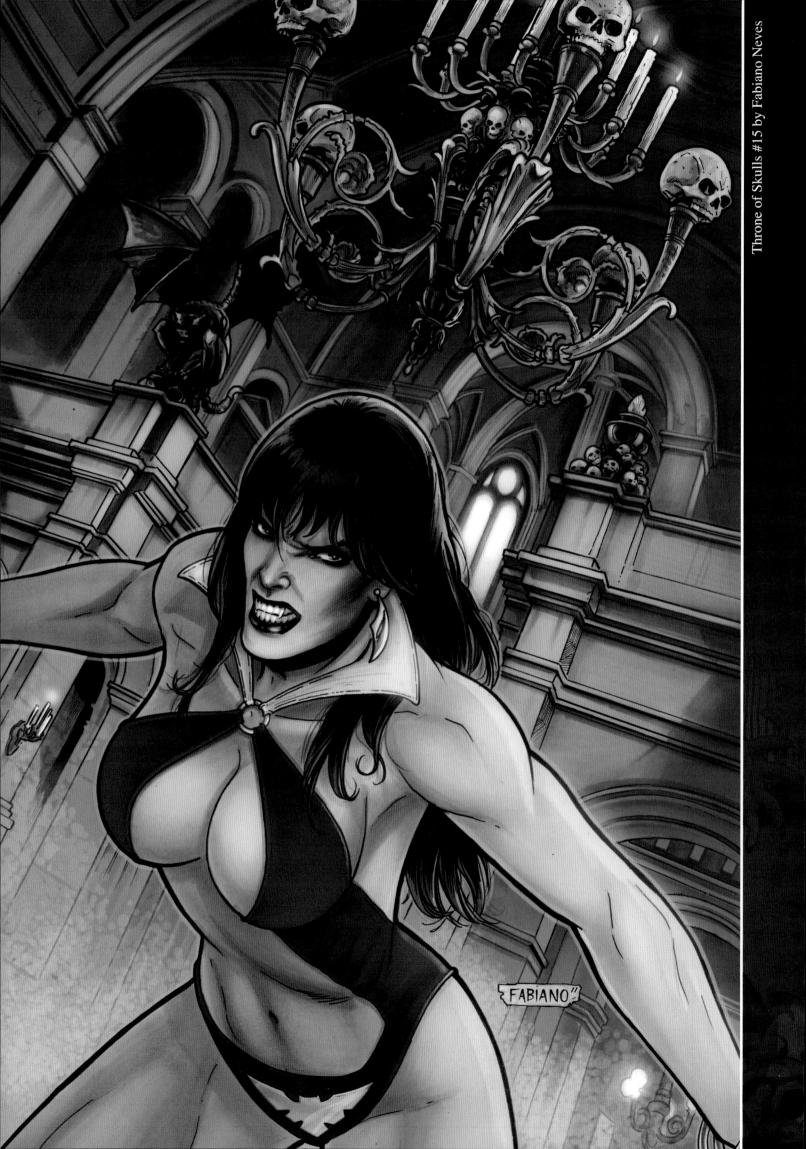

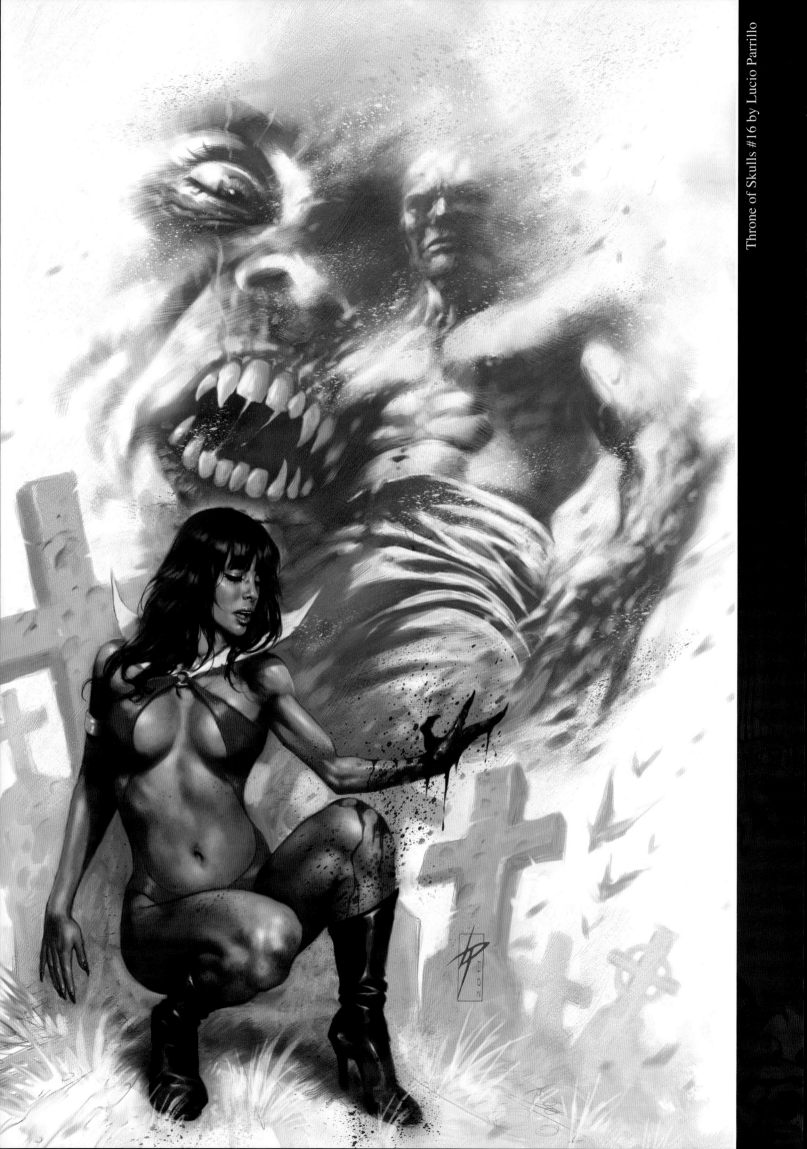

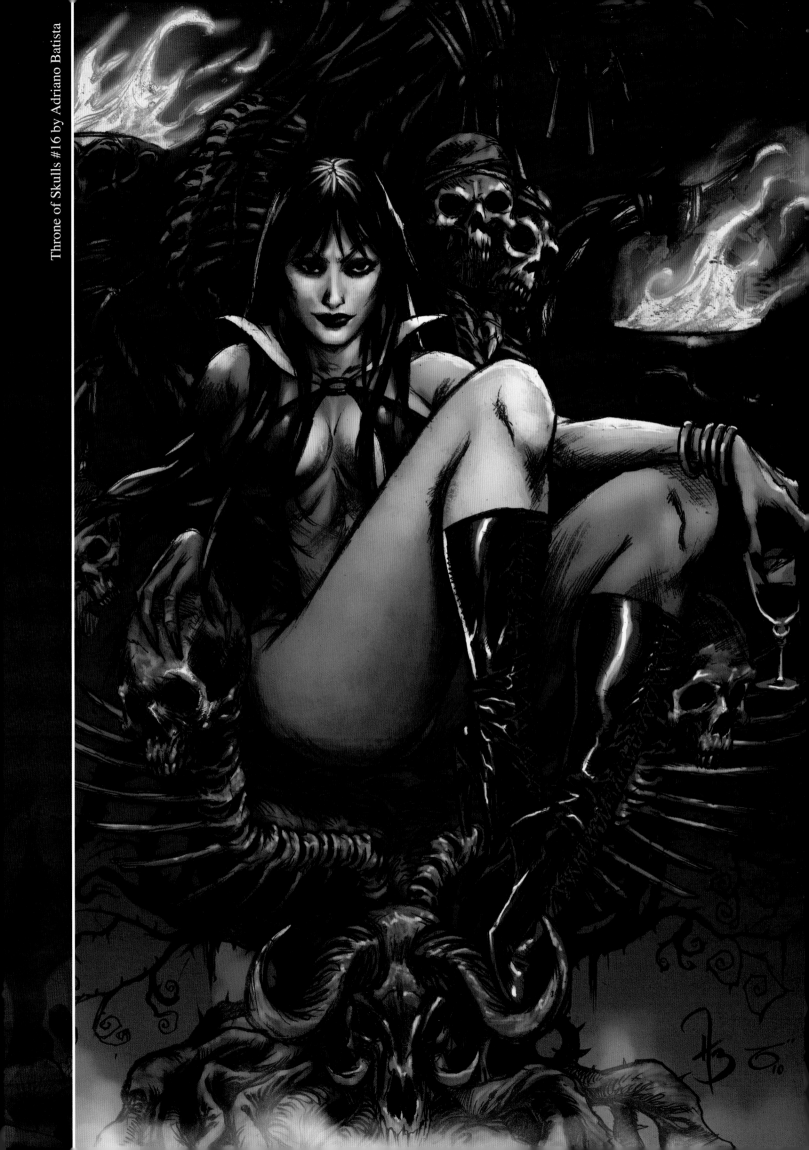

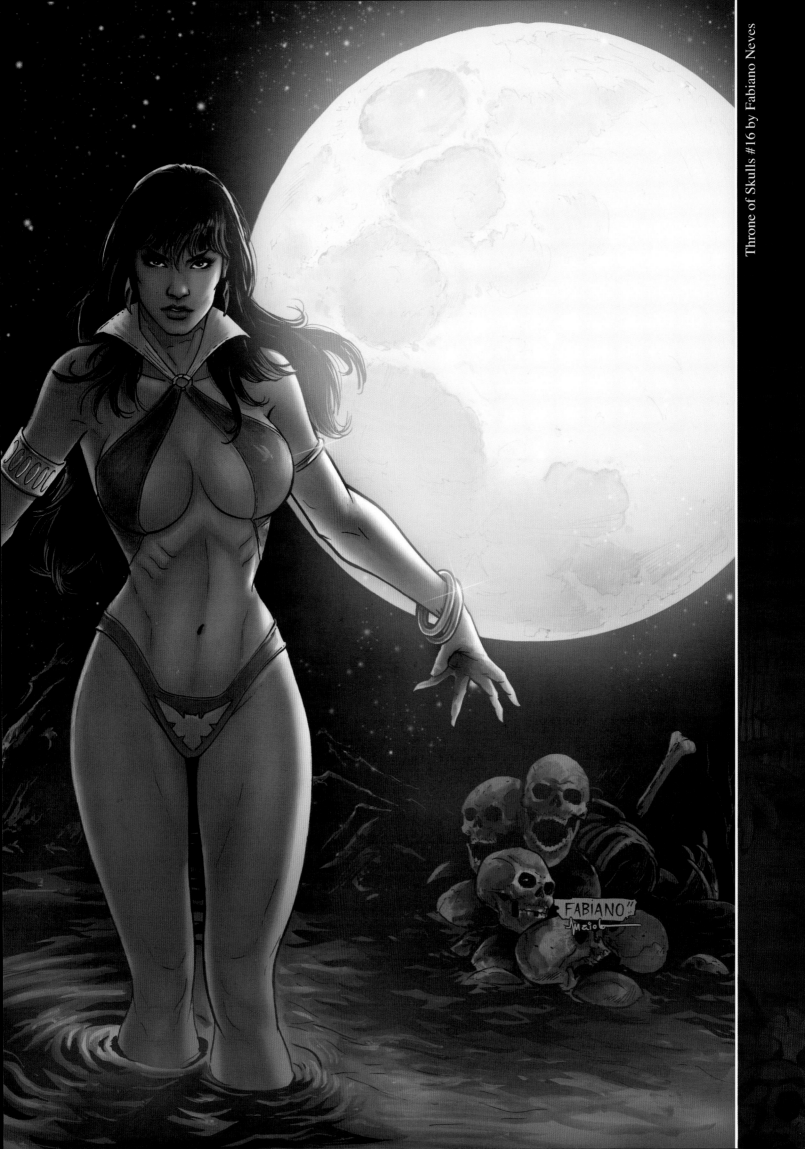

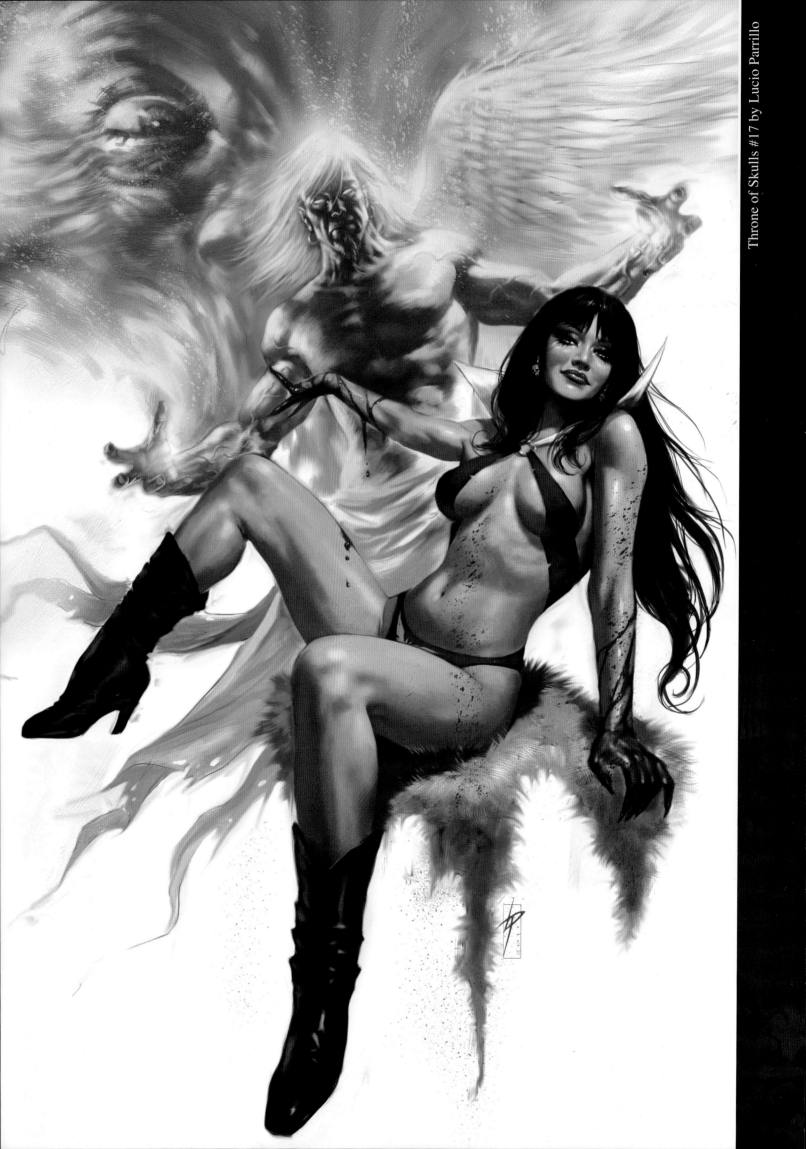

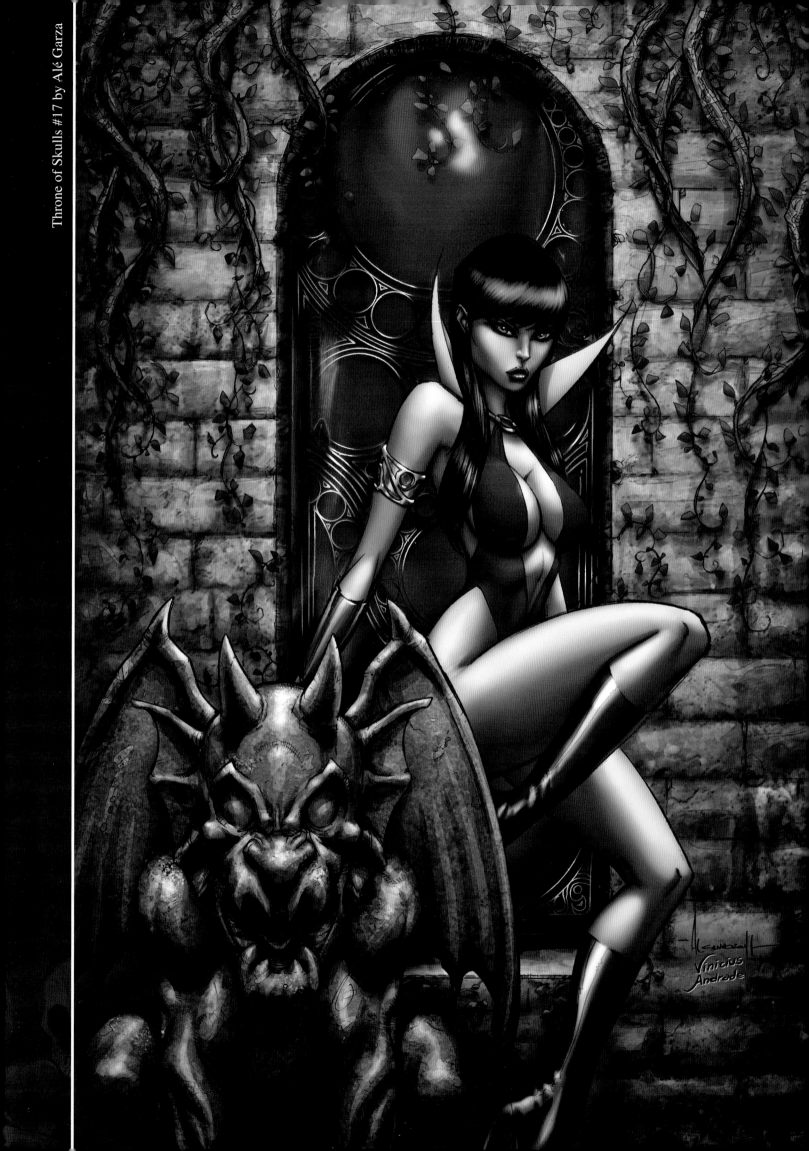

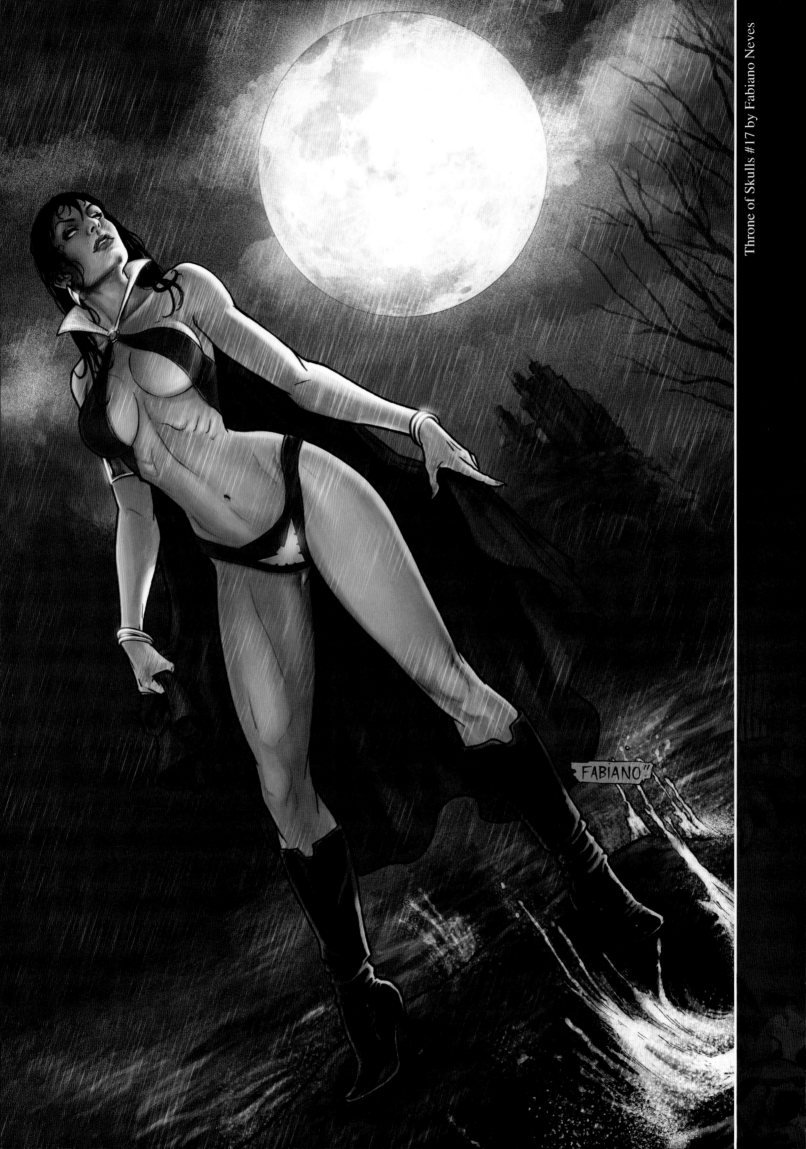

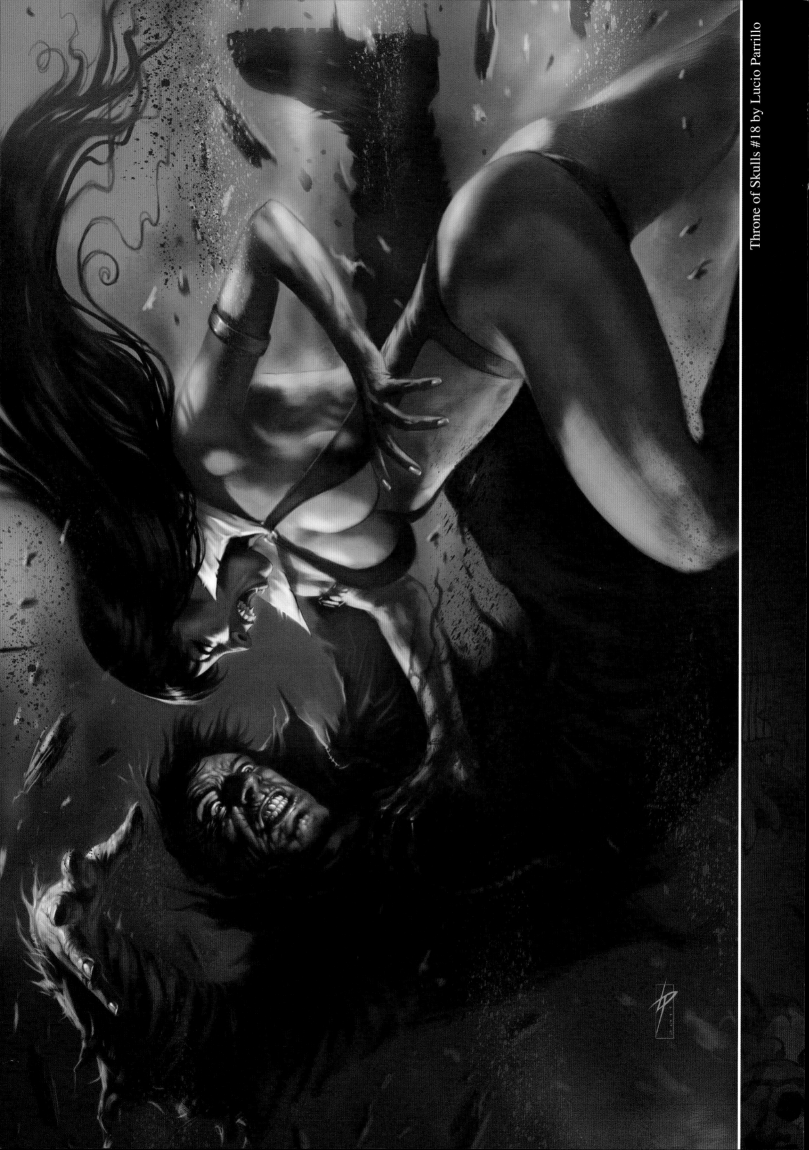

Vinicius Andrade

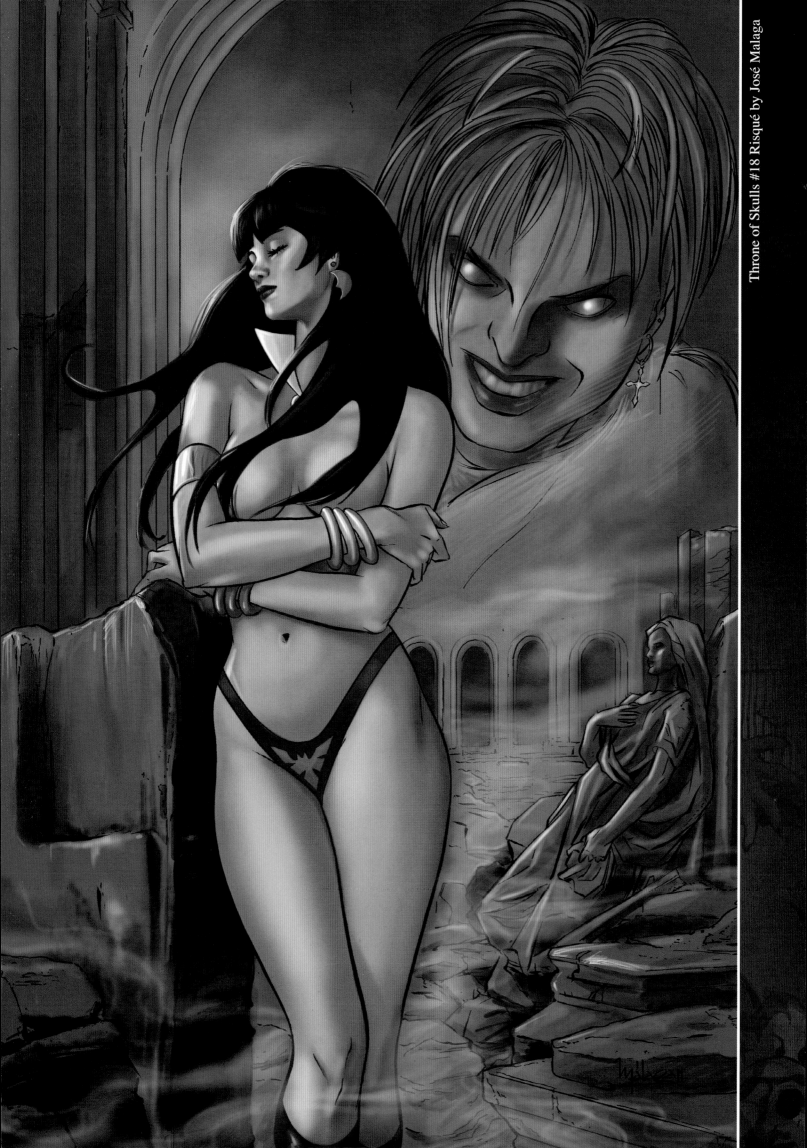

FABIANO"

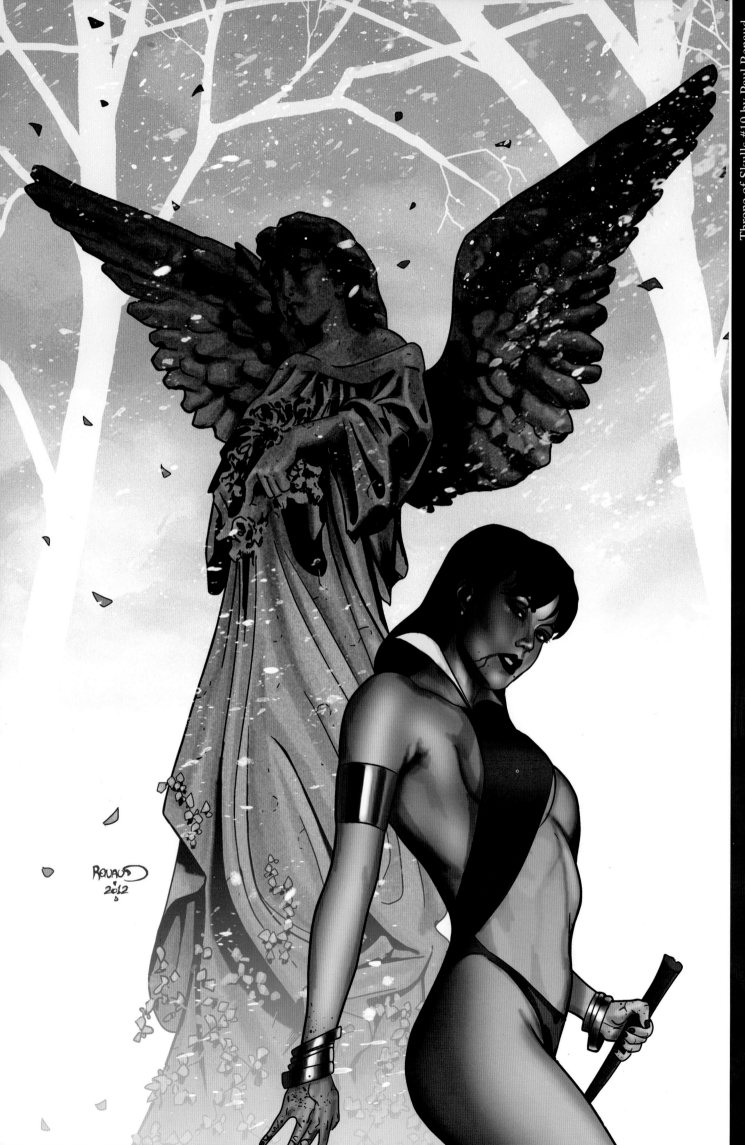

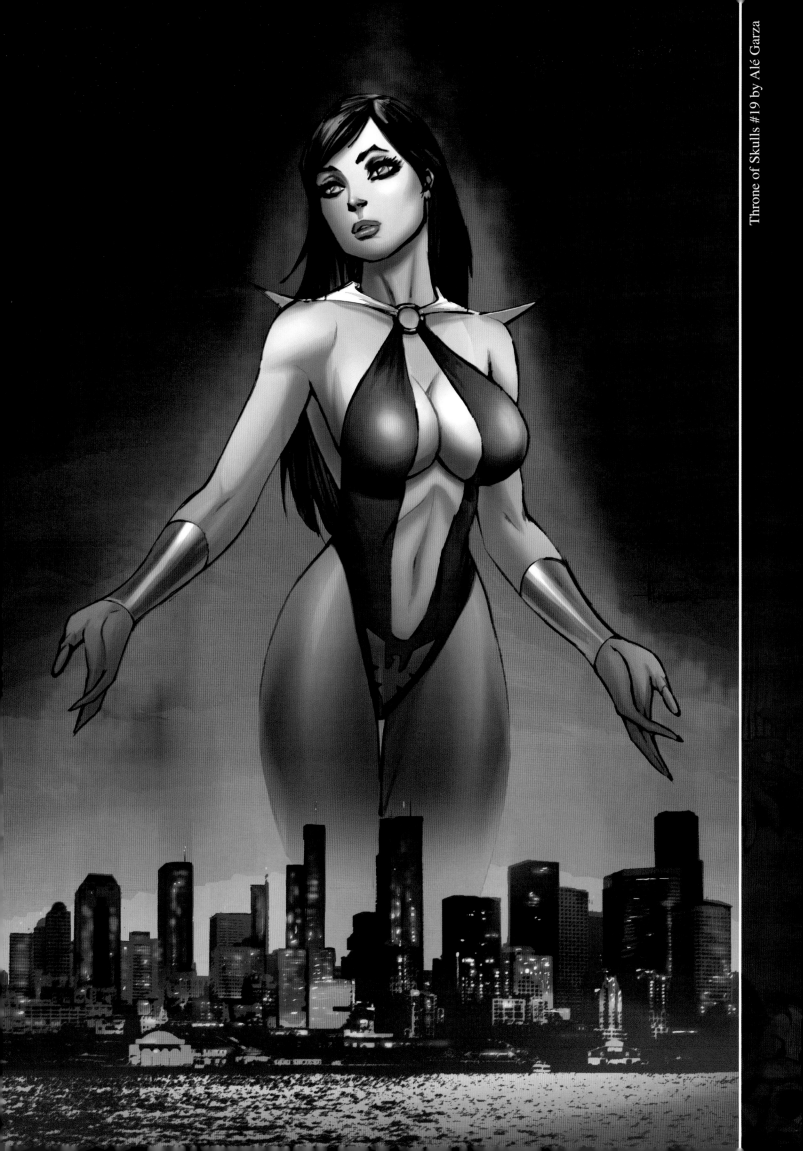

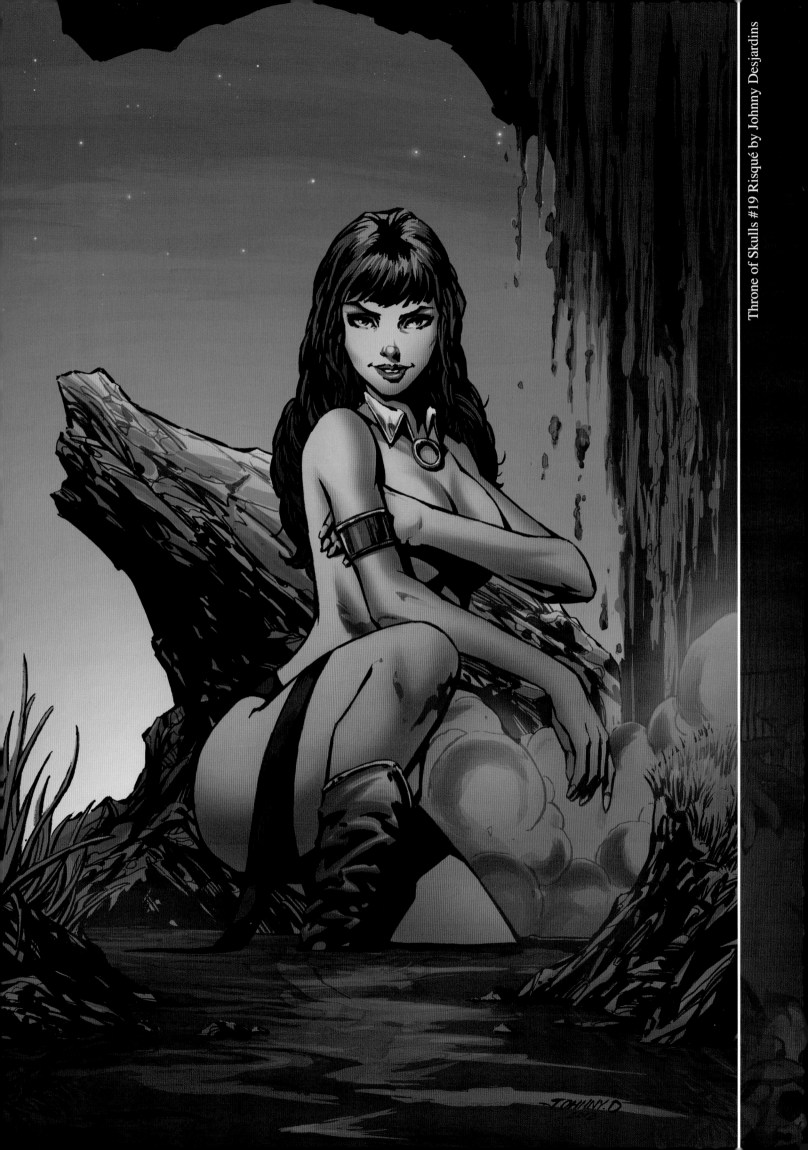

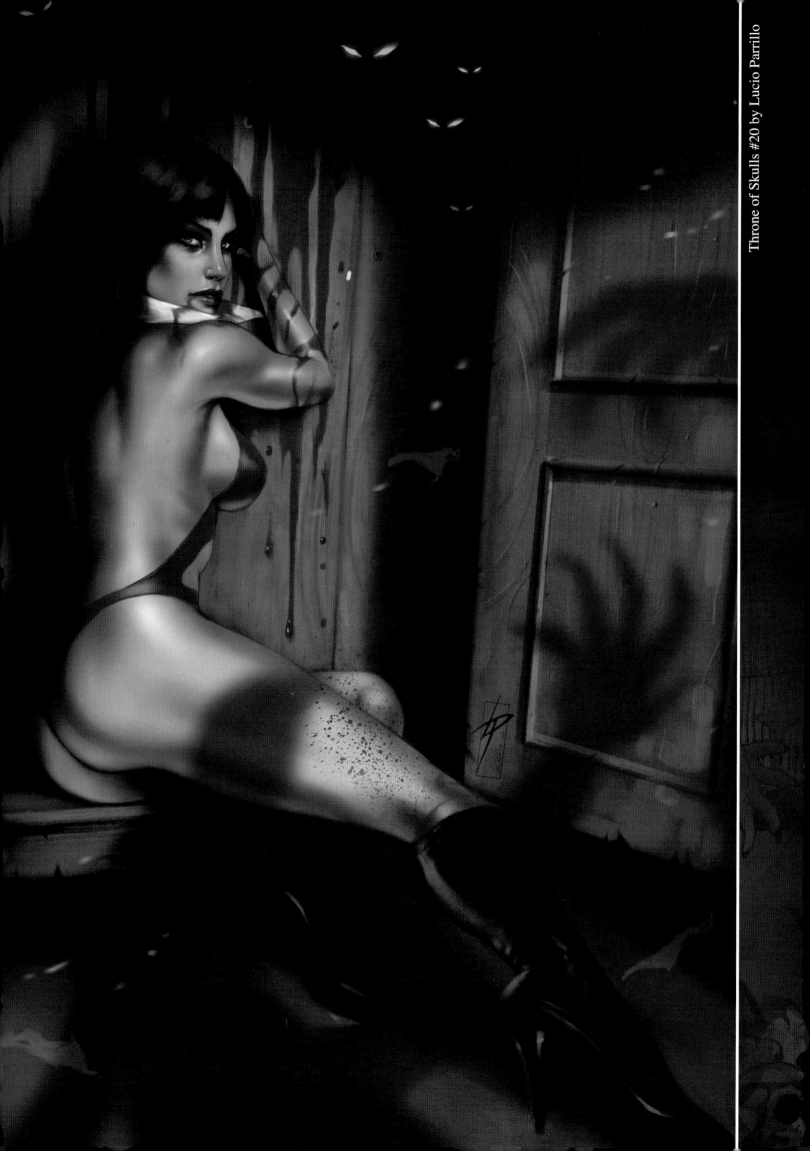

Vinicius
Andrade

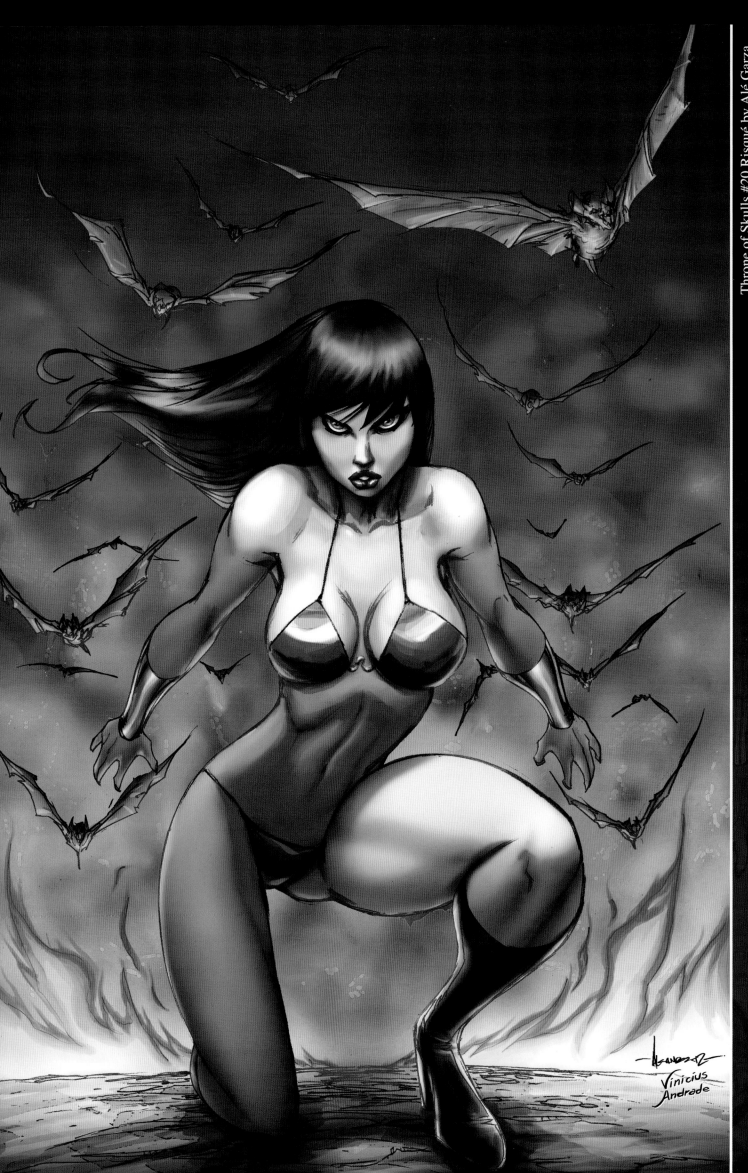

FABIANO '12

INQUISITION

VAMPIRELLA MUST DEFEND HER RECENT ACTIONS TO A TRIBUNAL DEEP WITHIN VATICAN CITY. ACCUSED OF FALLING TO THE CORRUPTING INFLUENCE OF CHAOS, SHE STRUGGLES TO PROVE HER INNOCENCE WHILE SIMULTANEOUSLY FIGHTING A PSYCHIC BATTLE WITH HER MOST POWERFUL ENEMY. MEANWHILE, THE VAMPIRE LORD DRACULA PREPARES HIS DARK ARMY FOR A MARCH AGAINST HUMANITY, EMPOWERING A TERRIFYING NEW LIEUTENANT TO LEAD THE CHARGE.

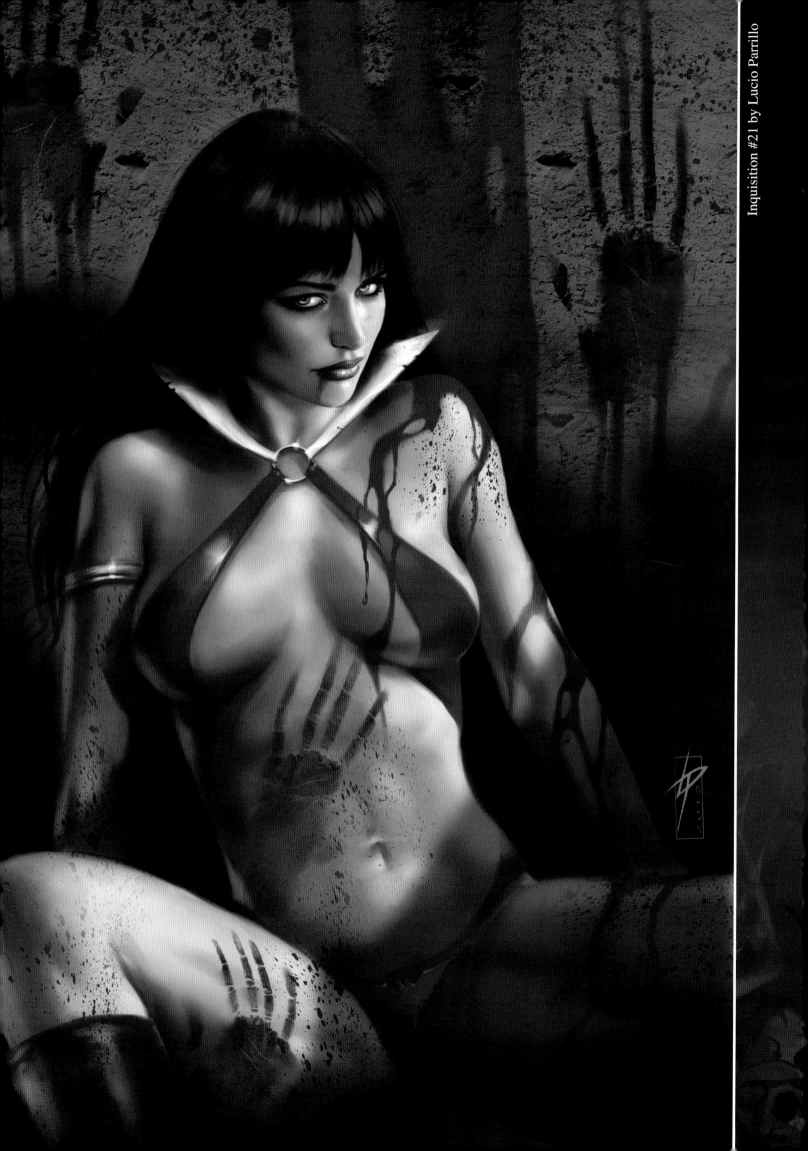

Inquisition #21 by Lucio Parrillo

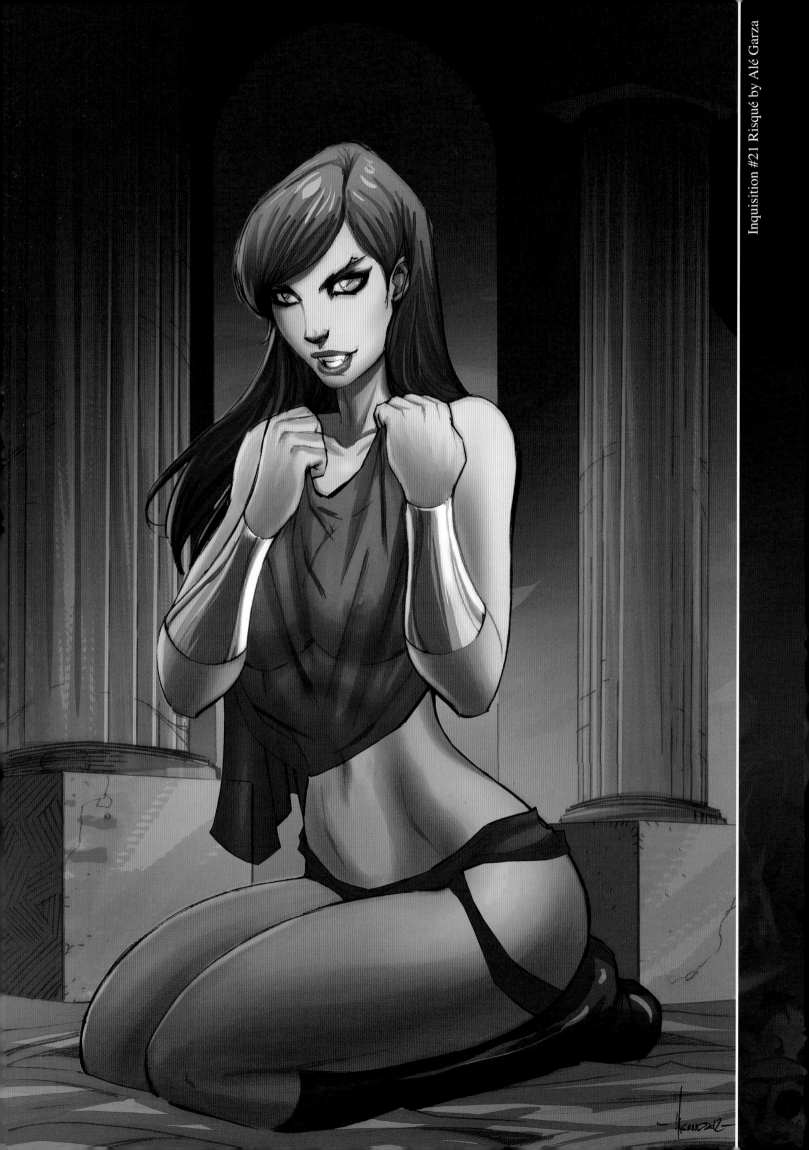

Vinicius
Andrade

Vinicius Andrade

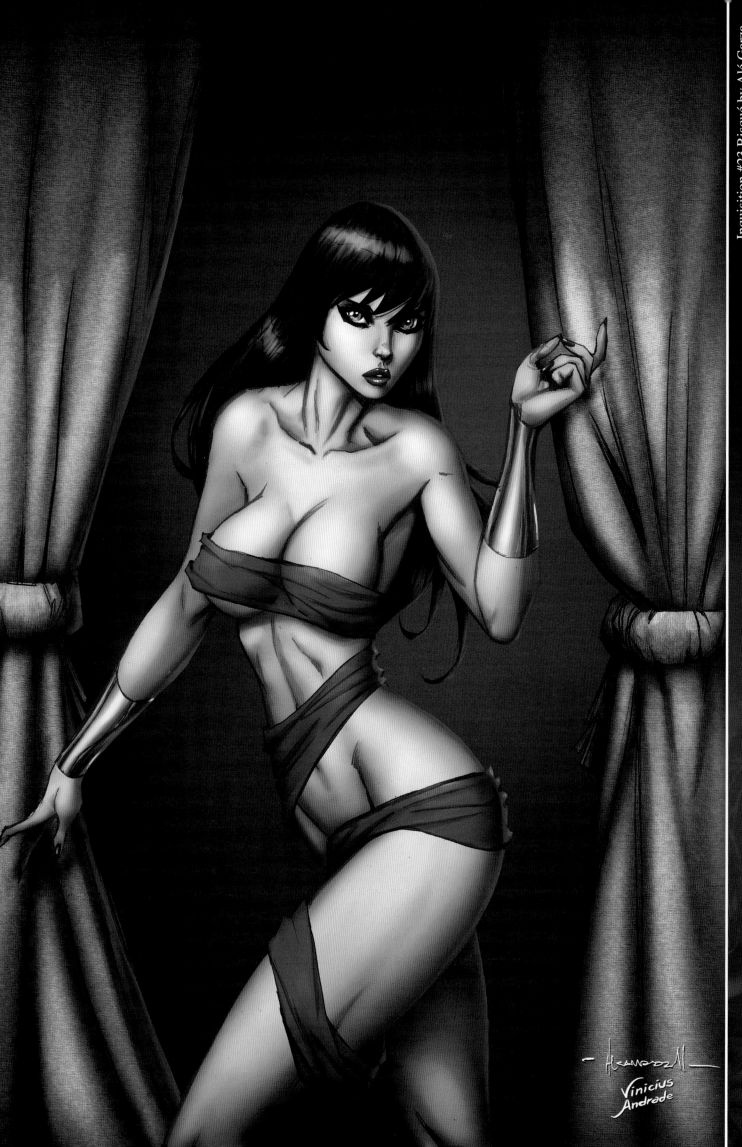

FABIANO '12

Vinicius Andrade

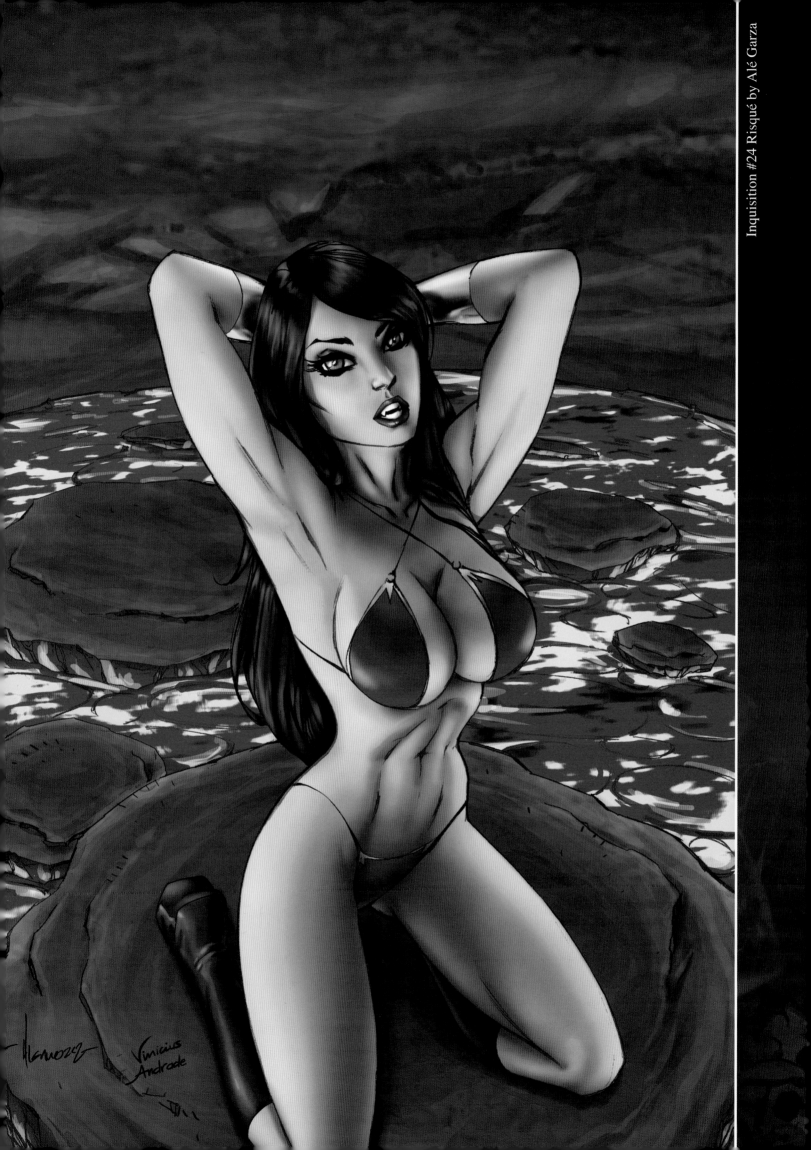

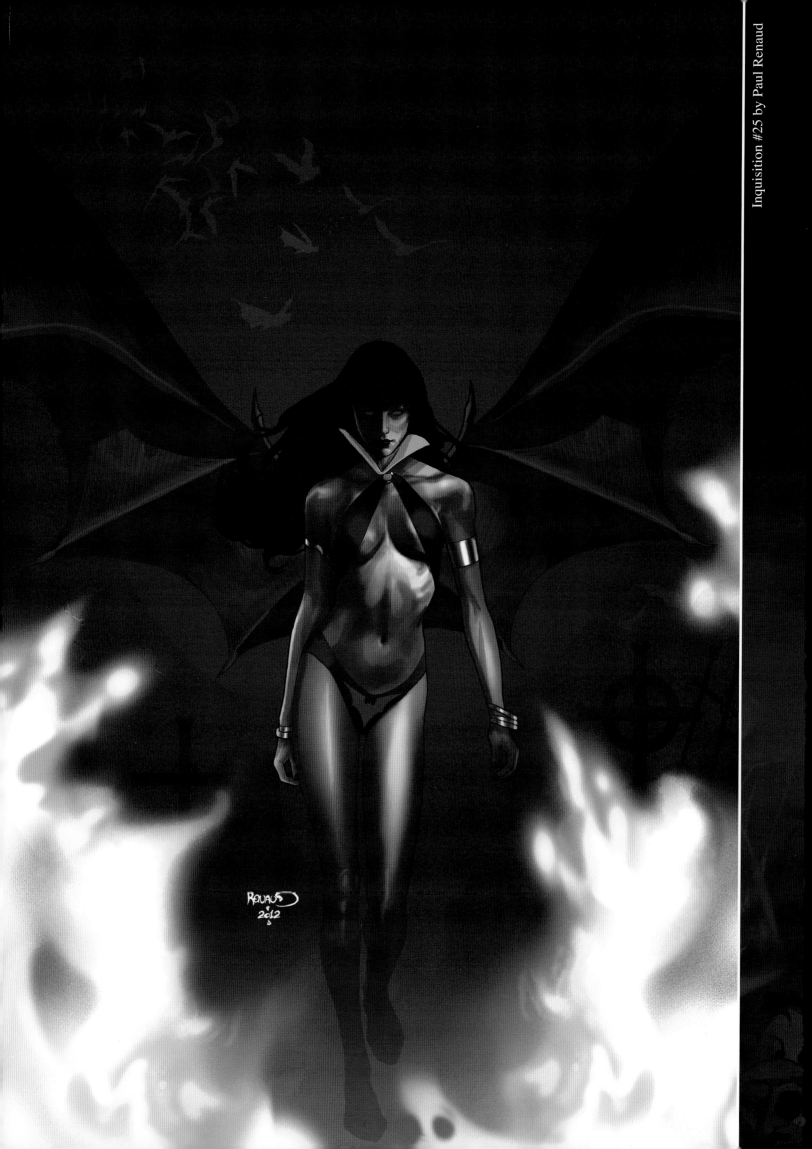

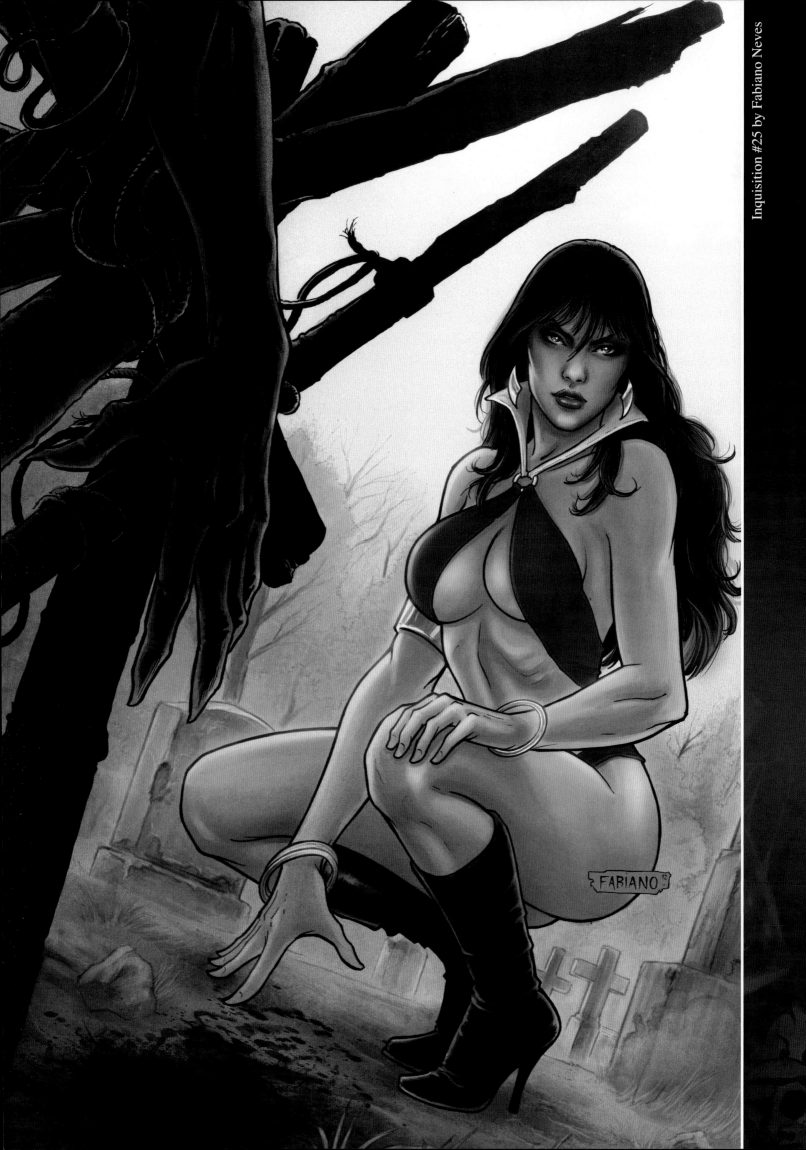

Lui Antonio

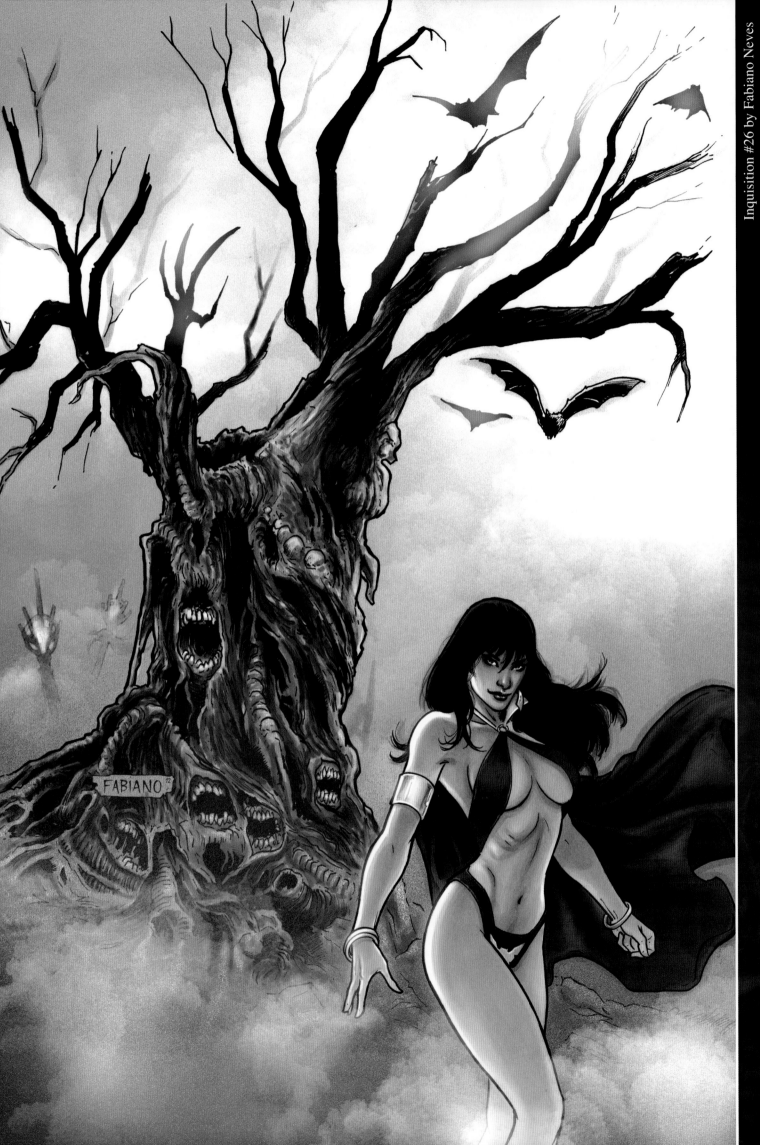

MOTHERS, SONS, AND A HOLY GHOST

Secrets (and blood) are spilled when supernatural heroine Vampirella is drawn into an unexpected family reunion! What are the secrets of The Conjuress and the man called Criswell... and how do they relate to Lilith, Vampirella's estranged mother? But bad blood and old grievances are put aside when a deadly coven of witches threatens to unravel all time and reality, and Vampirella finds herself stranded one hundred years in the future. A vision of things to come forces our heroine to make a painful decision, forever altering her fate. Will she survive as a new kingdom rises in the land?

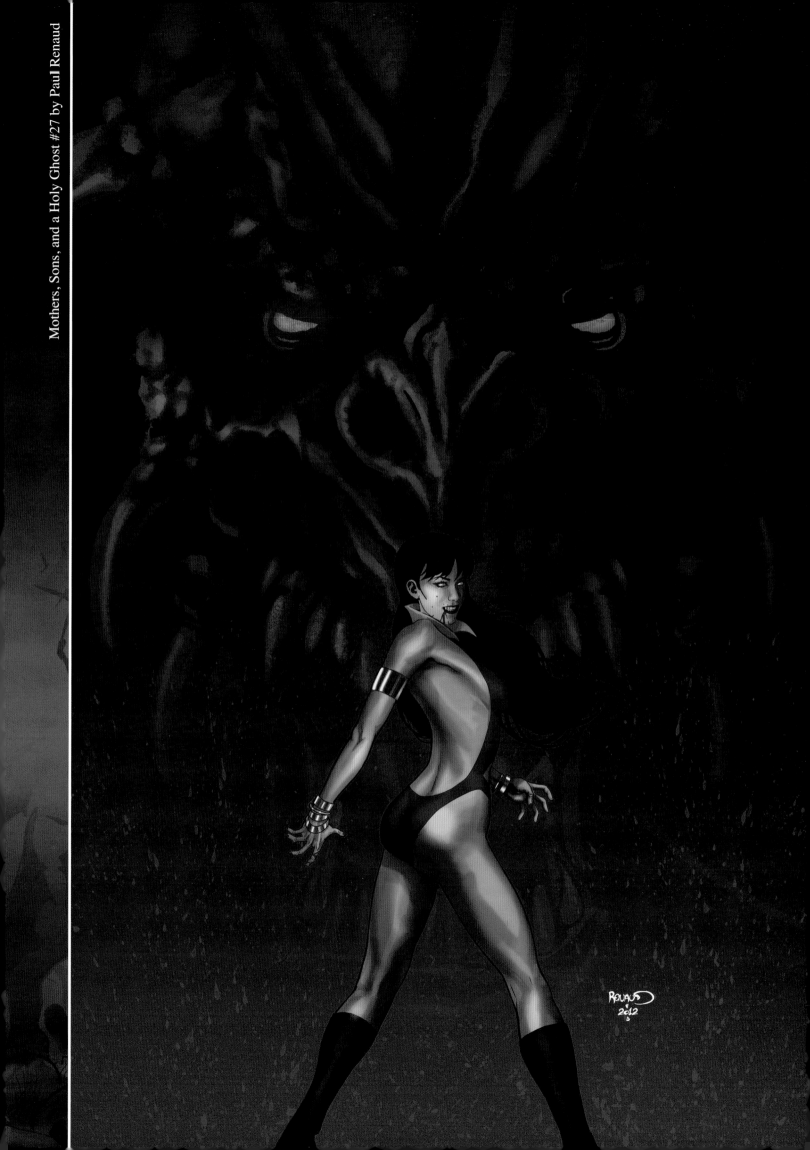

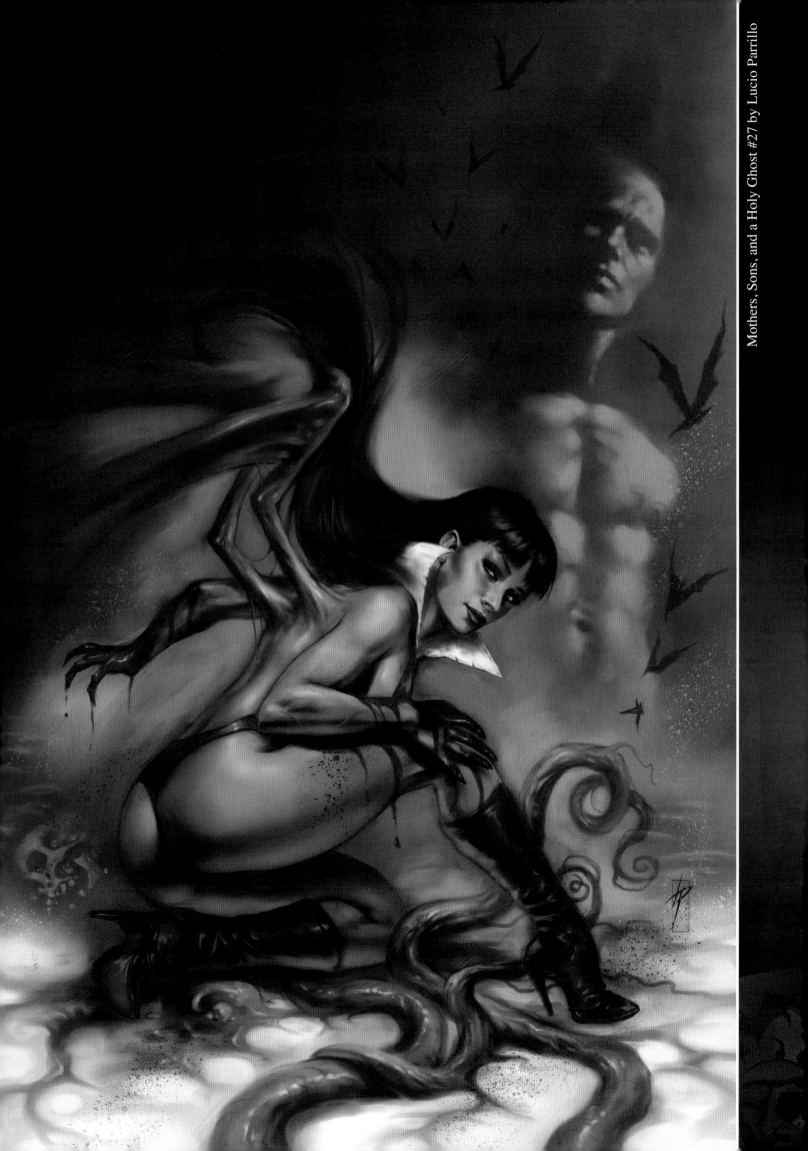

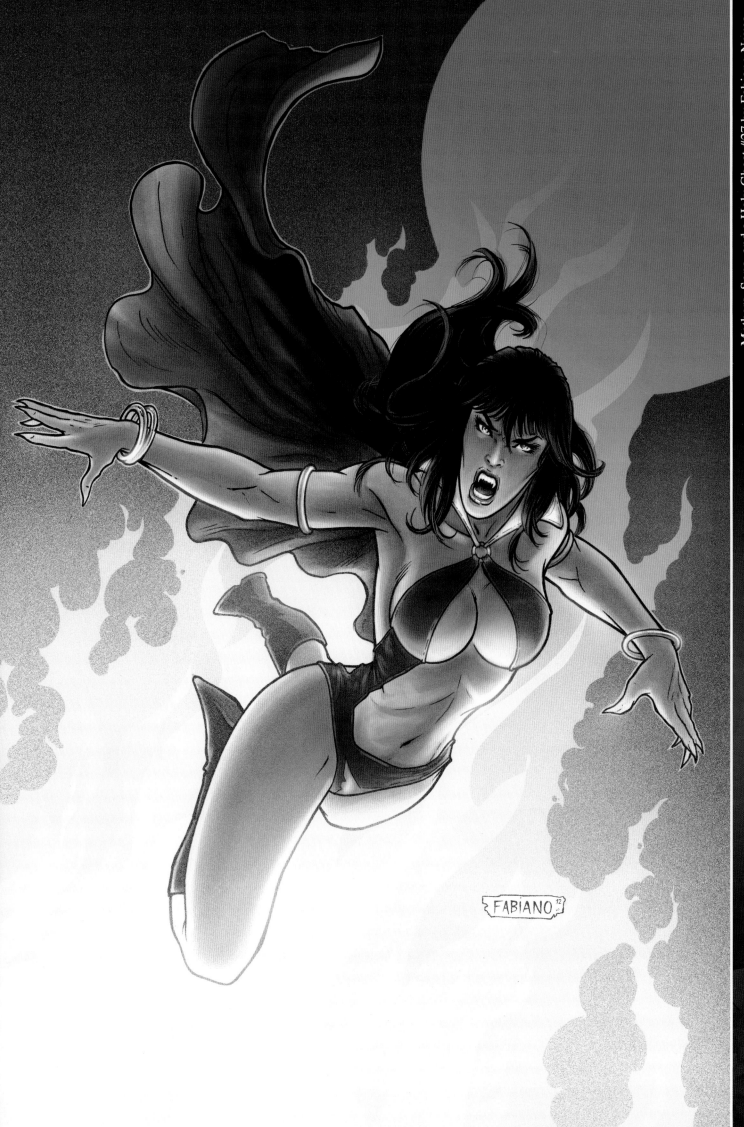

FABIANO 12

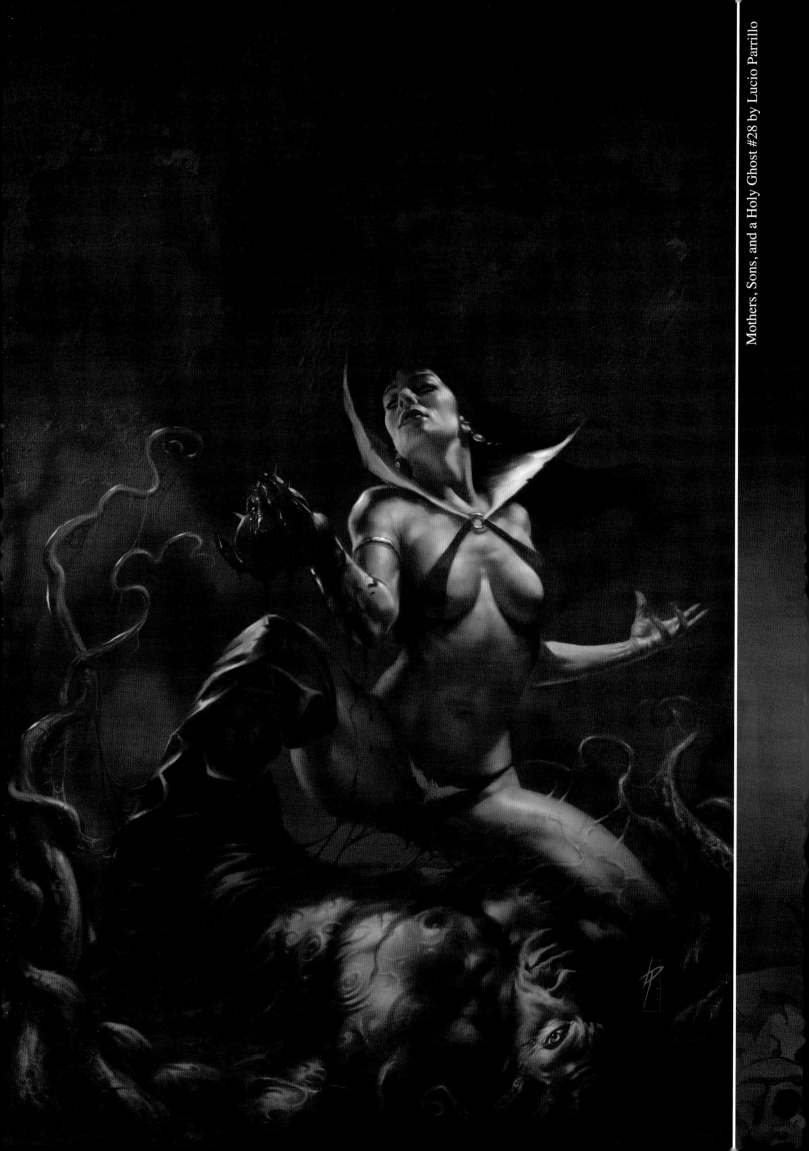

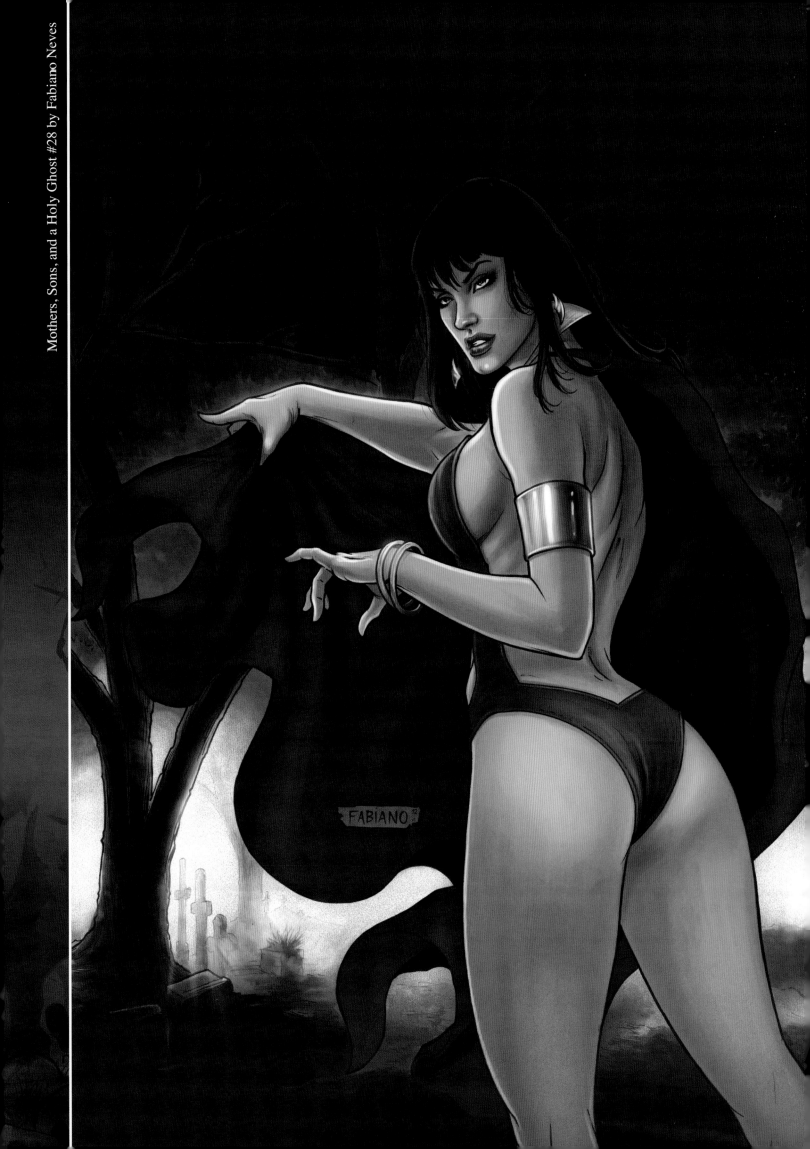

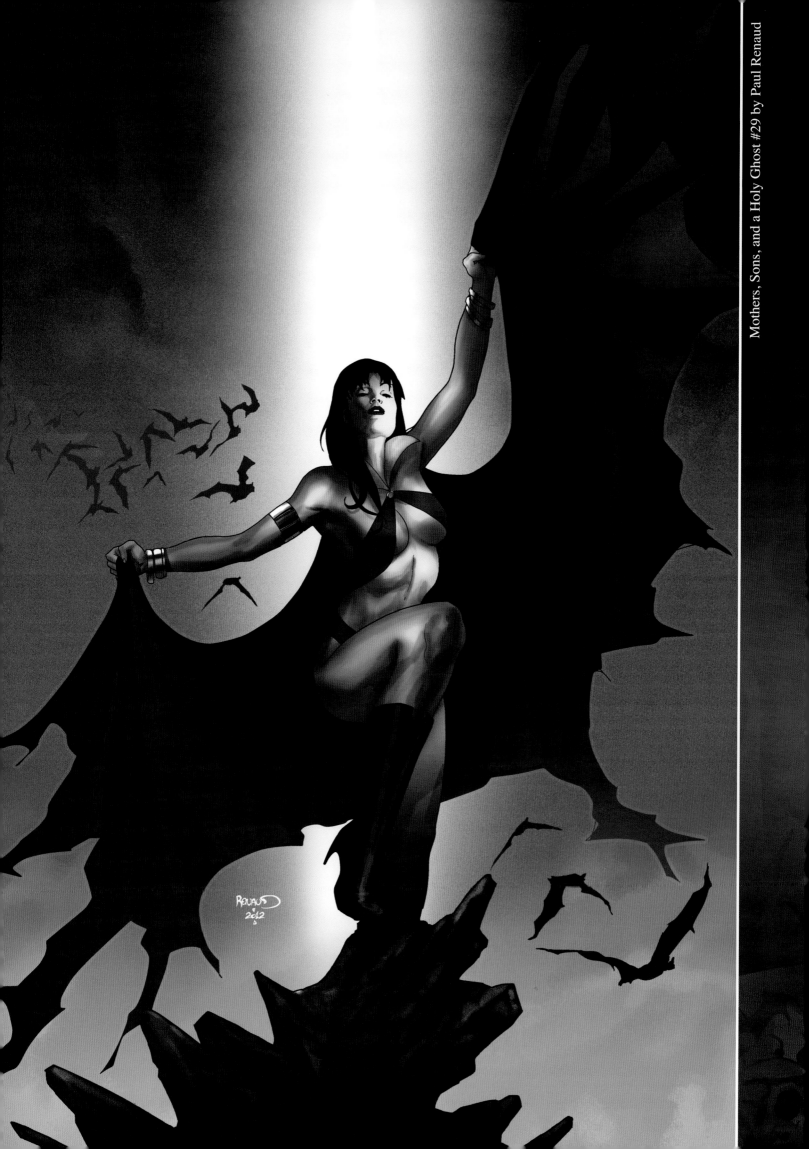

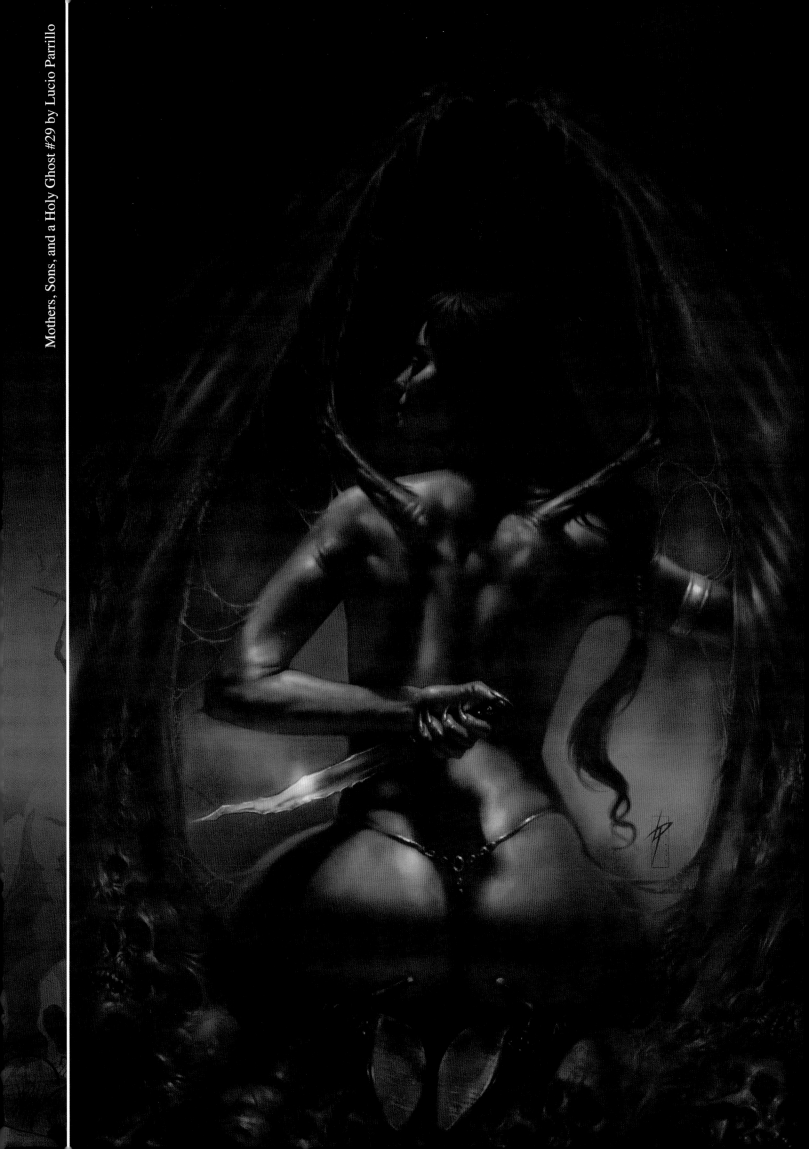

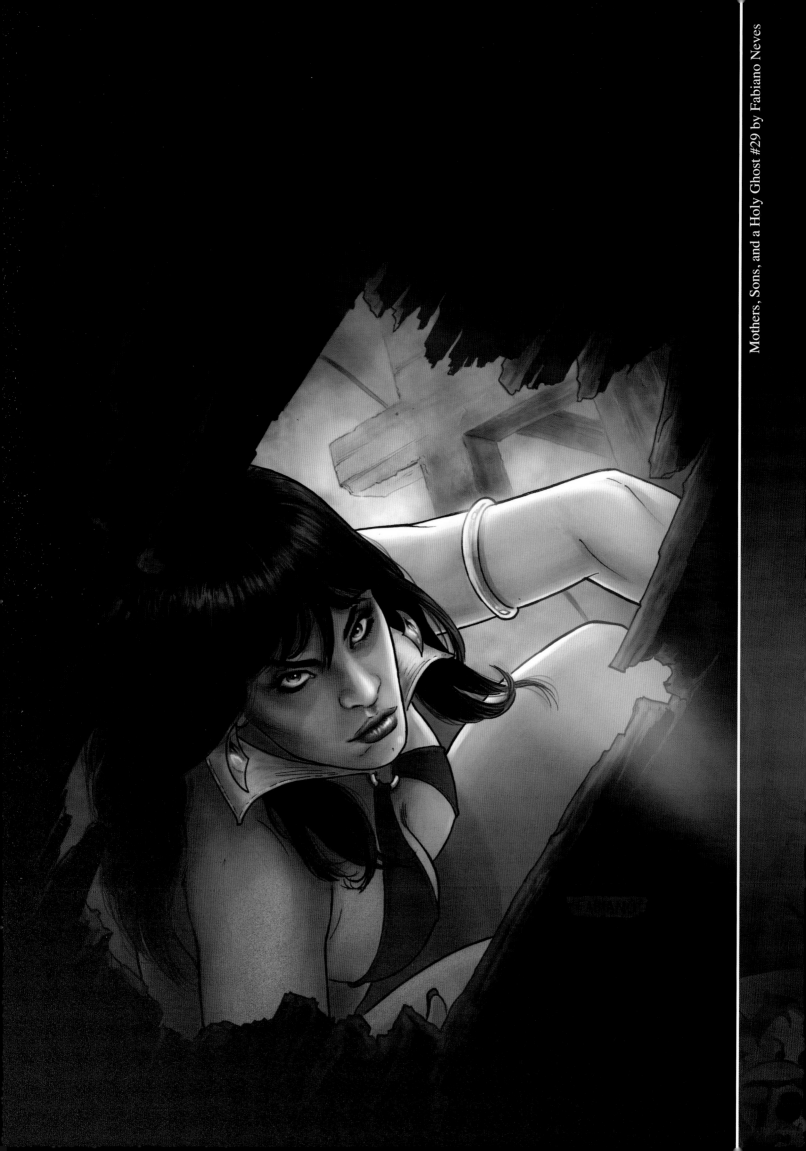

Mothers, Sons, and a Holy Ghost #29 by Fabiano Neves

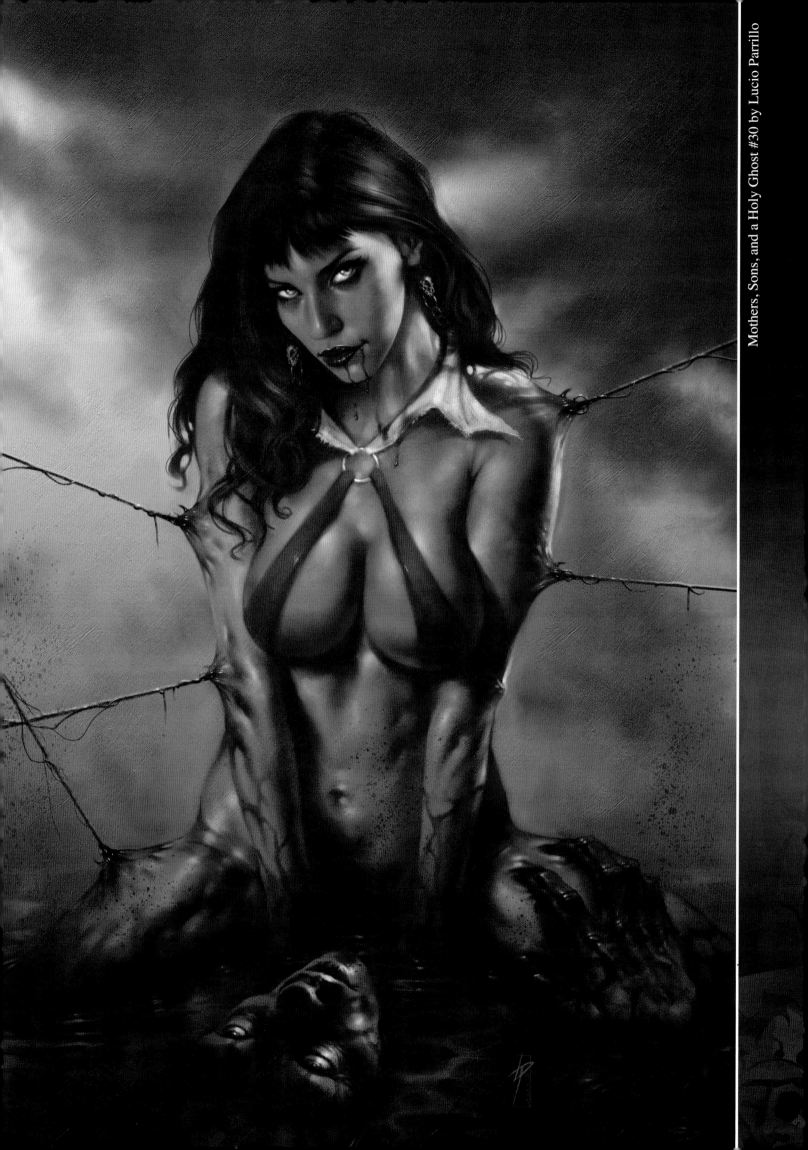

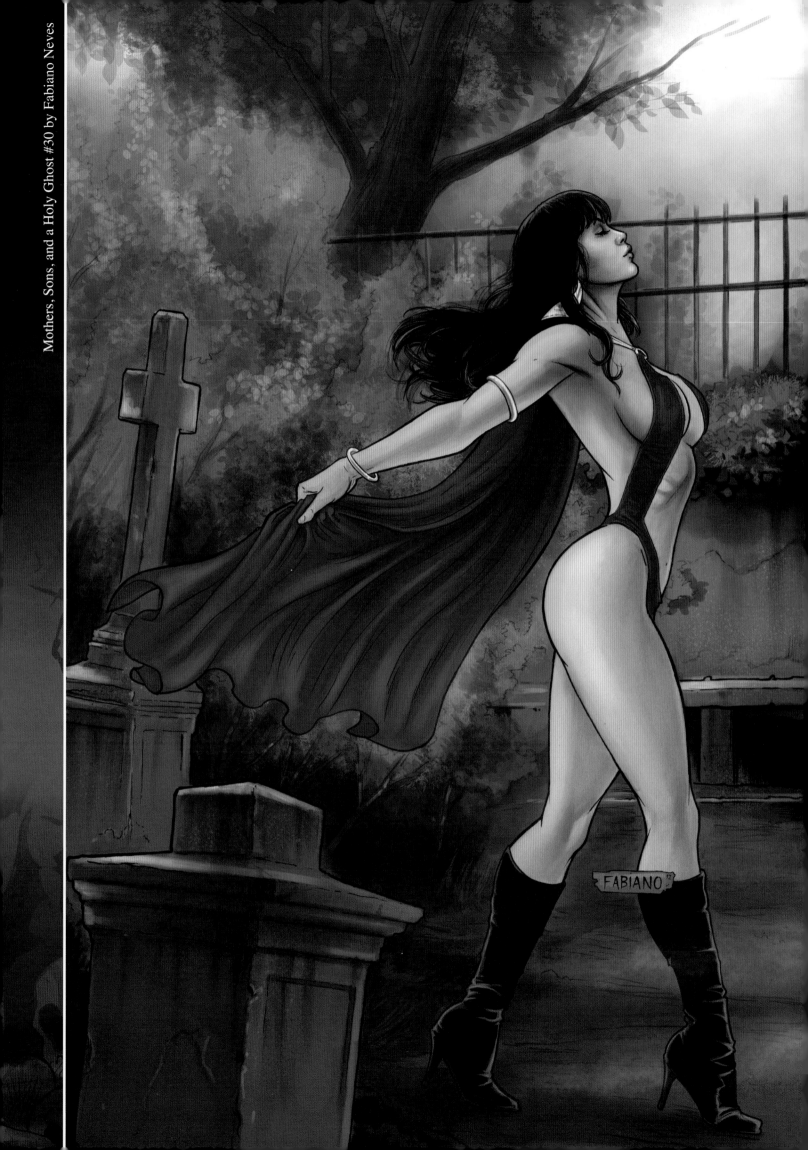

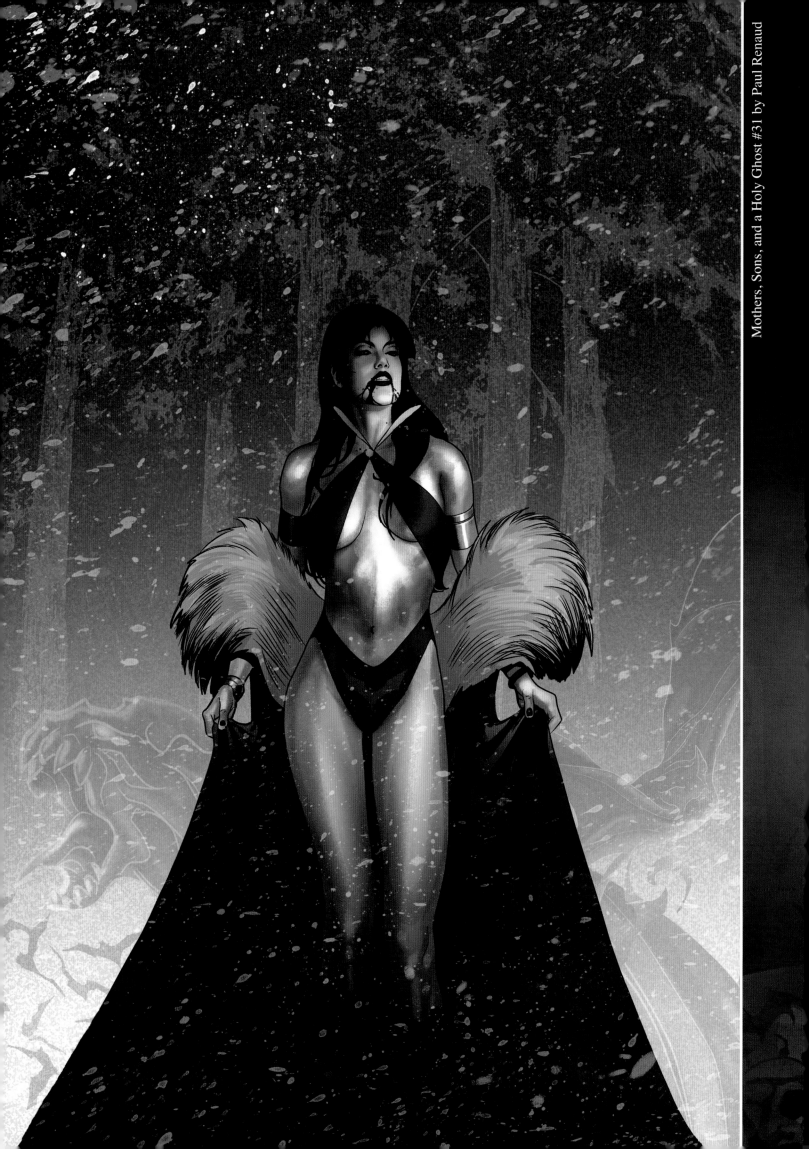

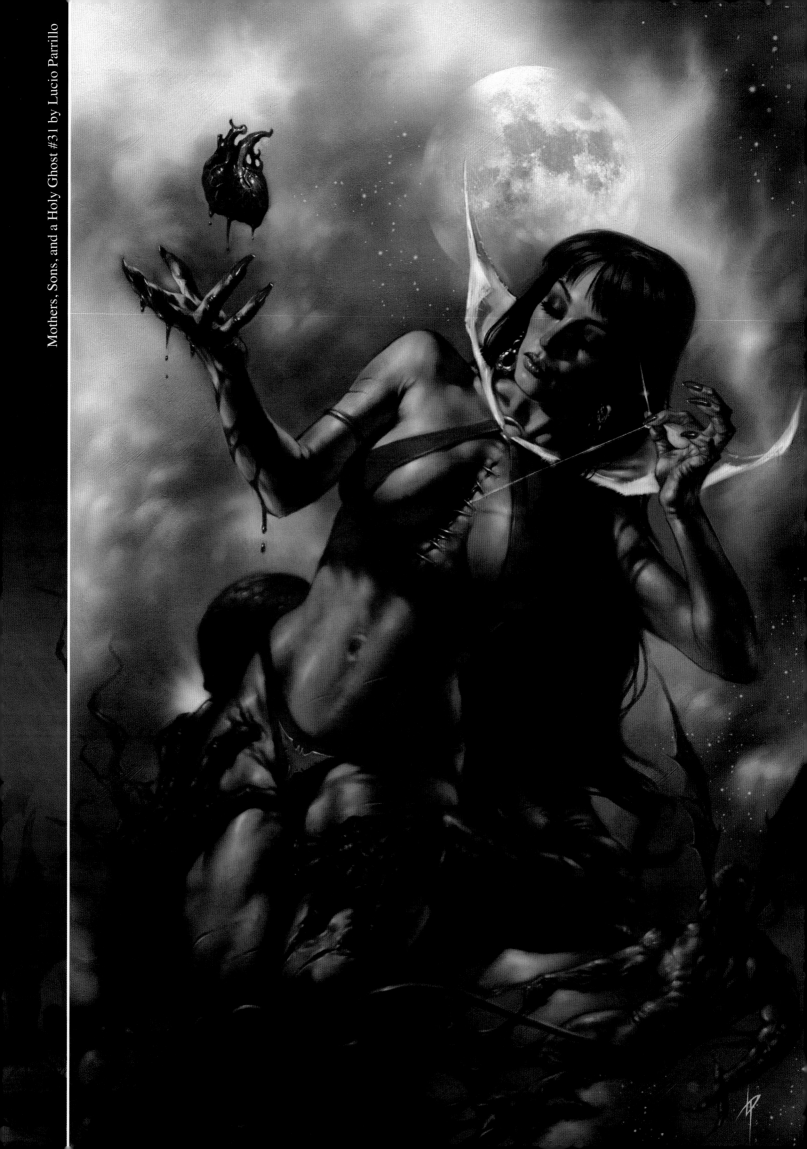

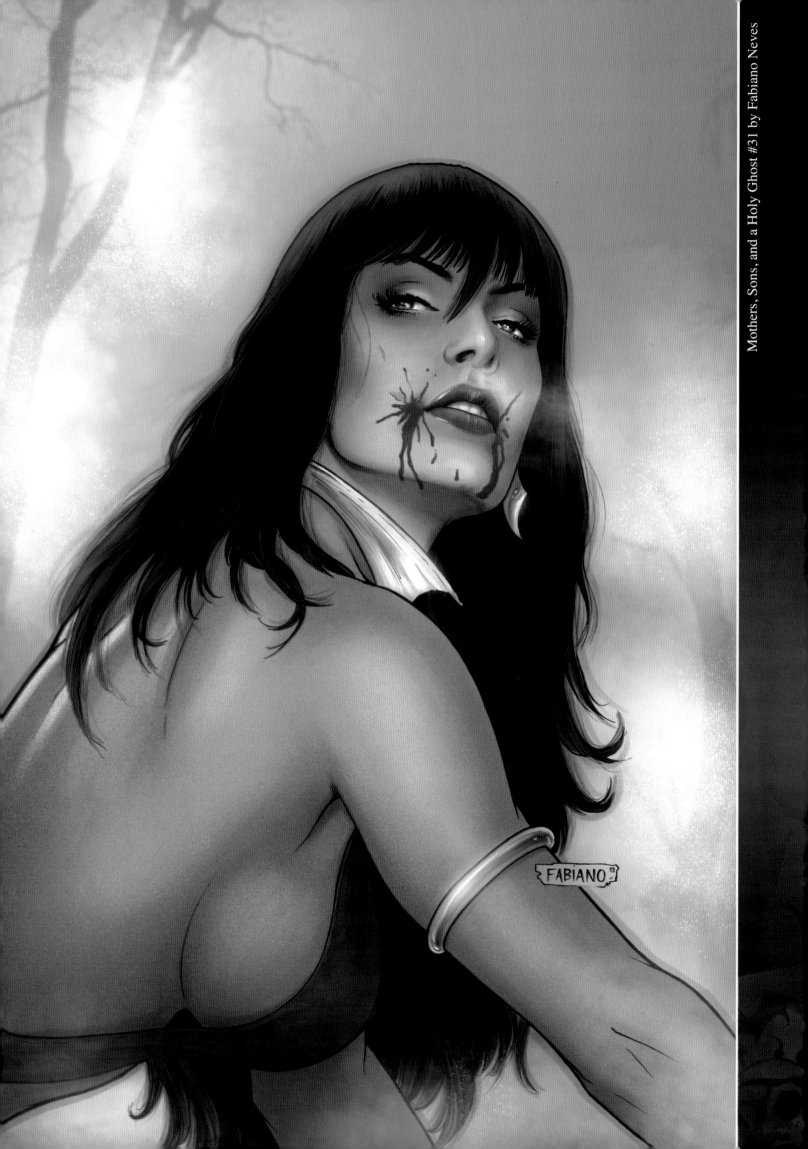

FABIANO

THE FINAL CURTAIN

WHAT BEGINS IN THE SHADOWY JUNGLES OF A VOODOO ISLAND EMPIRE WILL REACH ITS ASTONISHING CONCLUSION IN HELL ITSELF! EVERYONE'S FAVORITE DARK HEROINE WILL BE PUSHED TO THE BREAKING POINT AS HER SANCTUARY IS THREATENED, HER LOVE IS AT RISK, AND HER OWN MOTHER MIGHT JUST BE HER WORST ENEMY AFTER ALL! IT'S A STORY OF ENDINGS AND BEGINNINGS.

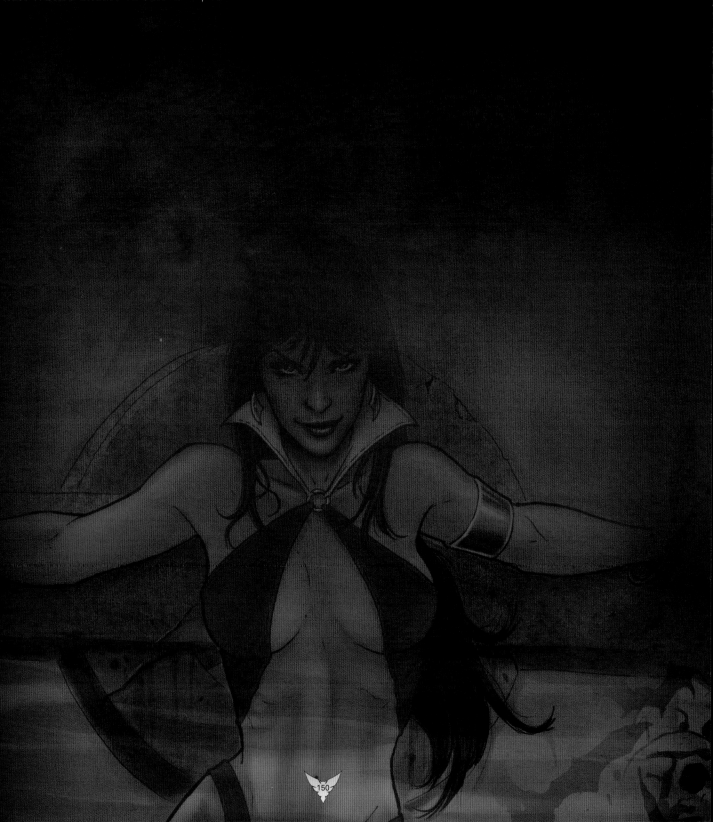

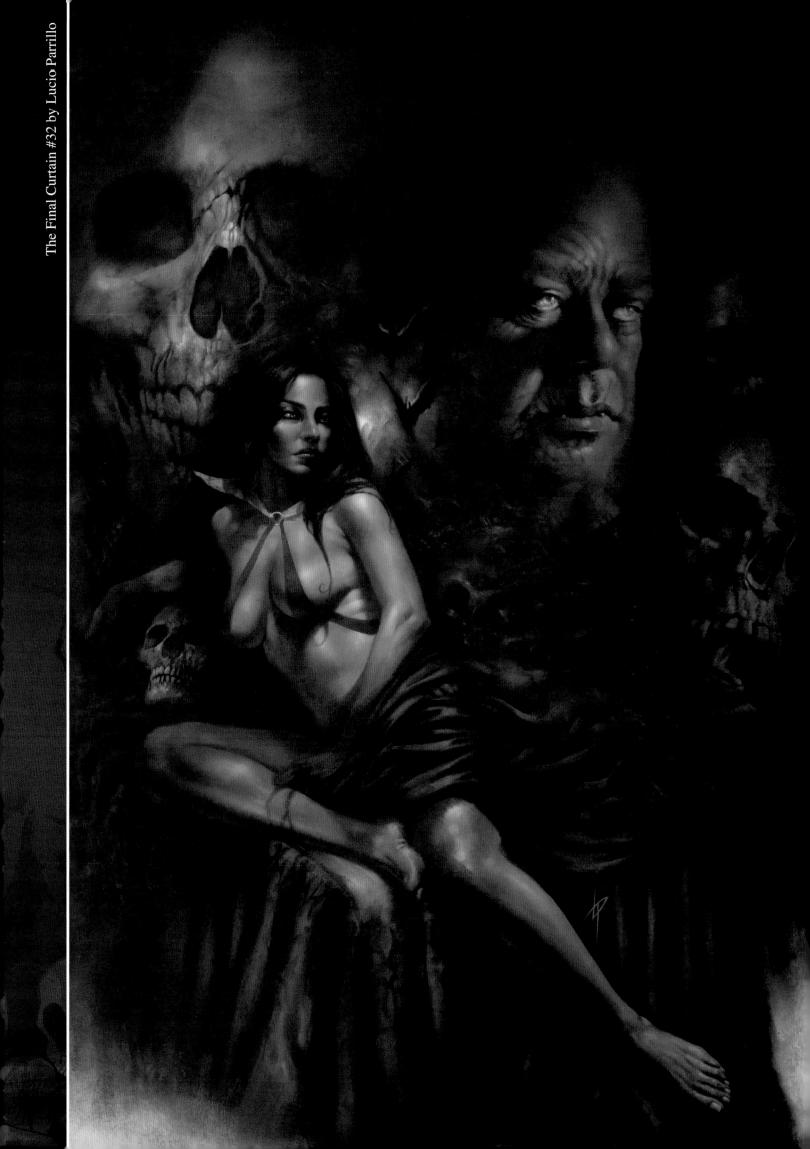

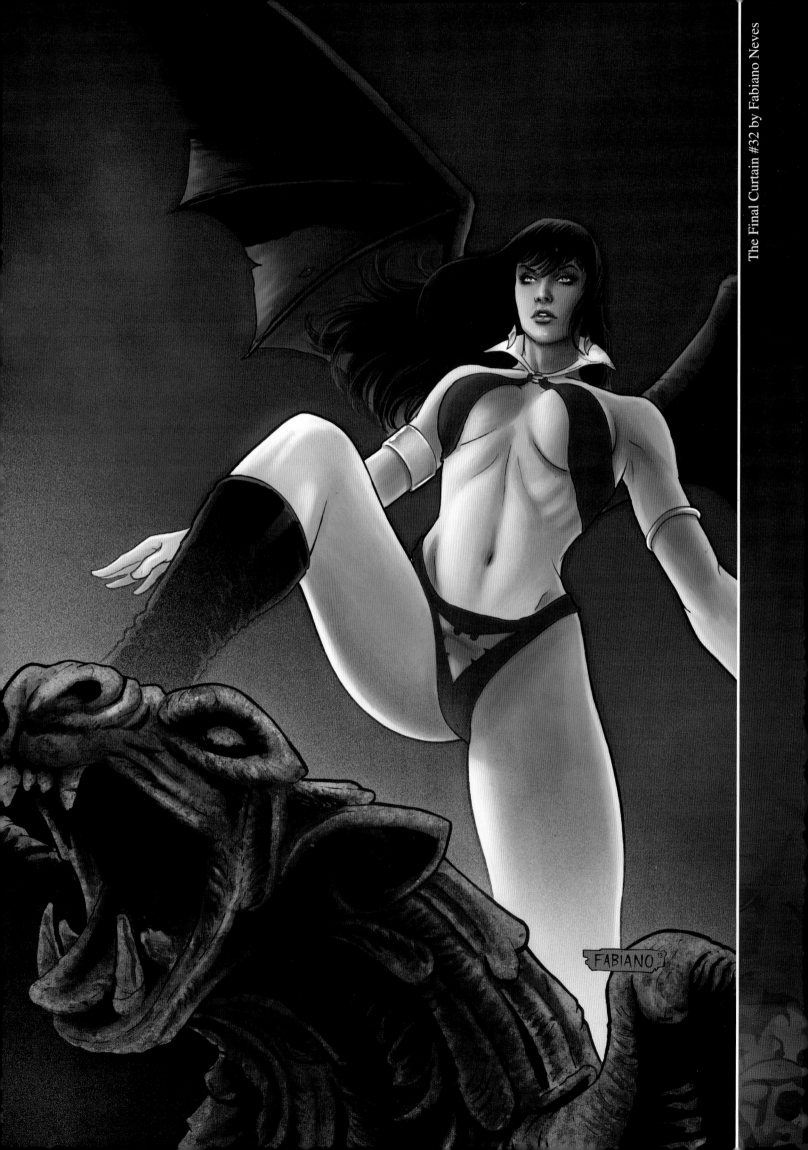

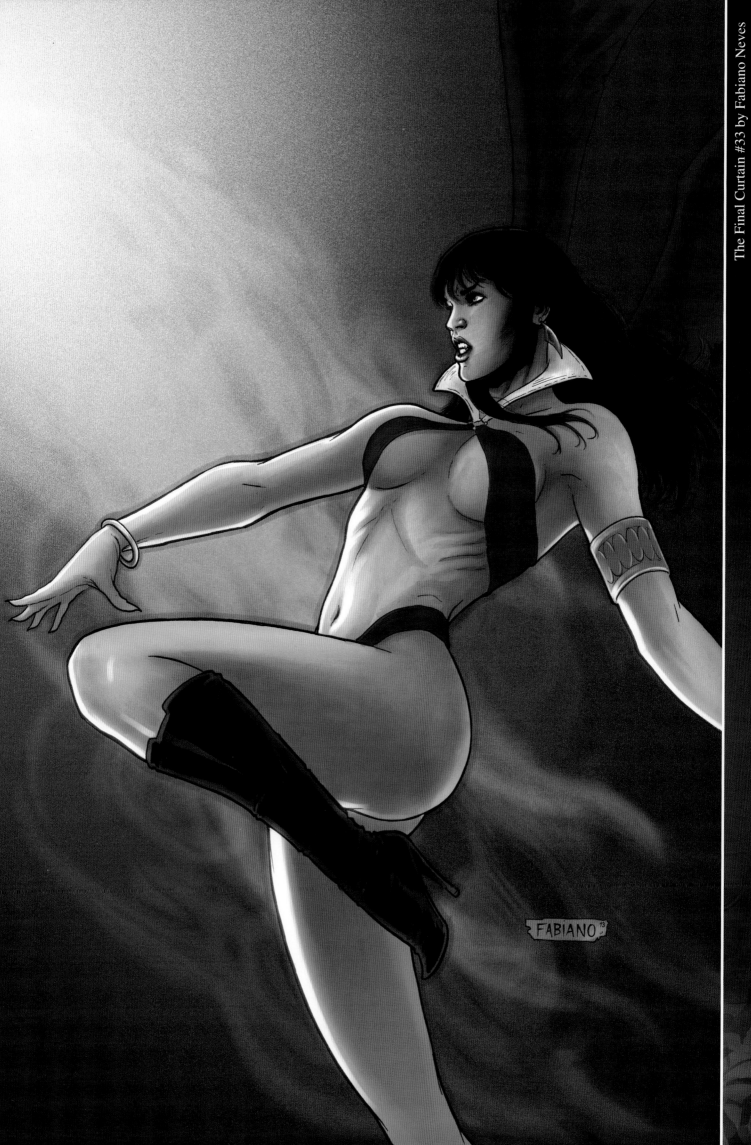

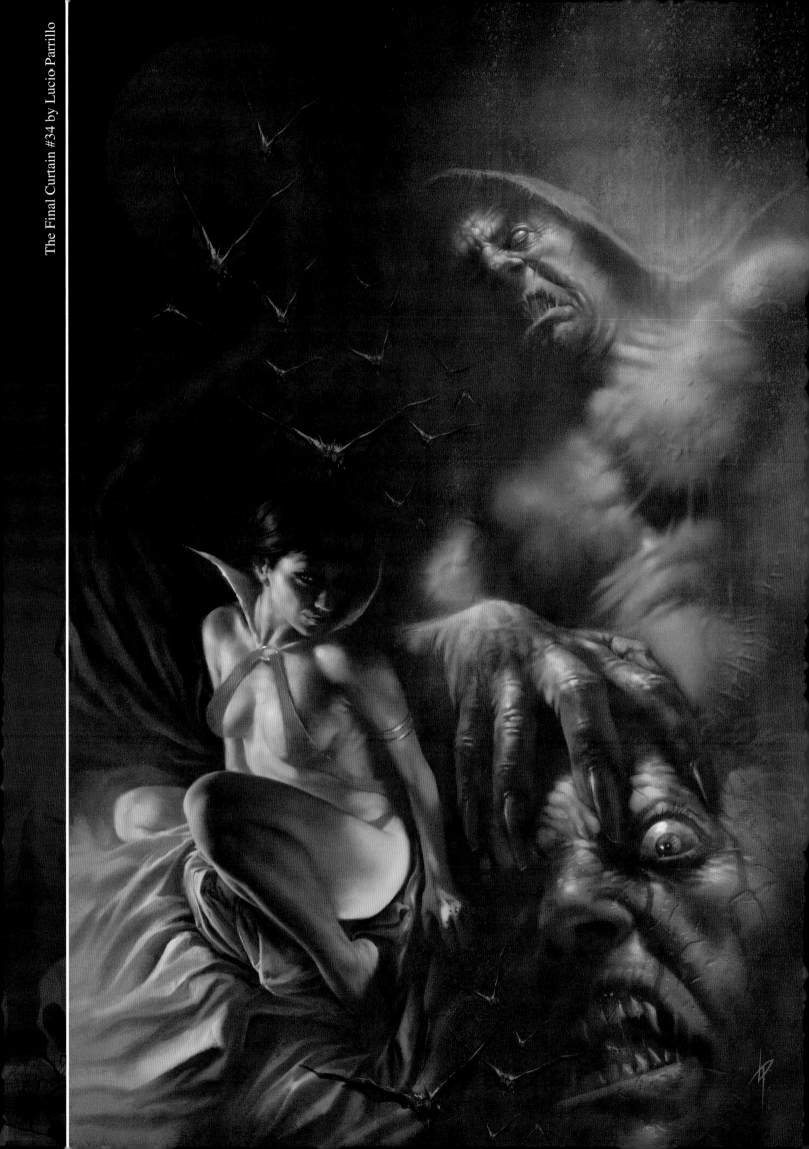

FABIANO '13

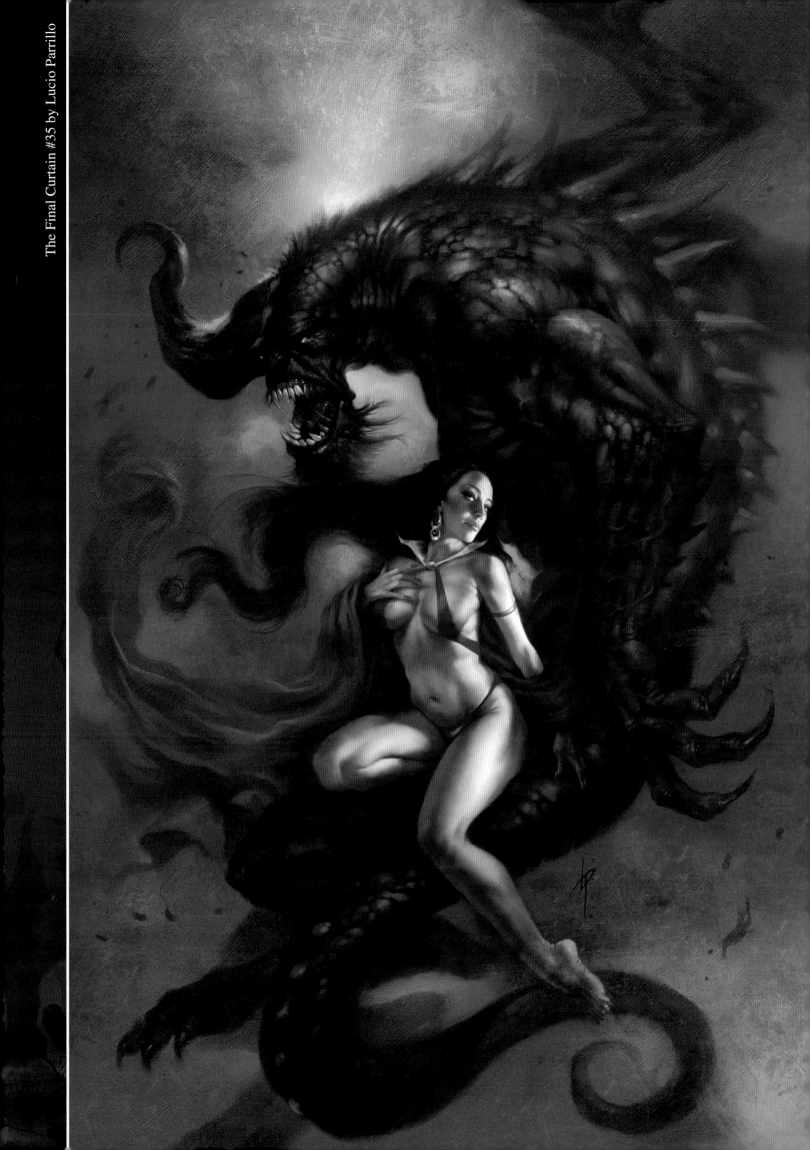

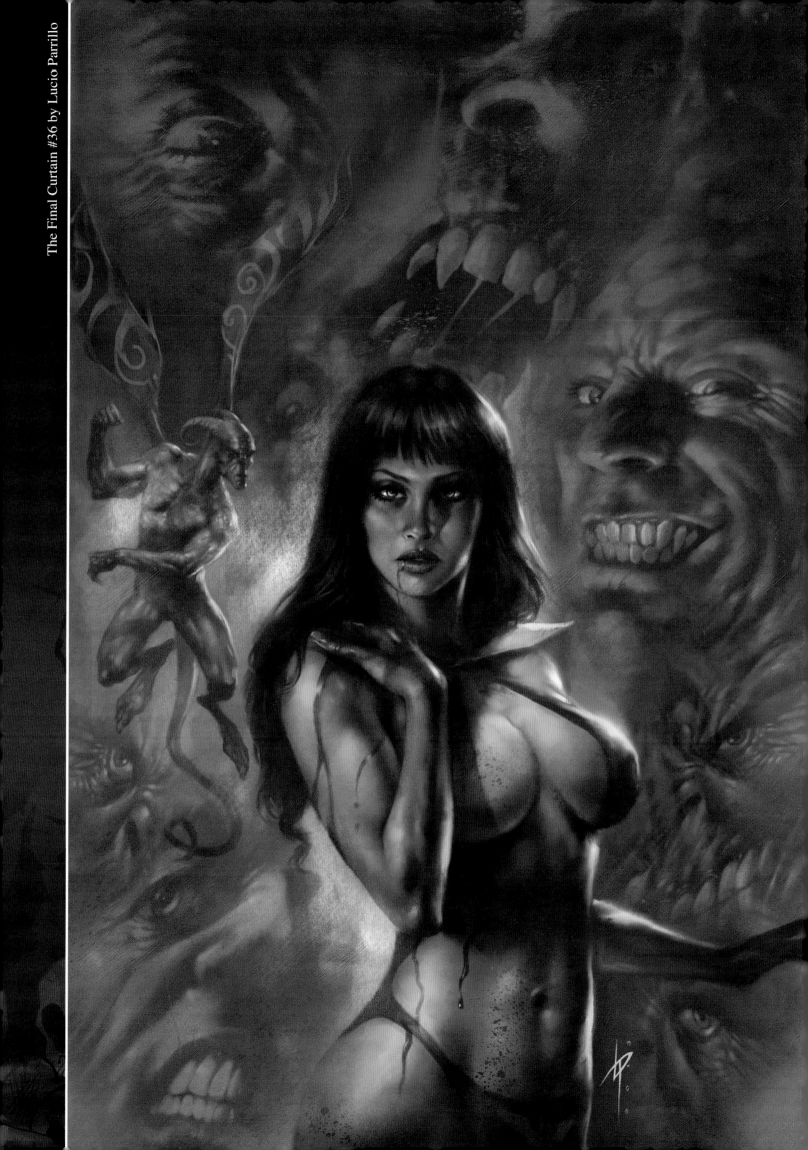

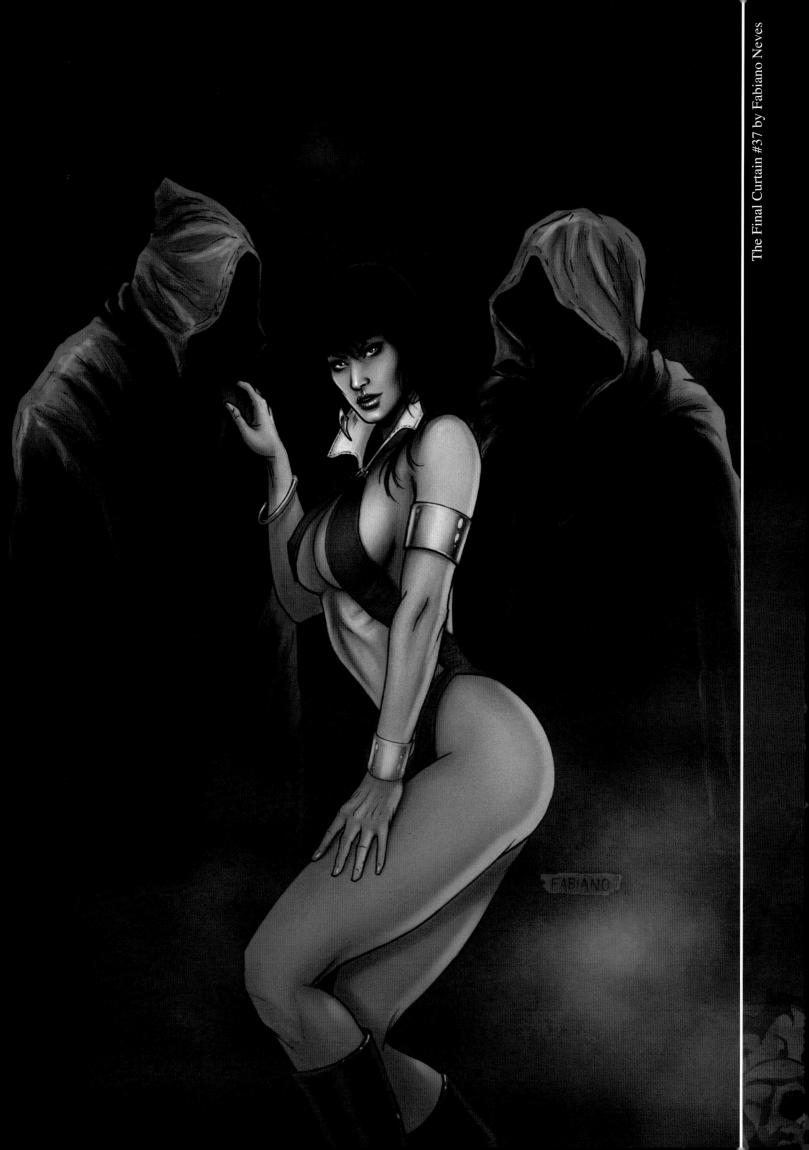

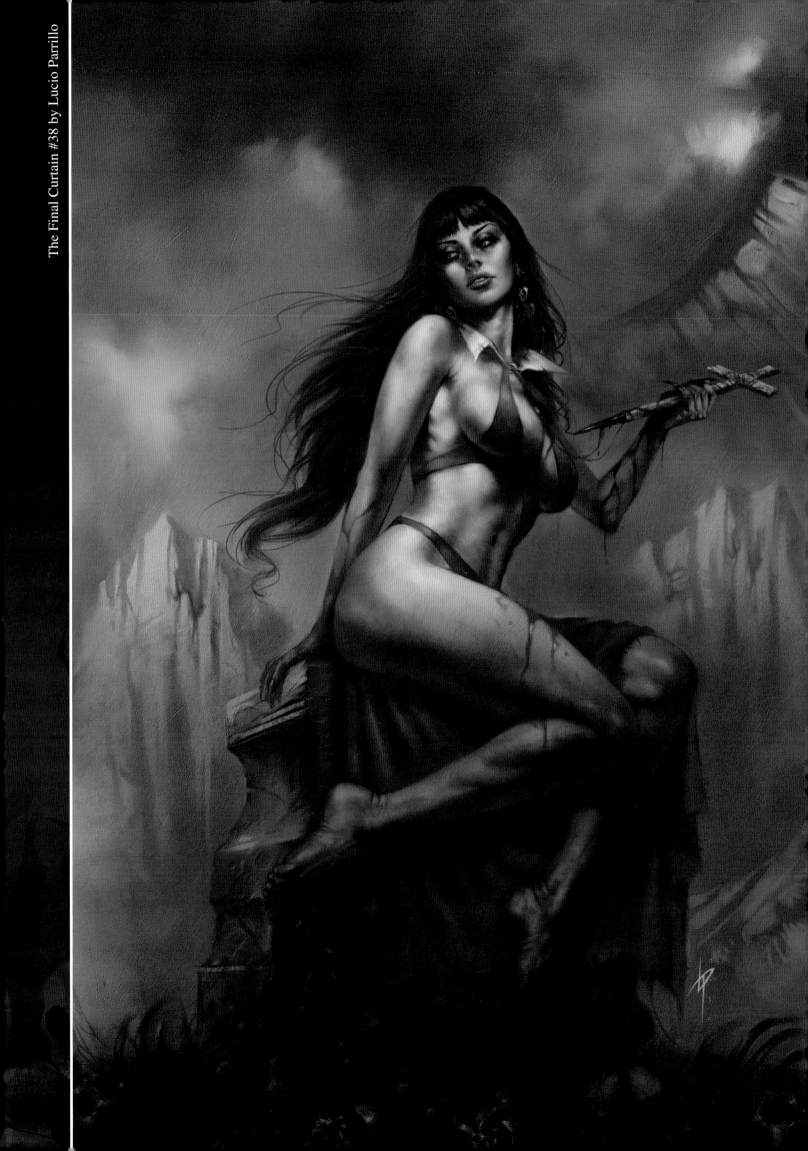

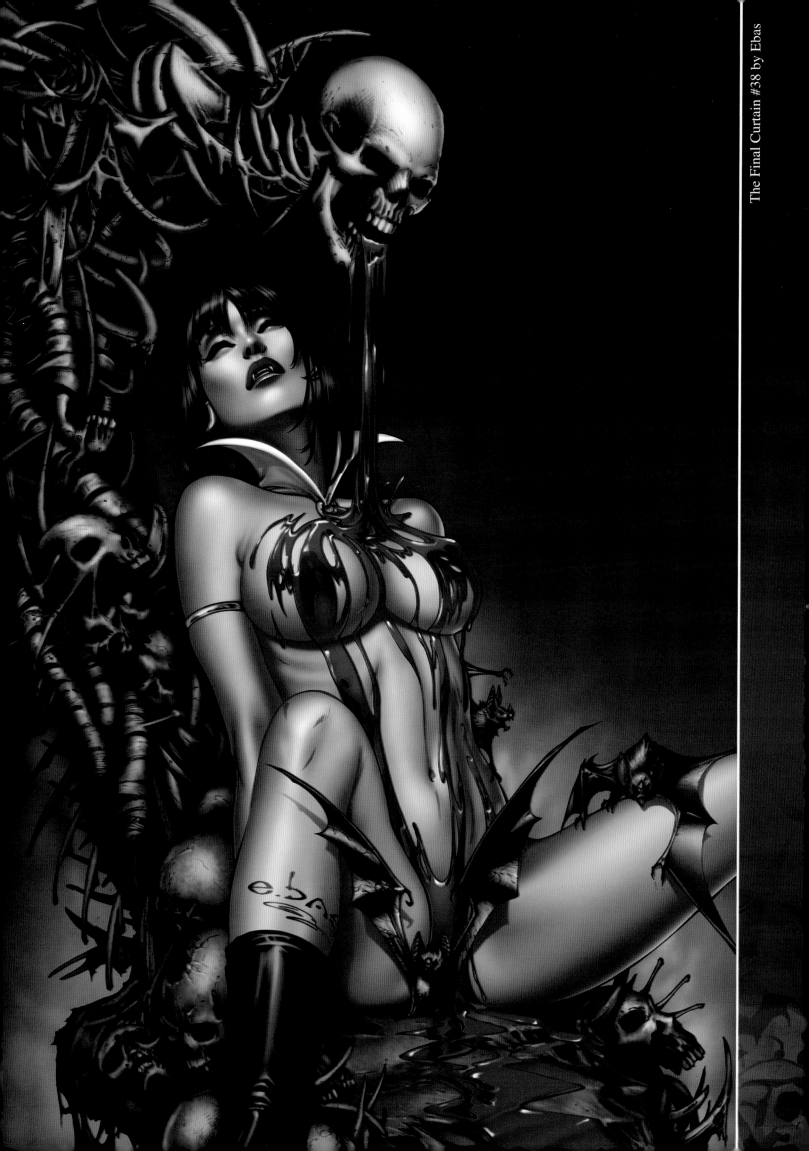

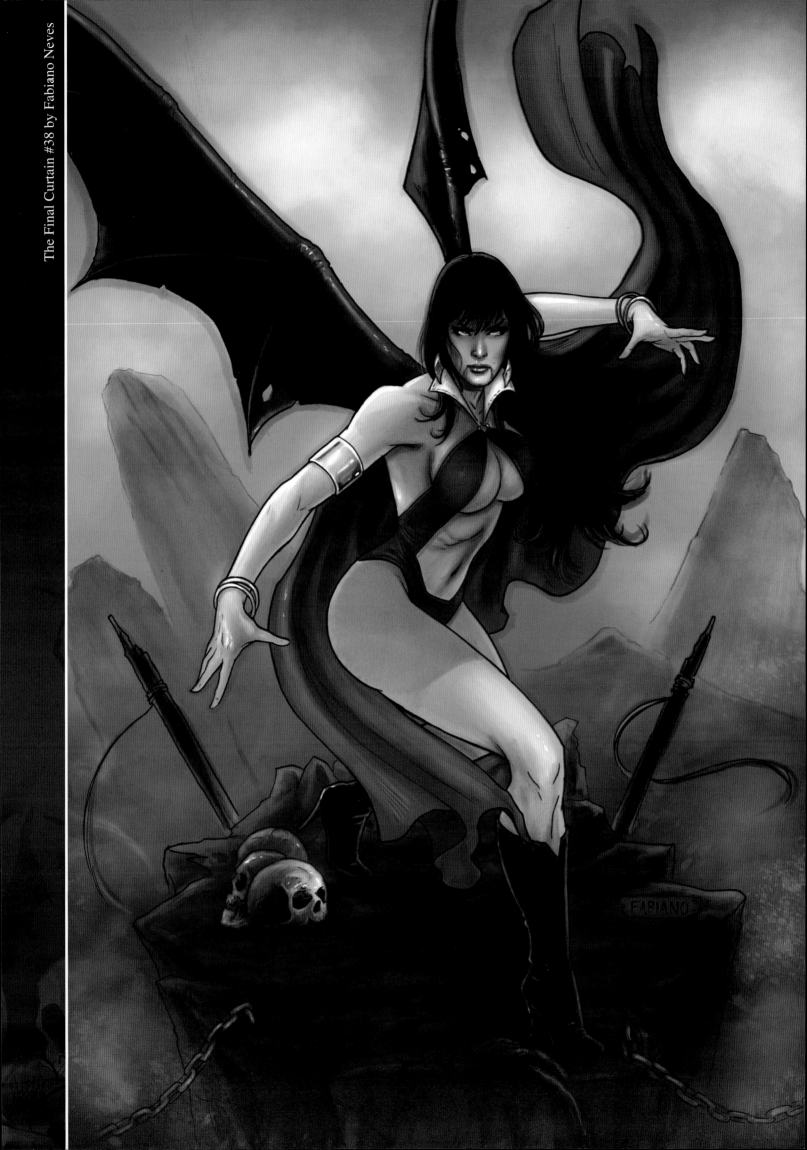

VAMPIRELLA BITES

The following is a collection of Vampirella's thrilling excursions into other vampire and horror worlds of pop-culture. Vampi attends a festival in a Pacific Northwest town that's the setting for a popular, sparkly vampire series. Vampi squares off against "Fluffy the Vampire Killer." She uncovers the grotesque secrets of a southern town whose vampire residents subsist on "Nu Blood." And in Florida, Vampi crosses paths with a serial-killer-with-a-code named "Baxter."

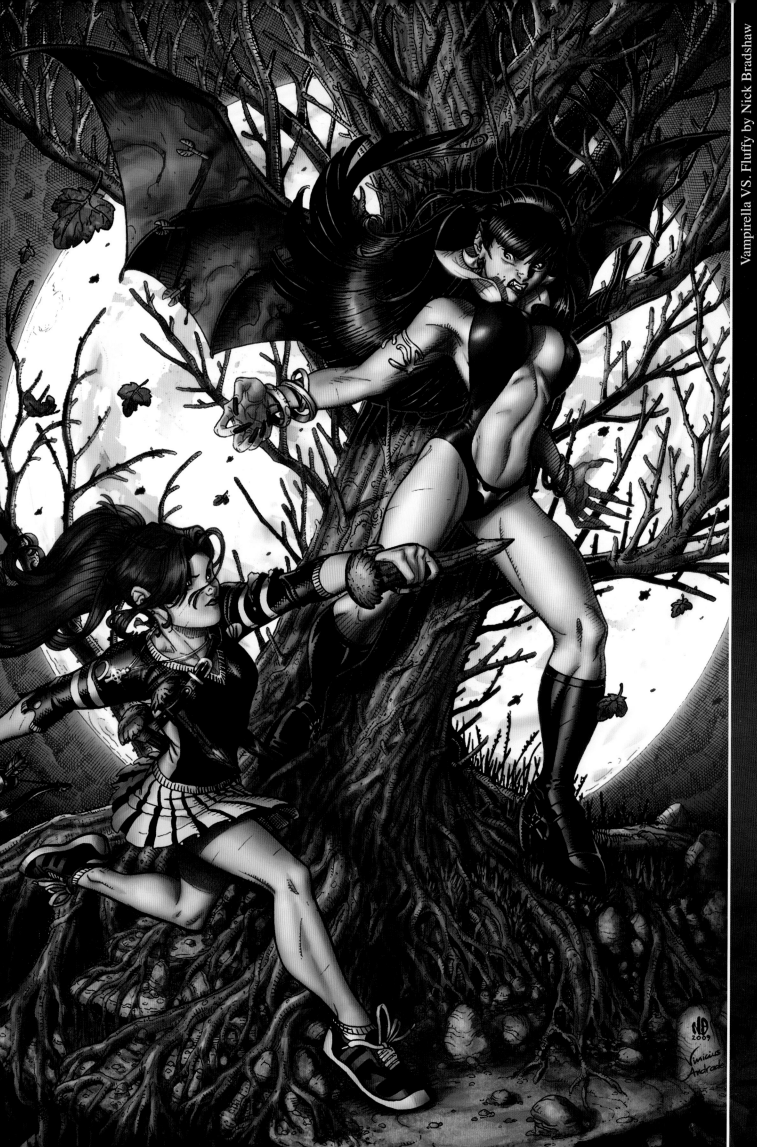

Vampirella Annual 2013 by Chris Bolson

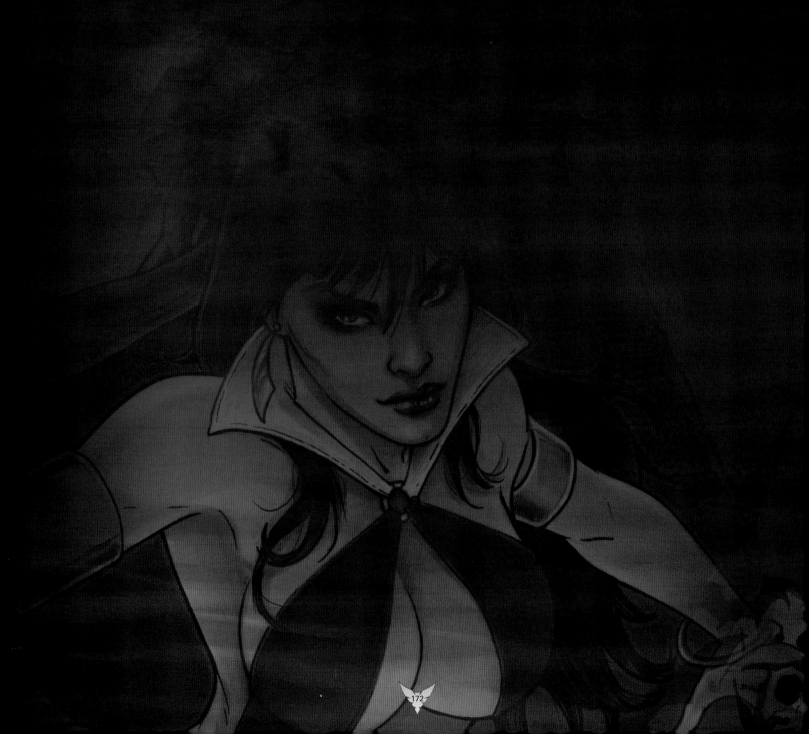

DARK SHADOWS
VAMPIRELLA

Can these very different vampire heroes set aside their distrust to come together and bring down the notorious Big Apple Butcher, or will their bloodthirsty natures destroy them before the killer strikes again? And who – or what – is pulling the strings of the Butcher? The answer is an evil older than Barnabas and Vampi combined!

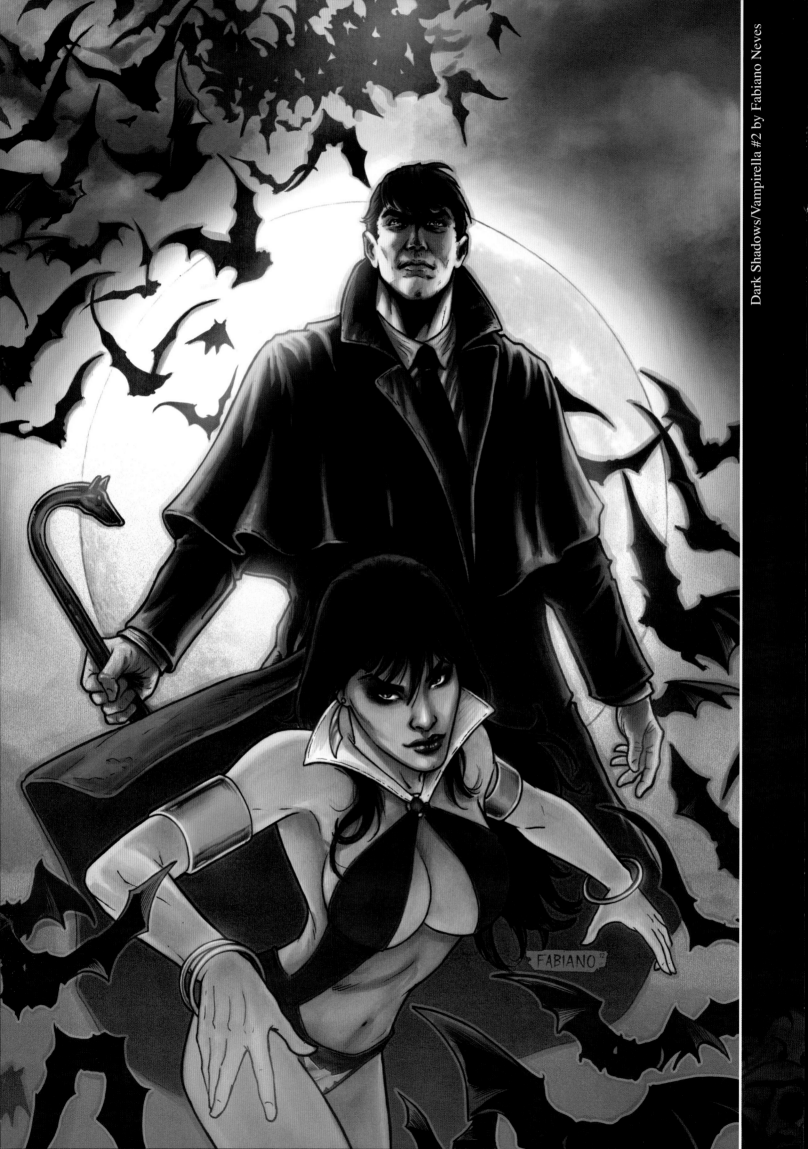

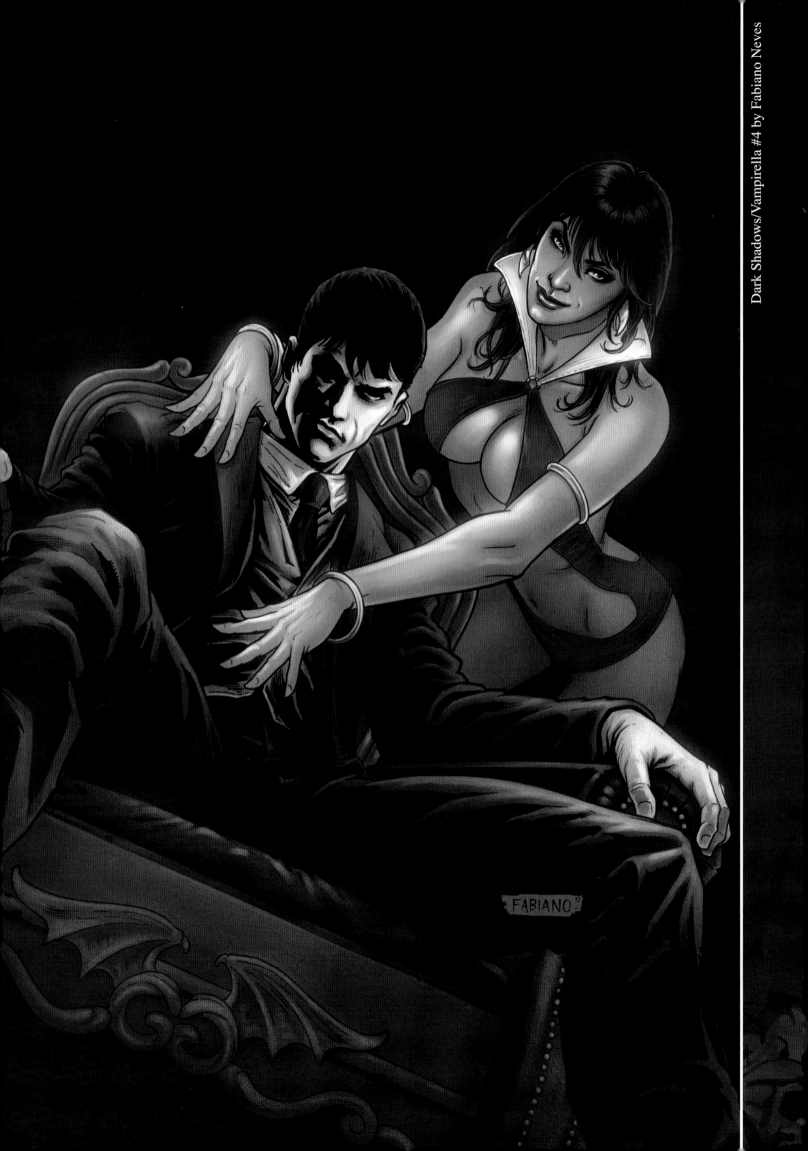

VAMPIRELLA® vs. Dracula

Spinning out of Alan Moore's retelling of the ageless horror classic, Dracula has come to America to play out his timeless narrative in this brave, New World. Only he didn't realize another vampire already beat him to it. Drawn to one another across continents and centuries by a mysterious force, both Vampirella and Bram Stoker's immortal monster find themselves sucked into a time-tossed epic of love, hate, death, and damnation. But can an epic built for one vampire possibly hold them both?

LINSNER
2011

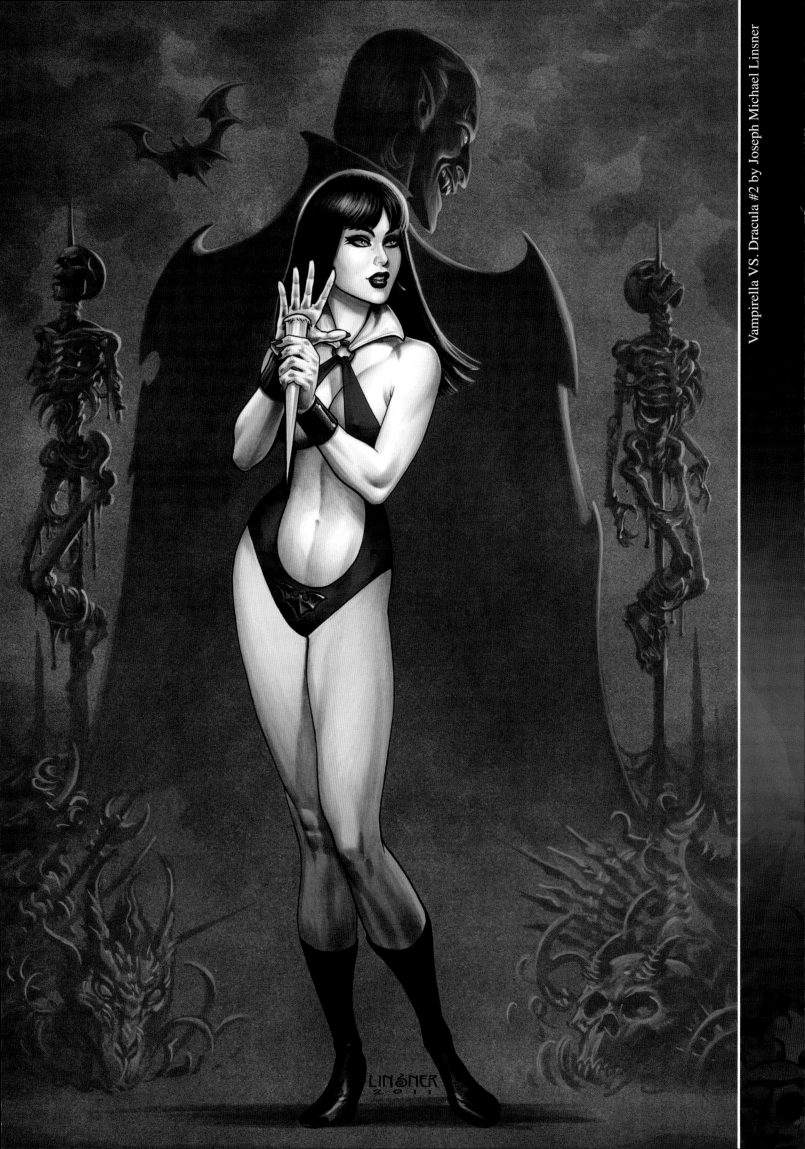

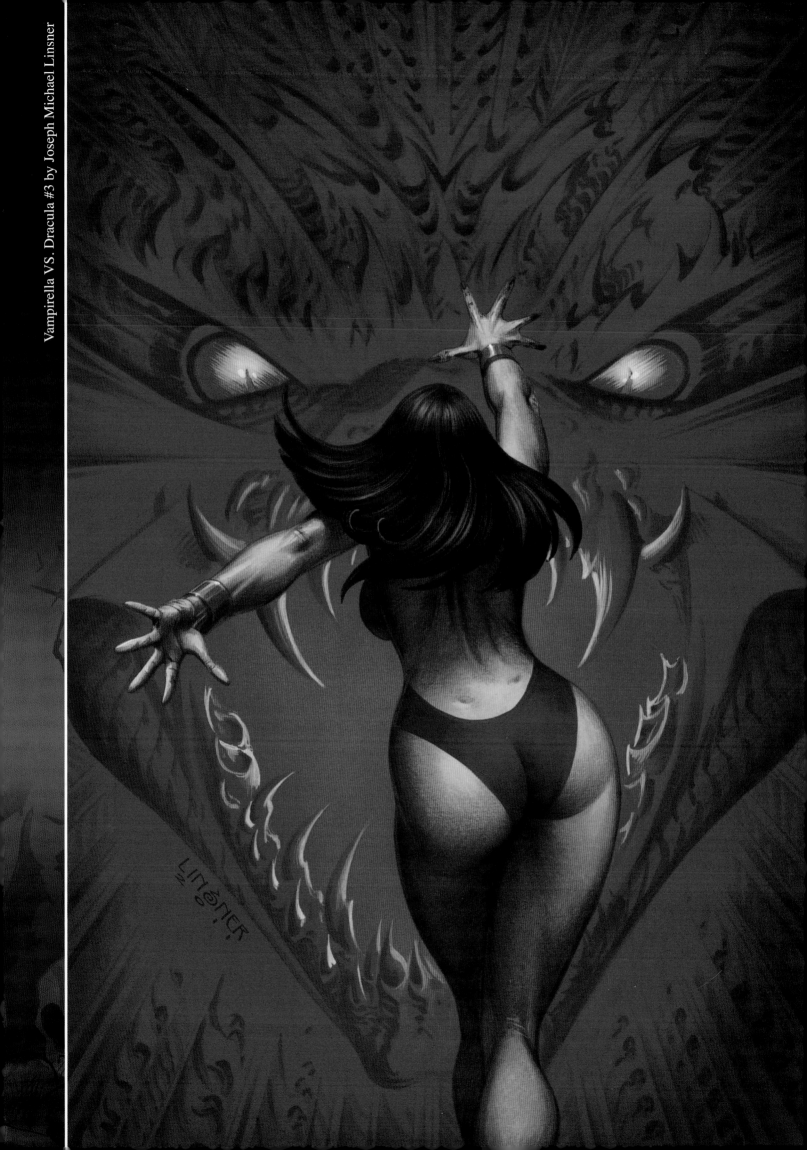

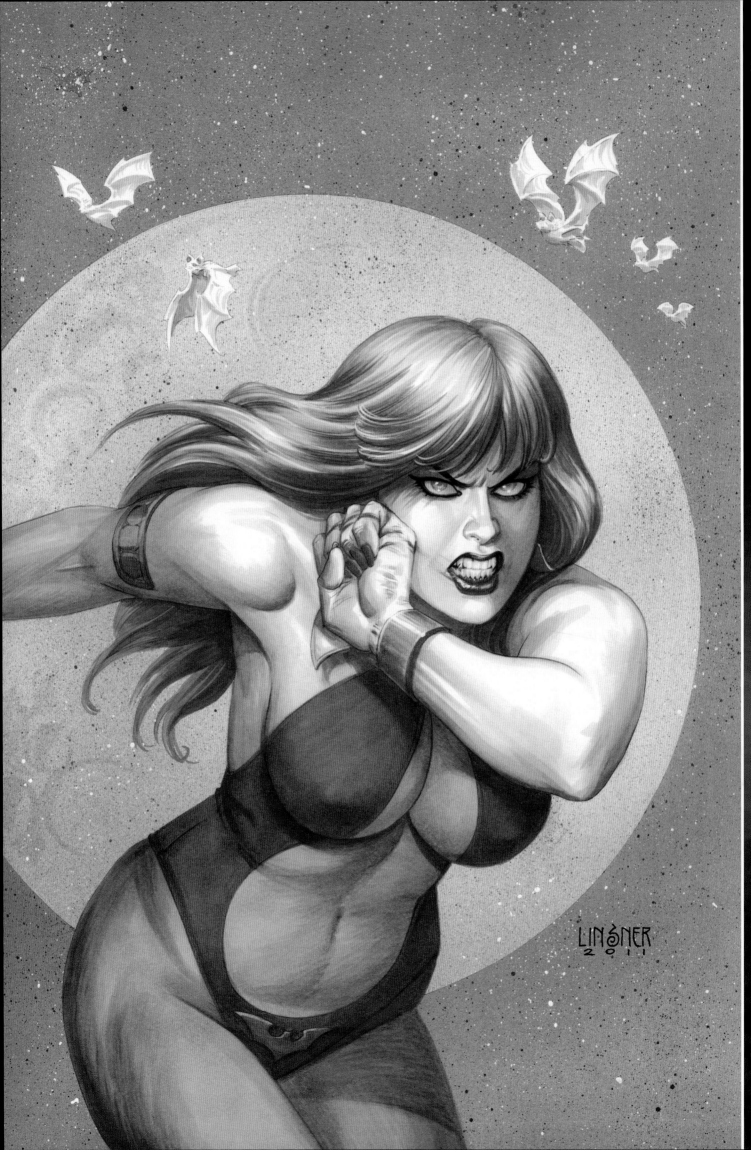

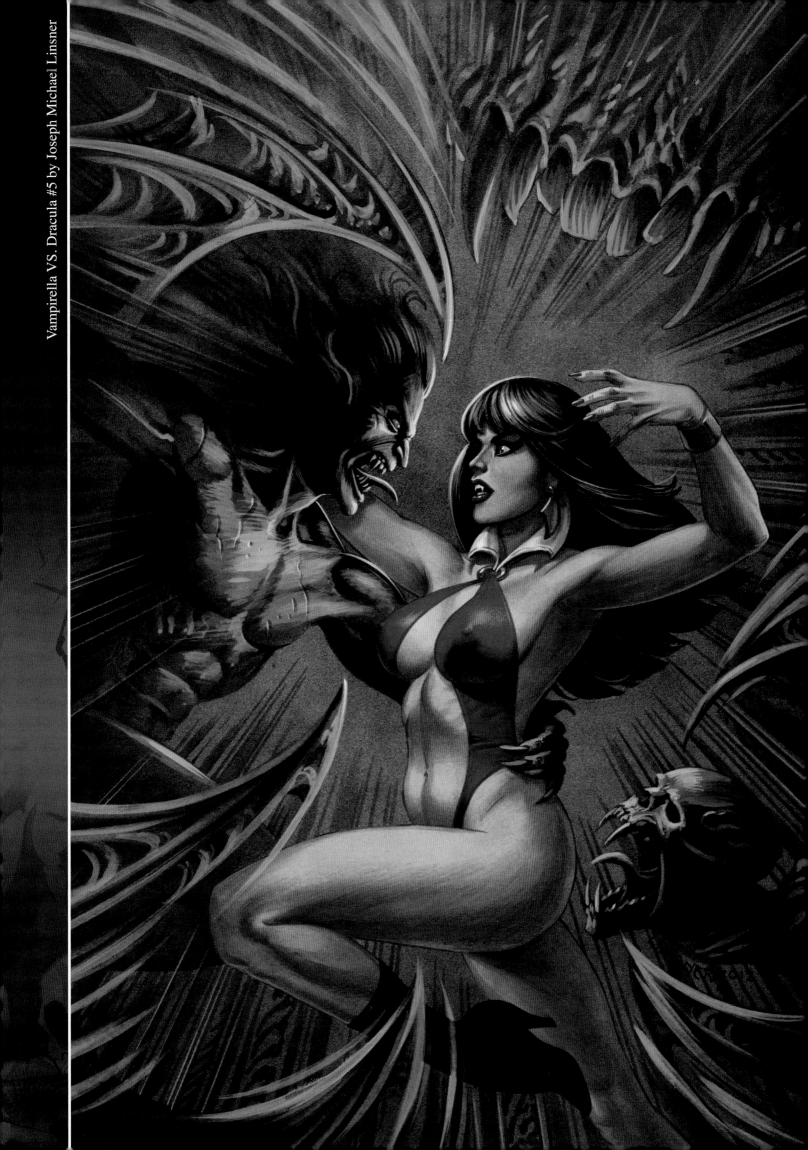

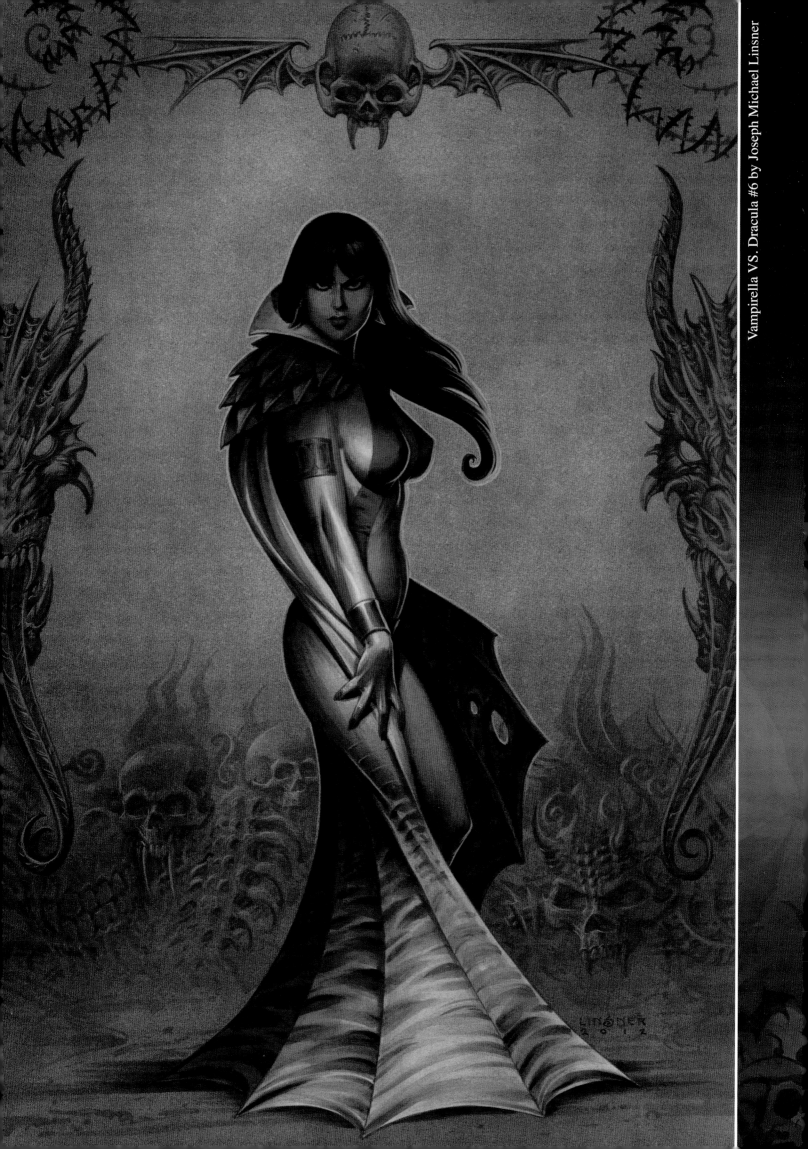

VAMPIRELLA
AND THE SCARLET LEGION

THE CRIMSON CHRONICLES, THAT FOUL BIBLE OF BLOOD, FORETELLS THE COMING OF CHAOS, THE DESTROYER AND HIS SERVANTS ON EARTH. SINCE HER EARLIEST DAYS, VAMPIRELLA HAS STOOD BETWEEN THAT VICIOUS CULT AND THEIR MAD GOD'S PLANS. BUT WHEN AN ANCIENT PROPHECY OF DOOM IS UNCOVERED AND A NEW PUSH TO RESURRECT THE FOULEST DEMONS FROM THE PIT IS REVEALED, IT'S CLEAR VAMPIRELLA WON'T BE ABLE TO TAKE THEM ON ALONE. ENTER THE SCARLET LEGION, A STRIKE FORCE ASSEMBLED TO KEEP THE DARK THINGS AT BAY AND PROTECT THIS WORLD FROM THE EVILS THAT LIE BEYOND. SET AGAINST A PLOT MILLENNIA IN THE MAKING, CAUGHT BETWEEN OLD FRIENDS, LIKE MORDECAI PENDRAGON AND ADAM VAN HELSING, AND OLD ENEMIES, SUCH AS ETHAN SHROUD AND UNFLINCHING WARRIOR MAIDENS WHO SERVE THE VATICAN, VAMPIRELLA WILL HAVE TO FIGURE OUT WHO TO TRUST, WHO TO BELIEVE AND WHAT TO DO NEXT.

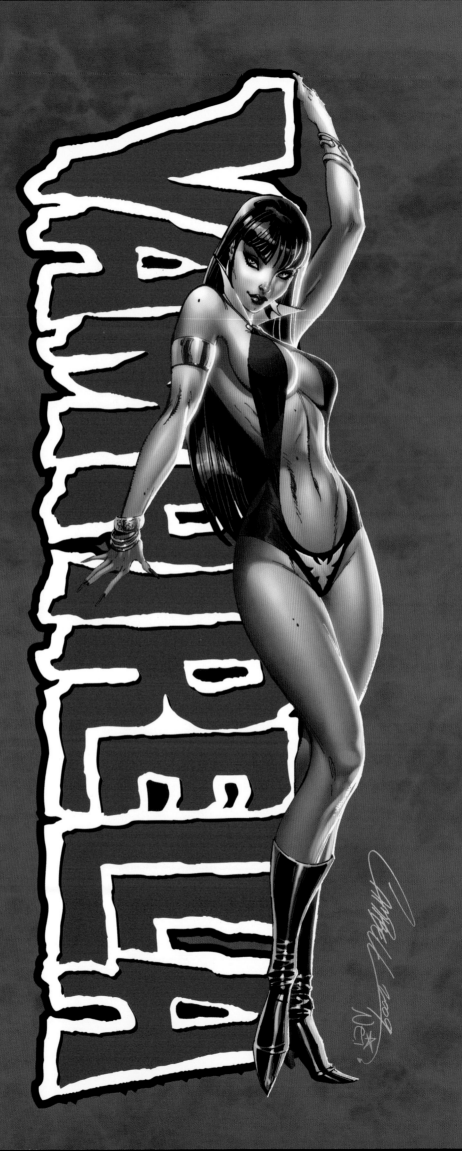

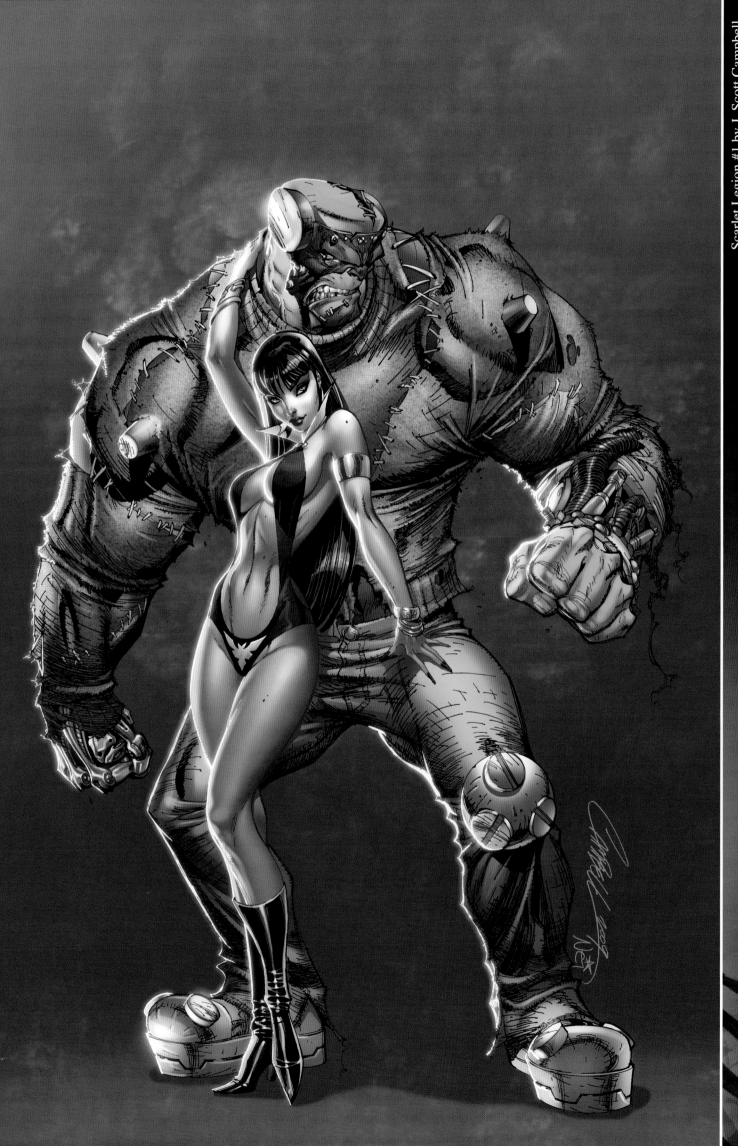

CÆSARTIST

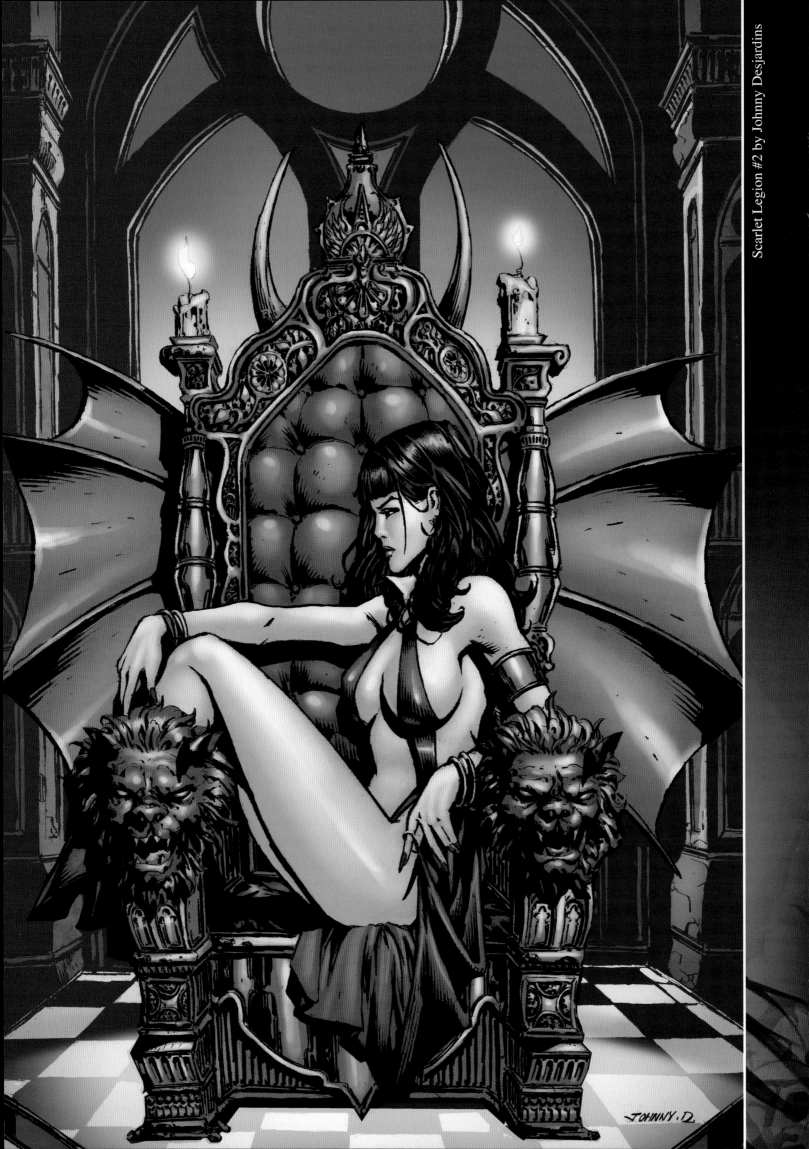

JOHNNY.D.

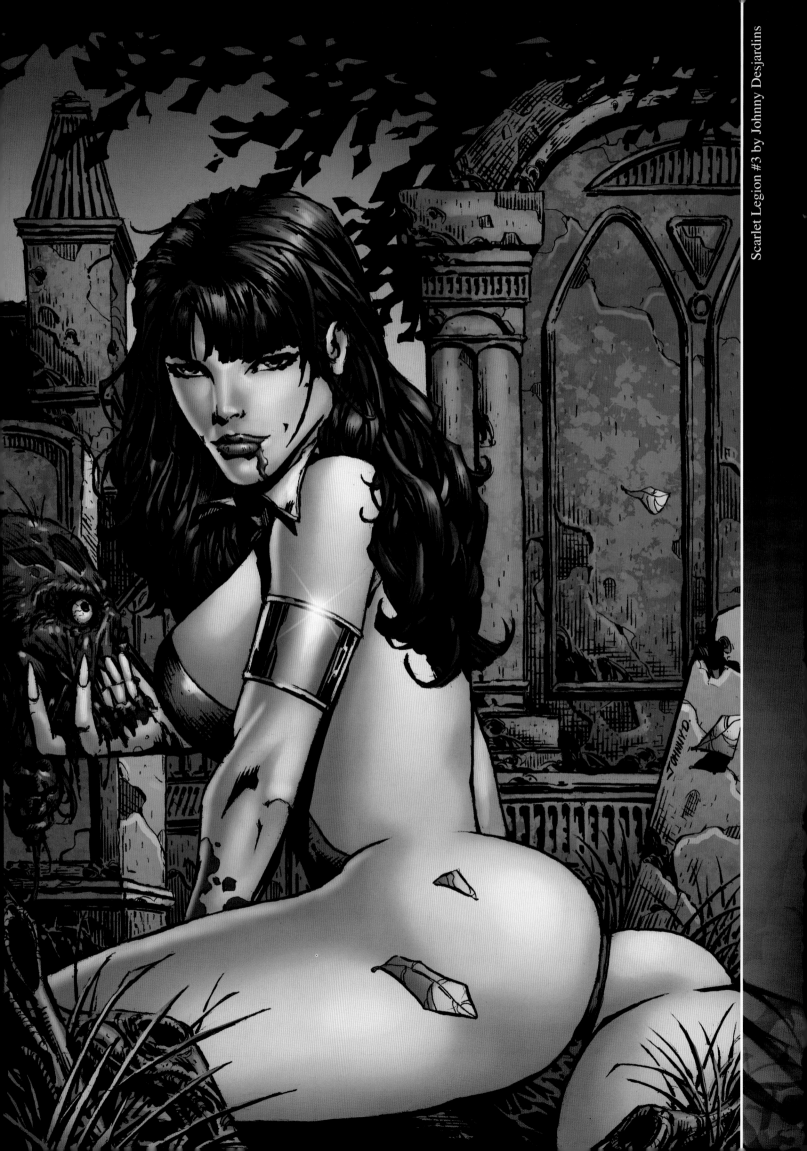

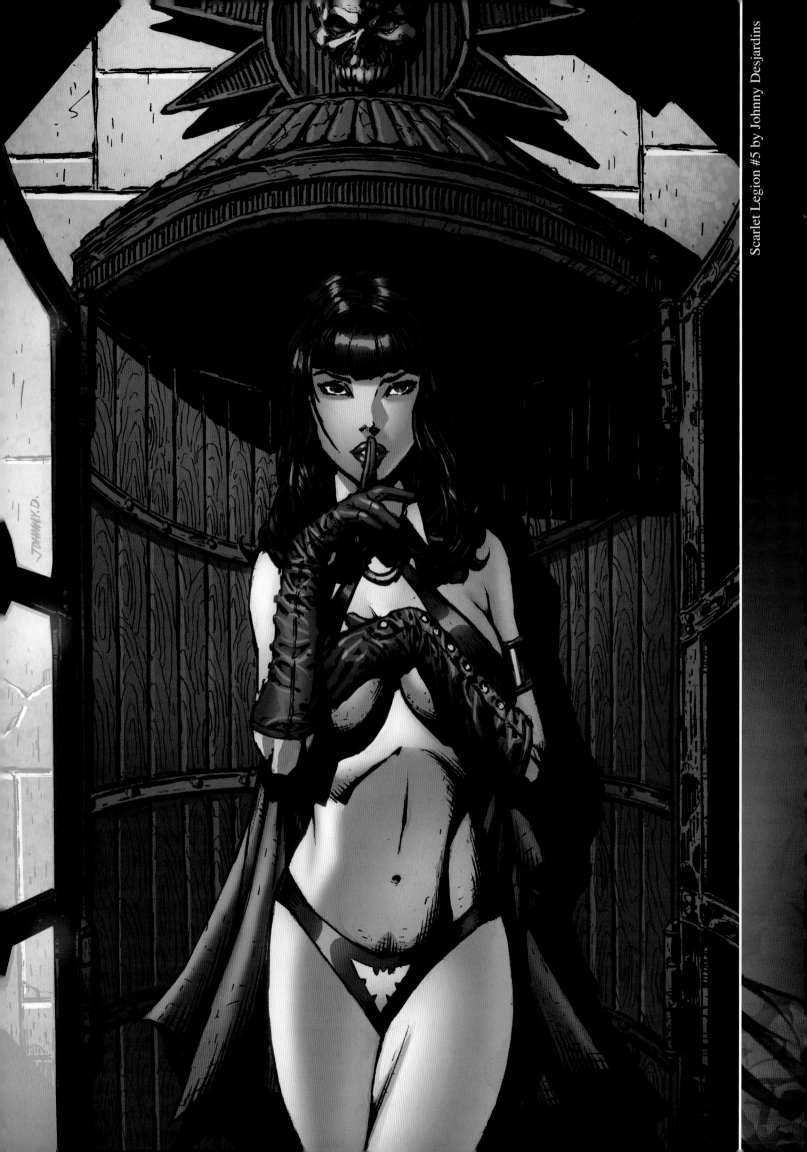

Scarlet Legion #5 by Johnny Desjardins

PROPHECY

The biggest crossover event ever from Dynamite Entertainment stars an astounding array of characters that must form an uneasy alliance and save the world from the Mayan doomsday prophecy! From sword-wielding woman warriors to mad scientists, from vampire vixens to undead overlords, Prophecy has everything... and then some! When flame-haired warrior Red Sonja follows sorcerer Kulan Gath through time from the barbaric Hyborian Age, she unleashes a chain of events that will put her side-by-side with an unprecedented gathering of characters: Dracula, Vampirella, Pantha, Athena, Eva, Herbert West the Reanimator, and Ash from "Army of Darkness." Even Sherlock Holmes, Dr. Watson, and Allan Quatermain get in on the action!

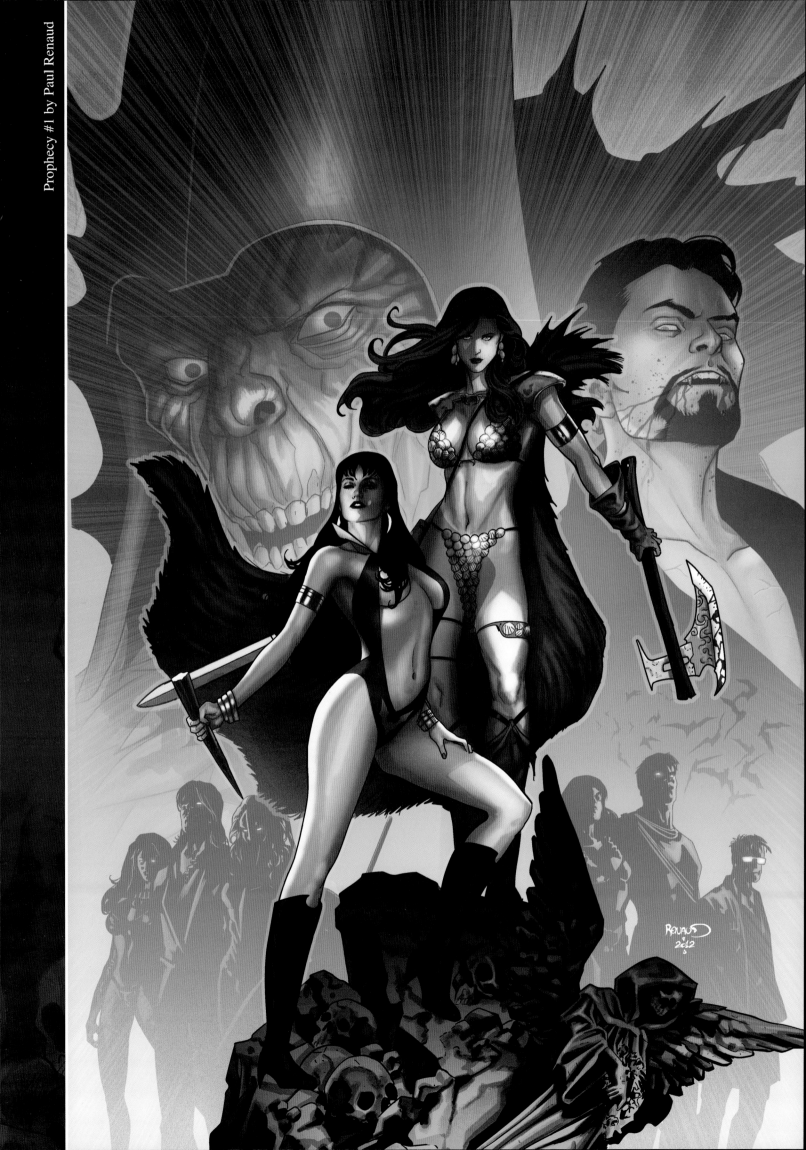

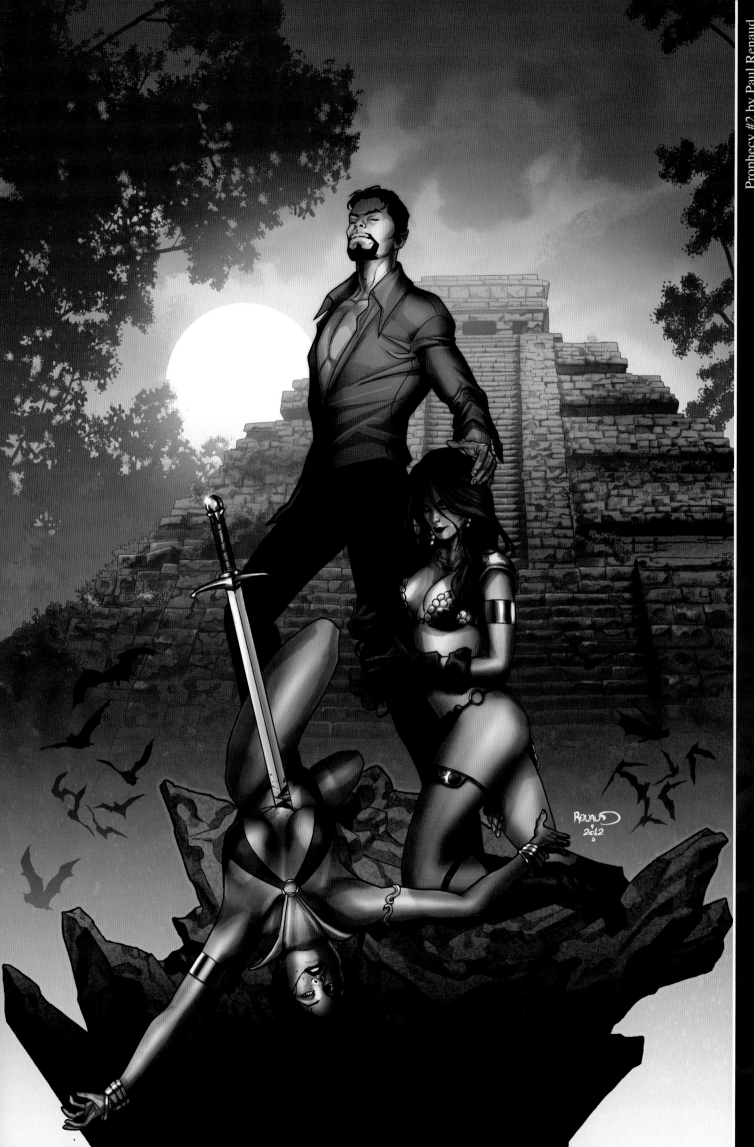

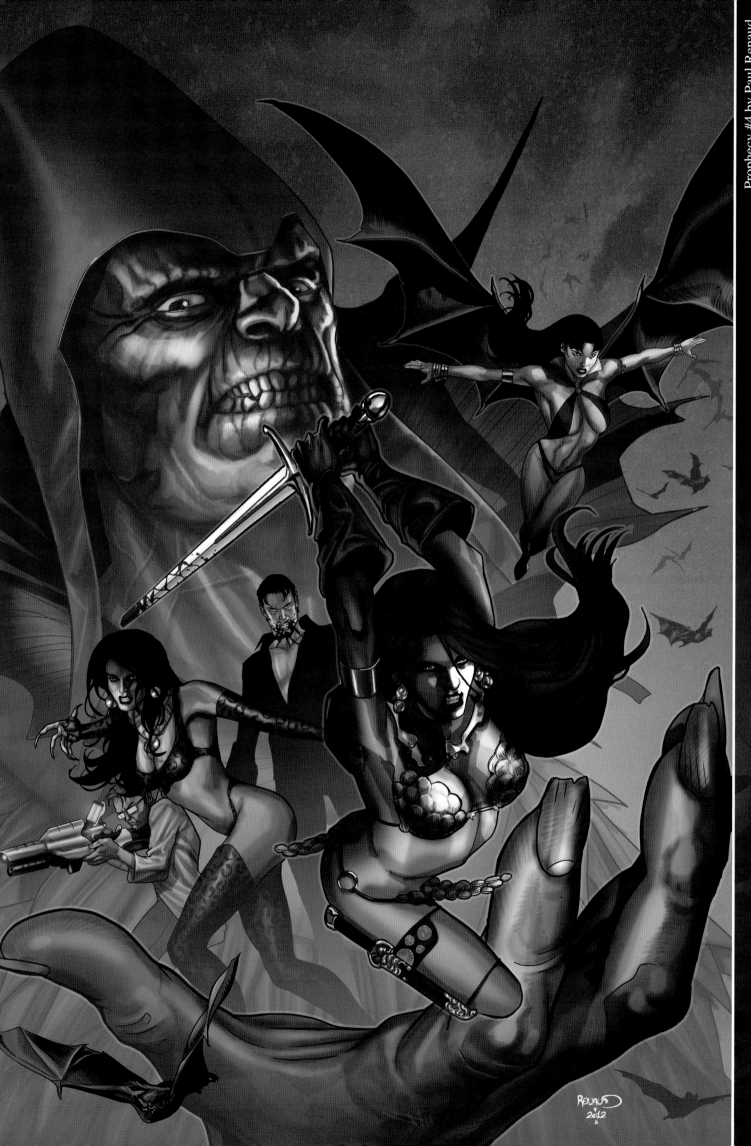

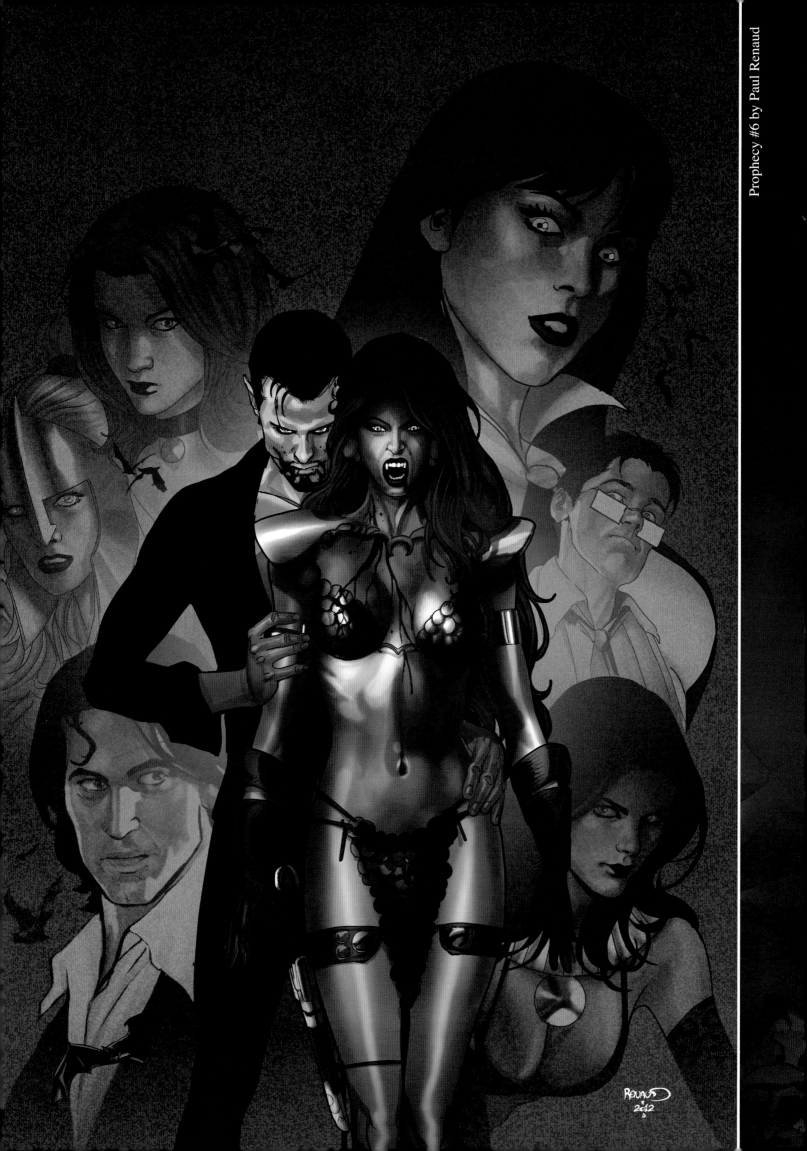

VAMPIRELLA AND A COLORFUL, DRIVEN LAWMAN NAMED AARON BURR TRACK VAMPIRES ON A BLOOD-LETTING RAMPAGE THROUGH RURAL ARKANSAS TO THE RED ROOM, AN UNDERGROUND CIRCUIT WHERE HIGH ROLLERS STAGE MORTALS VS. MONSTERS DEATH MATCHES. SHE FACES A HOST OF FIENDS, QUICKLY REALIZING MORE ARCANE FORCES DRIVE THE BOUTS AND THAT THEIR FRENZIED COMBATANTS, ENHANCED WITH A POWERFUL, CORRUPTING ESSENCE, ARE FIRMLY STACKING THE ODDS AGAINST VAMPIRELLA SURVIVING THE NIGHT.

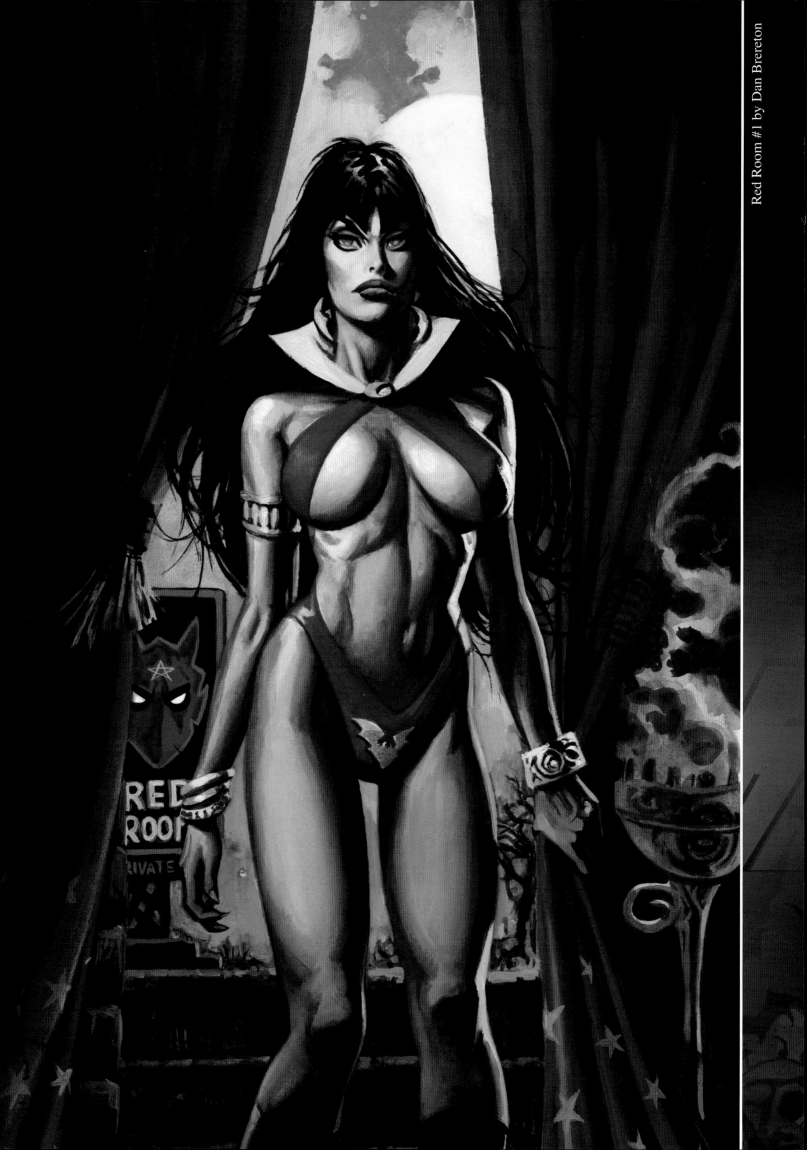

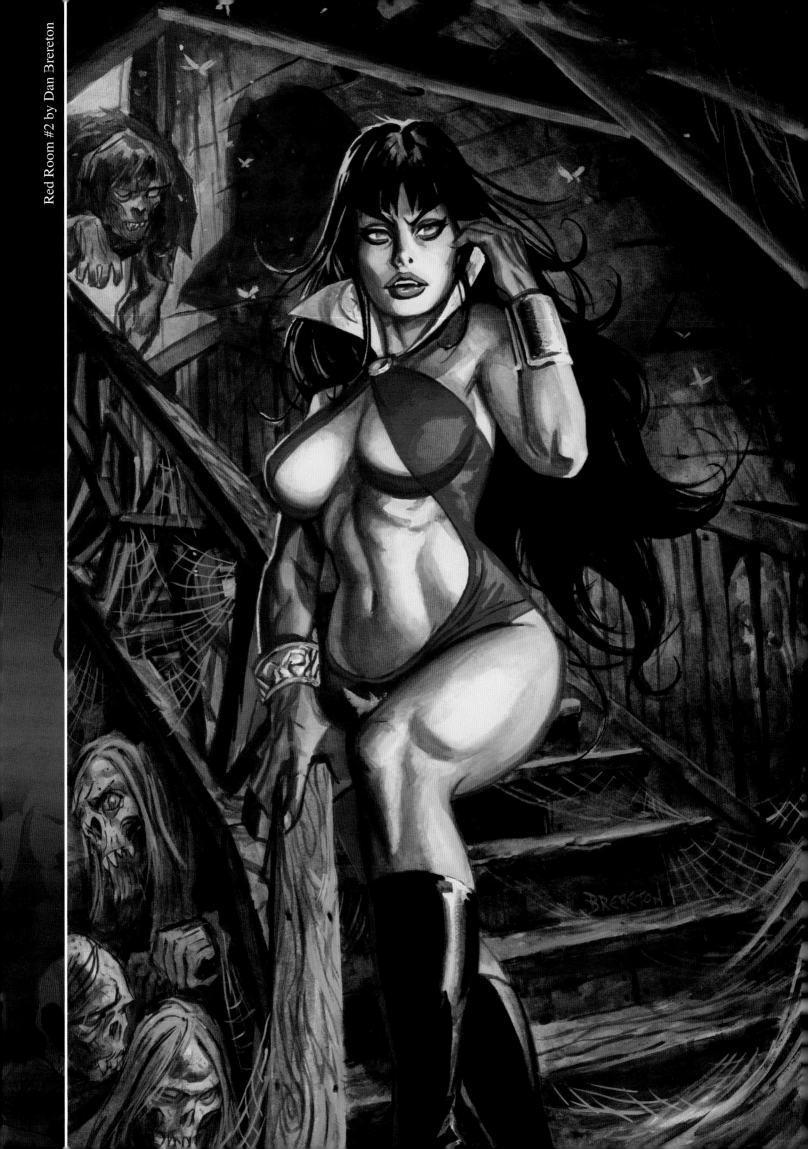

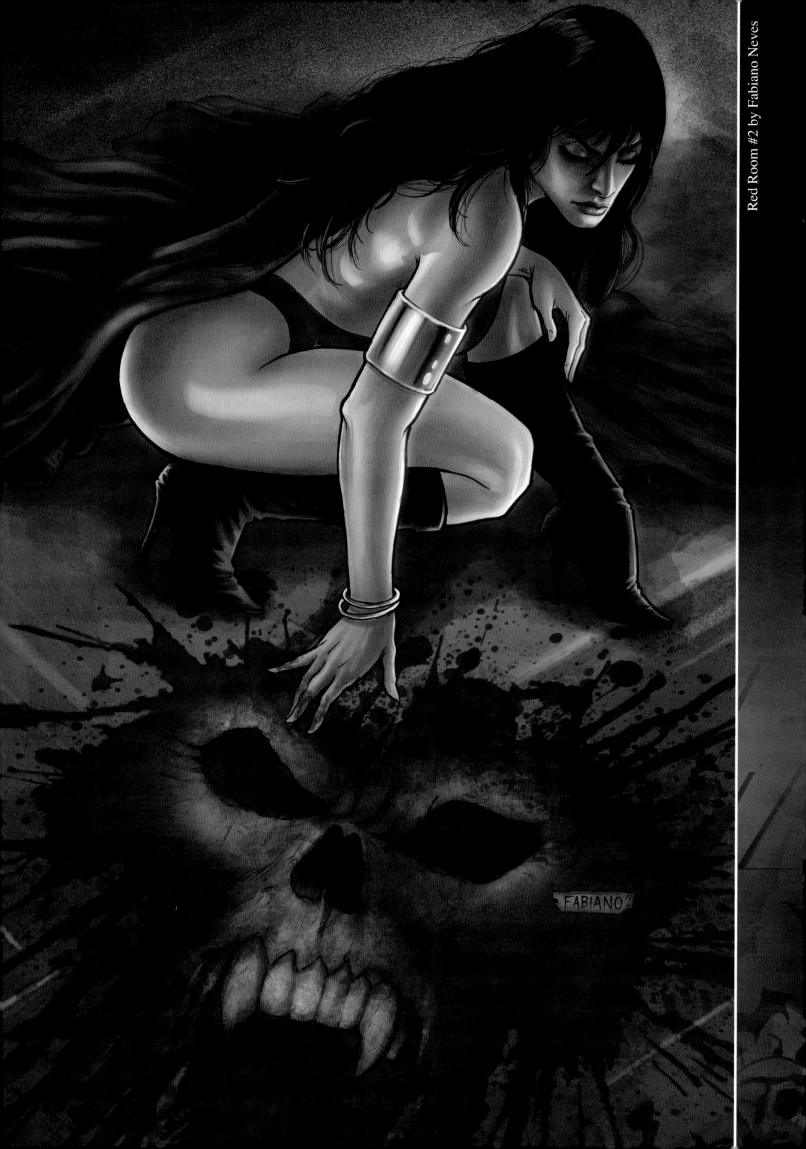

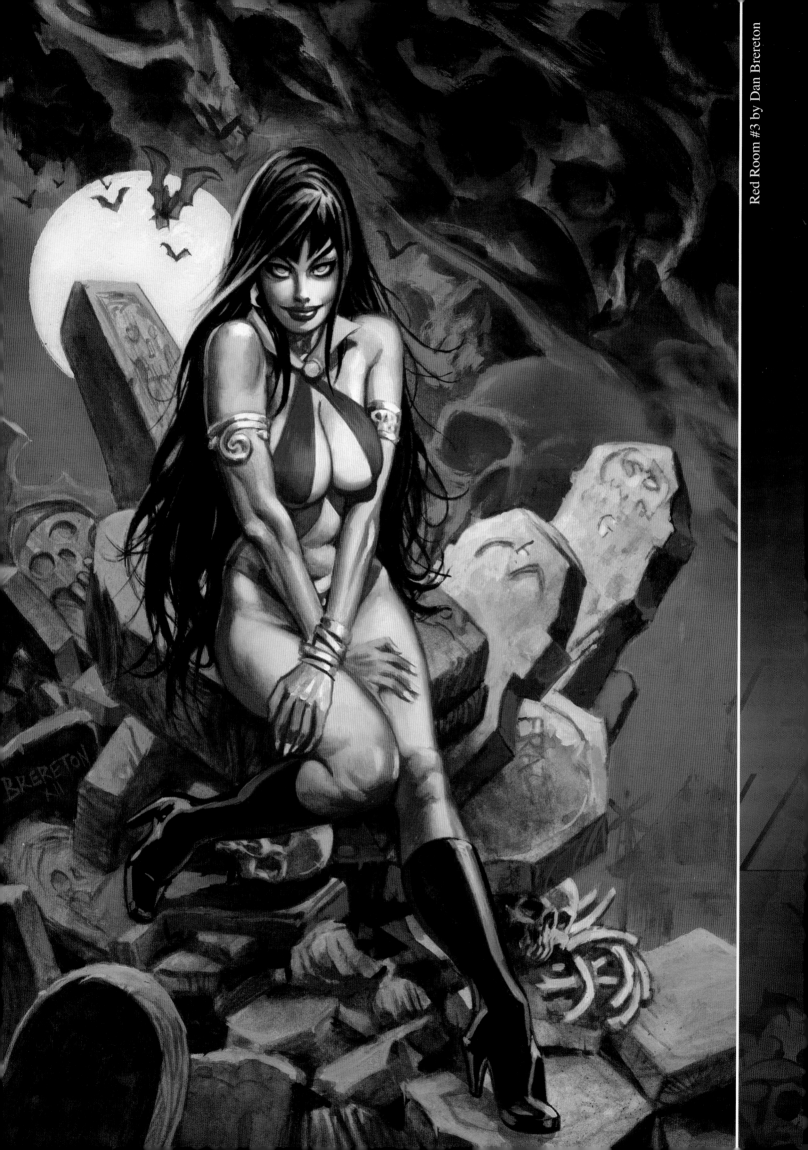

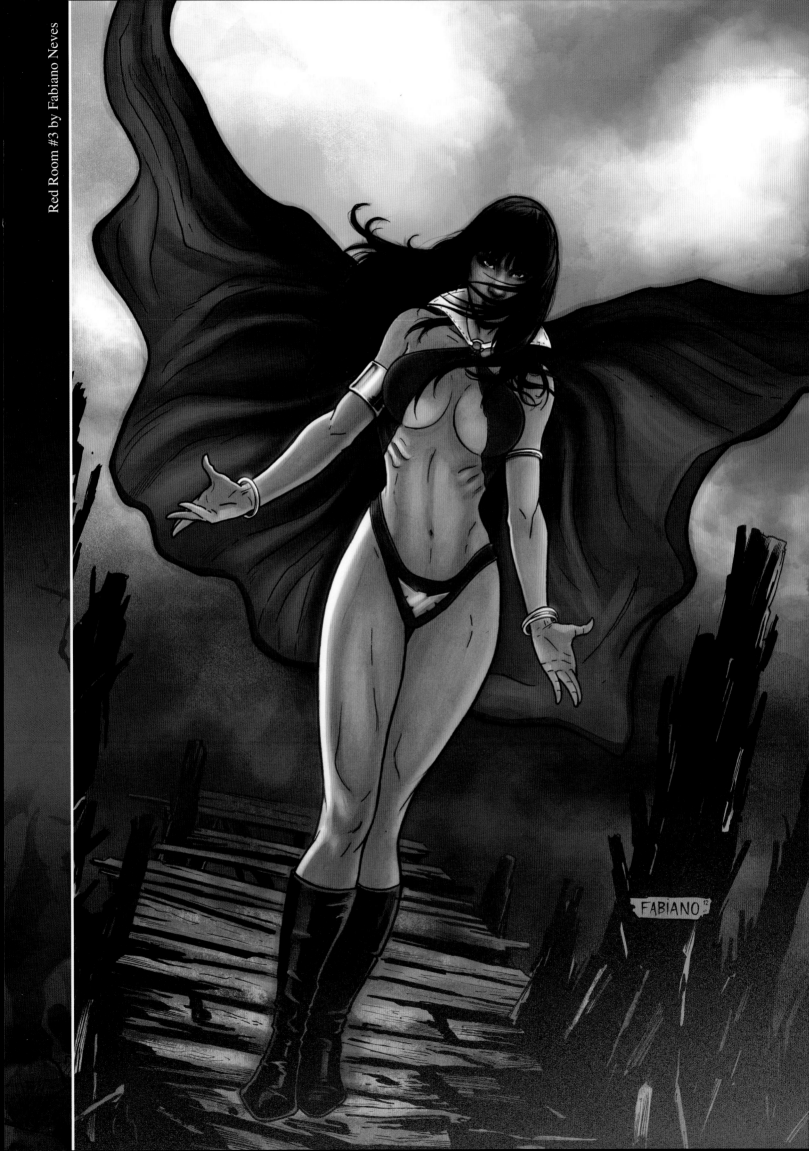

Vinicius
Andrade

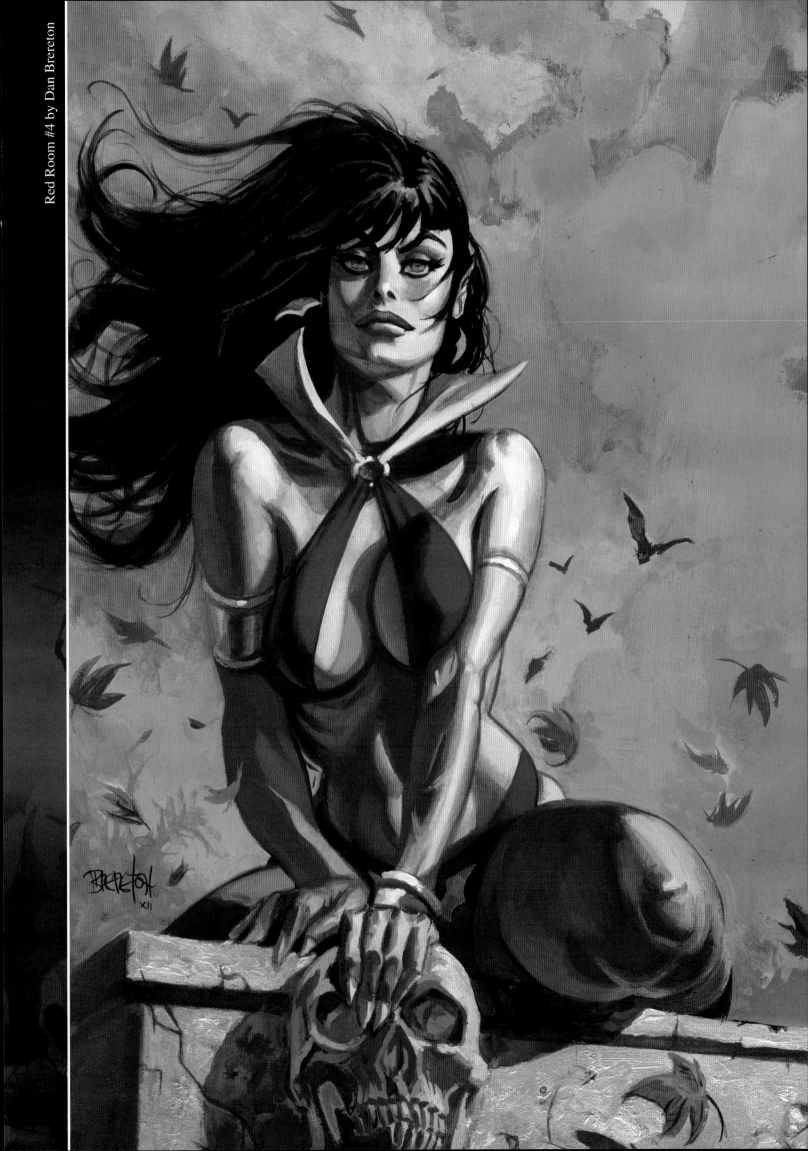

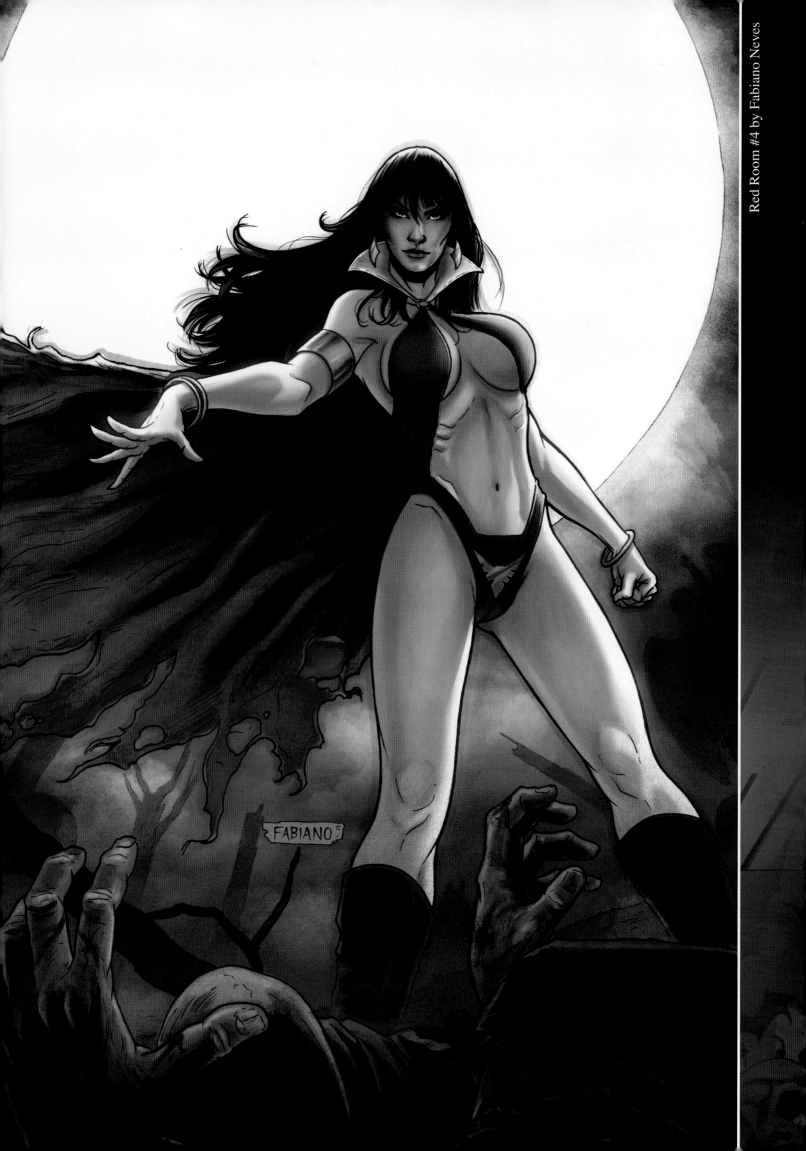

VAMPIRELLA
Southern Gothic

Vampirella, the beautiful and bloodthirsty heroine, travels to Mississippi to help an old flame solve the mystery of his murdered fiancée... a woman who appears to have died thirty-seven times before. Burdened by a mystical wound that will not heal, can Vampi hack through racist demons, evade corrupt lawmen, and solve this strange Southern mystery... or will the man she once loved sacrifice his soul to get the answers instead?

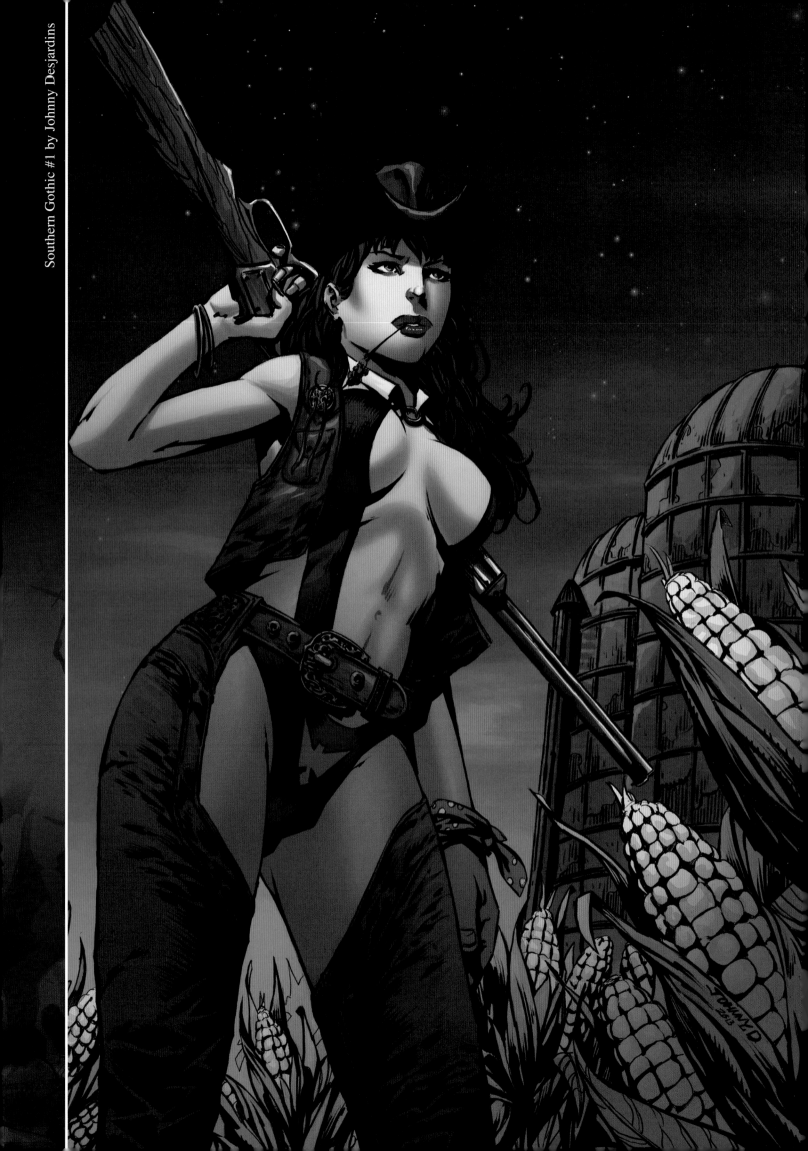

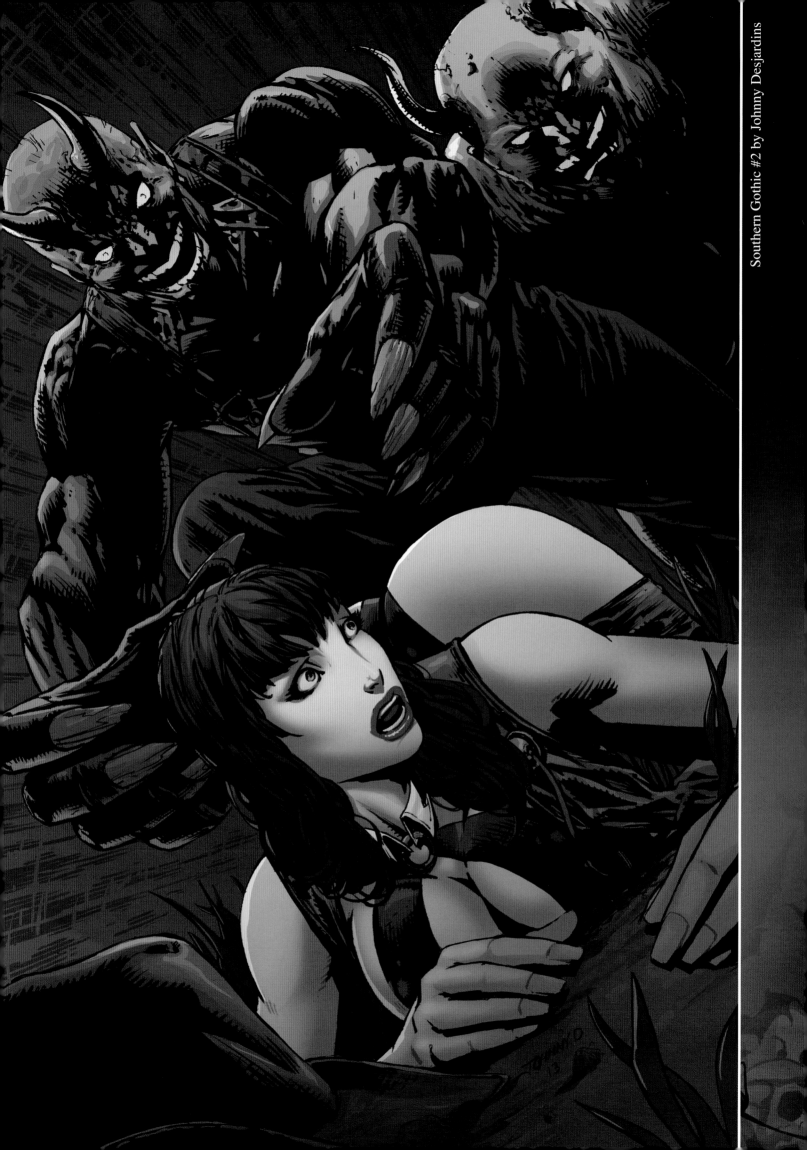

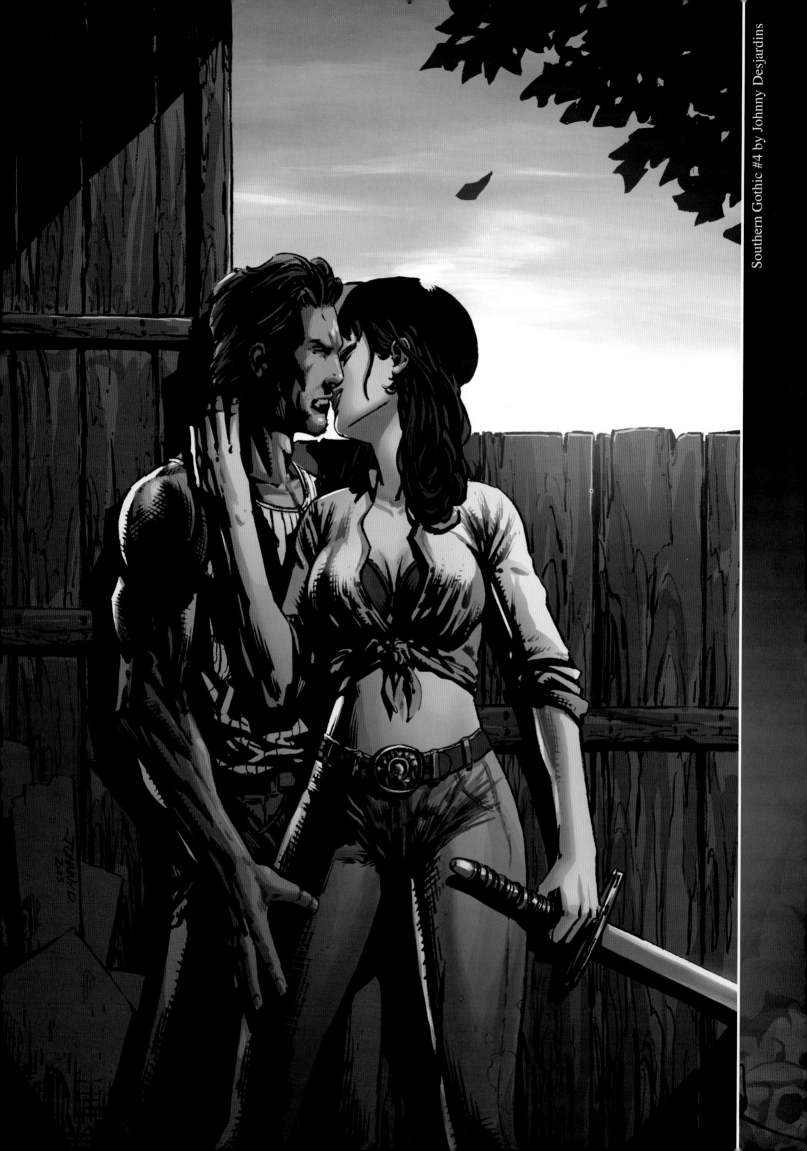

VAMPIRELLA STRIKES

FOR YEARS, THE RAVEN-HAIRED HEROINE VAMPIRELLA HAS HUNTED THE WORLD'S SUPERNATURAL THREATS, ALL THE WHILE FIGHTING BACK HER OWN BLOODTHIRSTY NATURE. AFTER A NIGHT OUT IN BOSTON LEADS TO PARTICULARLY BRUTAL VIOLENCE, SHE SEEKS COMFORT IN HER BROWNSTONE HOME... BUT DISCOVERS THE MOST UNEXPECTED SURPRISE OF ALL. ANGELS HAVE BEEN SENT TO HER BY GOD— AND THEY COME ASKING FOR HELP! ENTER JANUS, A FORMER SOLDIER IN THE LEGION OF HEAVEN, WHO SKIRTS THE LINE BETWEEN THE DAMNED AND DIVINE. ONLY A FALLEN ANGEL CAN NAVIGATE VAMPIRELLA THROUGH THE SEEDY, DEMON-RUN UNDERWORLD, WHERE SHE HOPES TO FIND THE SOURCE OF AN ADDICTIVE, BODY-ALTERING DRUG DERIVED FROM ARCHANGEL BLOOD. WILL VAMPIRELLA'S MISSION REDEEM HER... OR WILL SHE UNCOVER SECRETS SO SHOCKING THAT THEIR DISCOVERY WILL DAMN HER FOREVER?

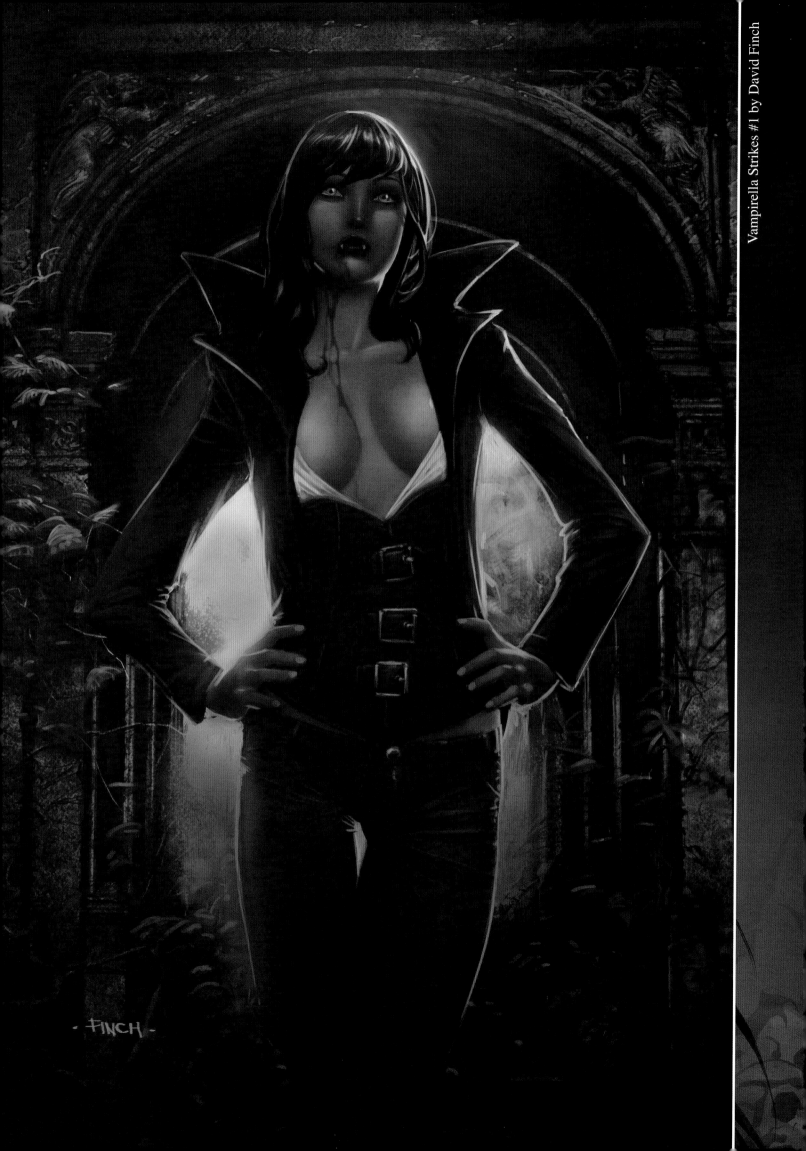

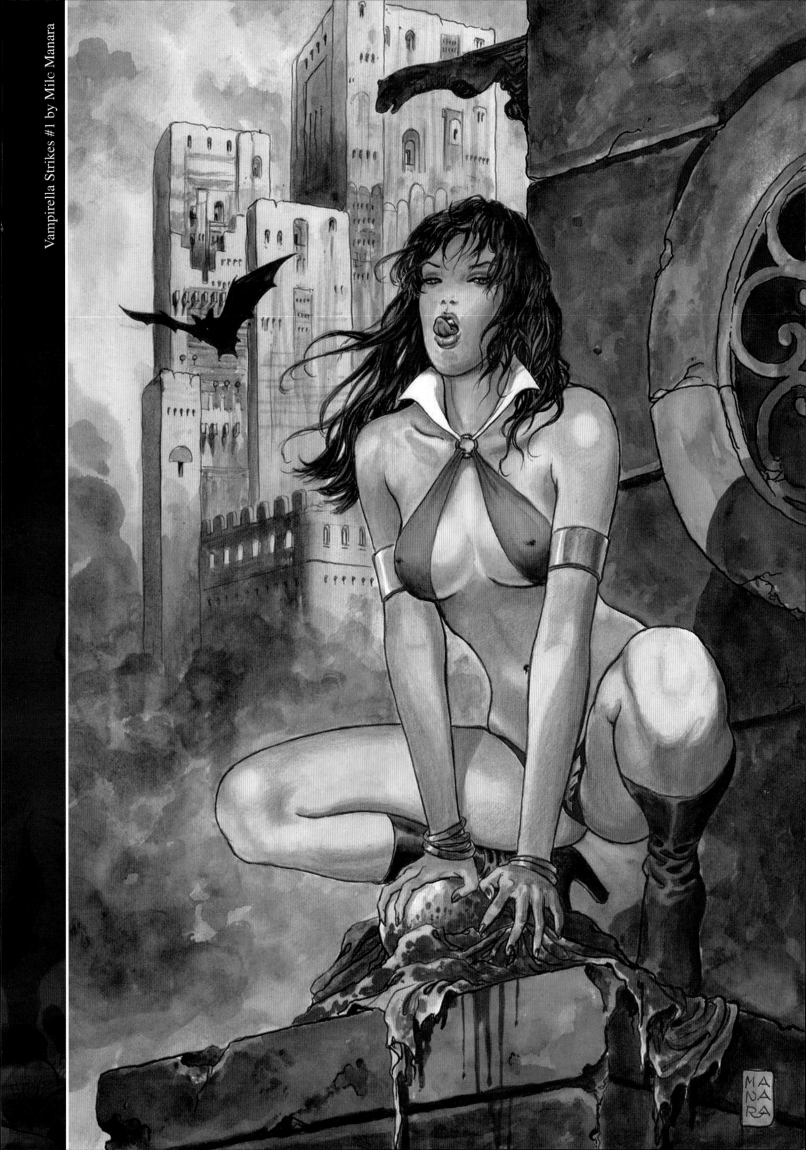

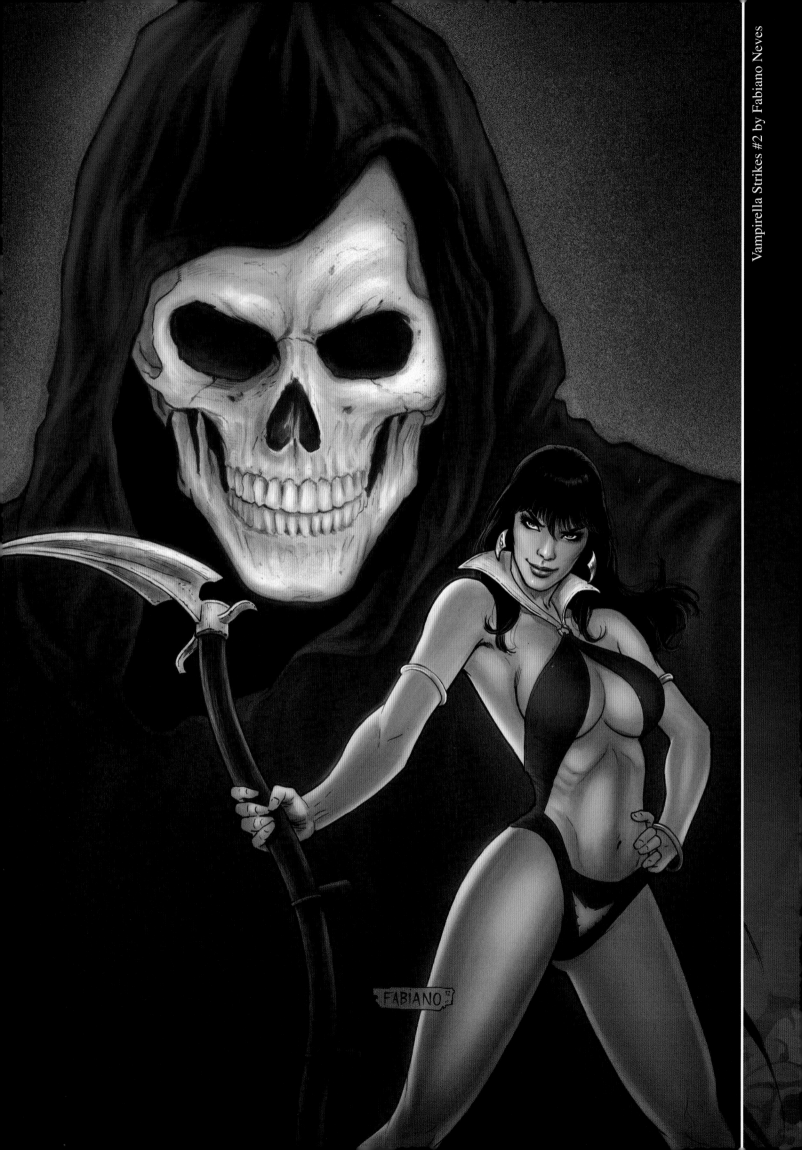

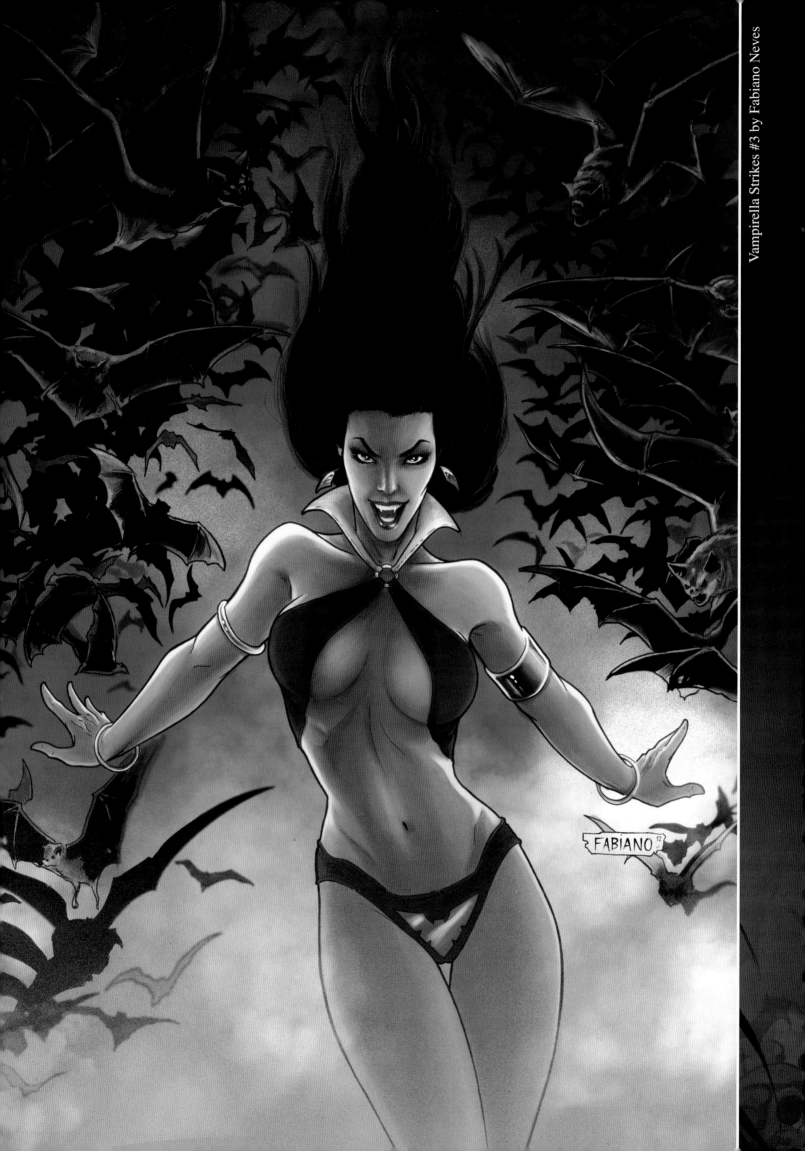

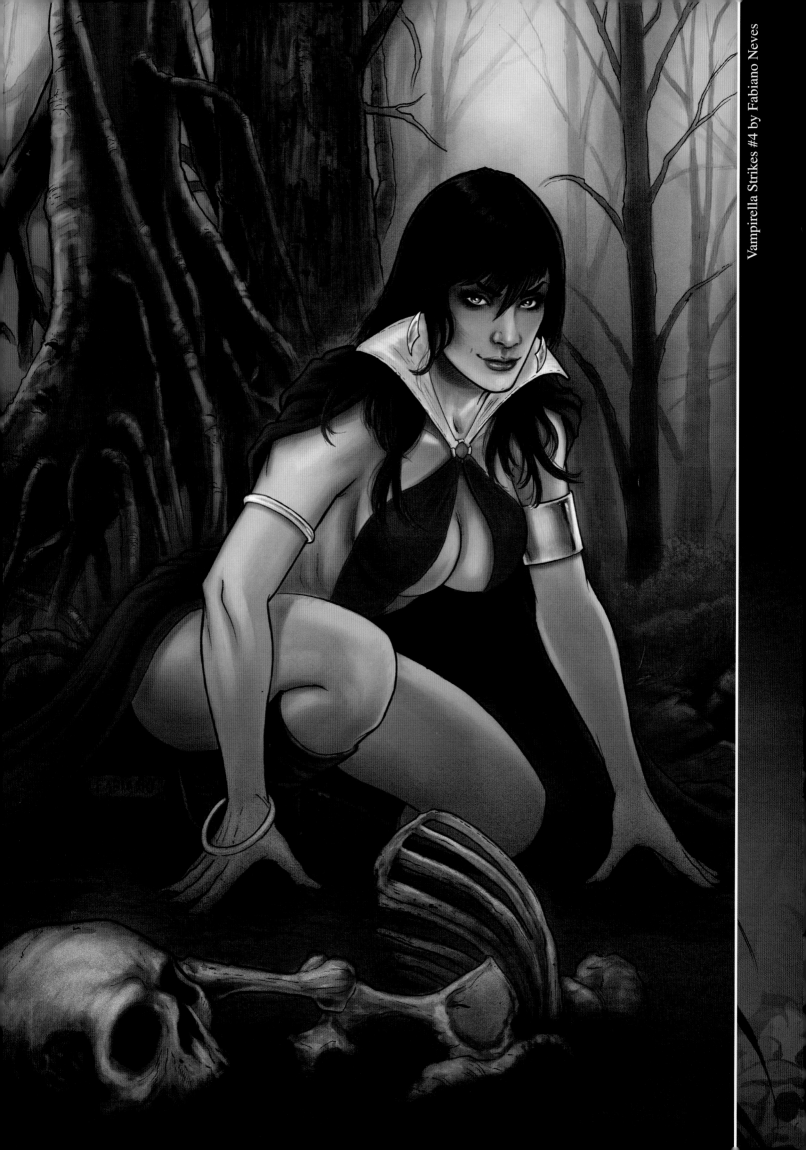

JOHNNY.D.
.2012.

Vinicius
Andrade

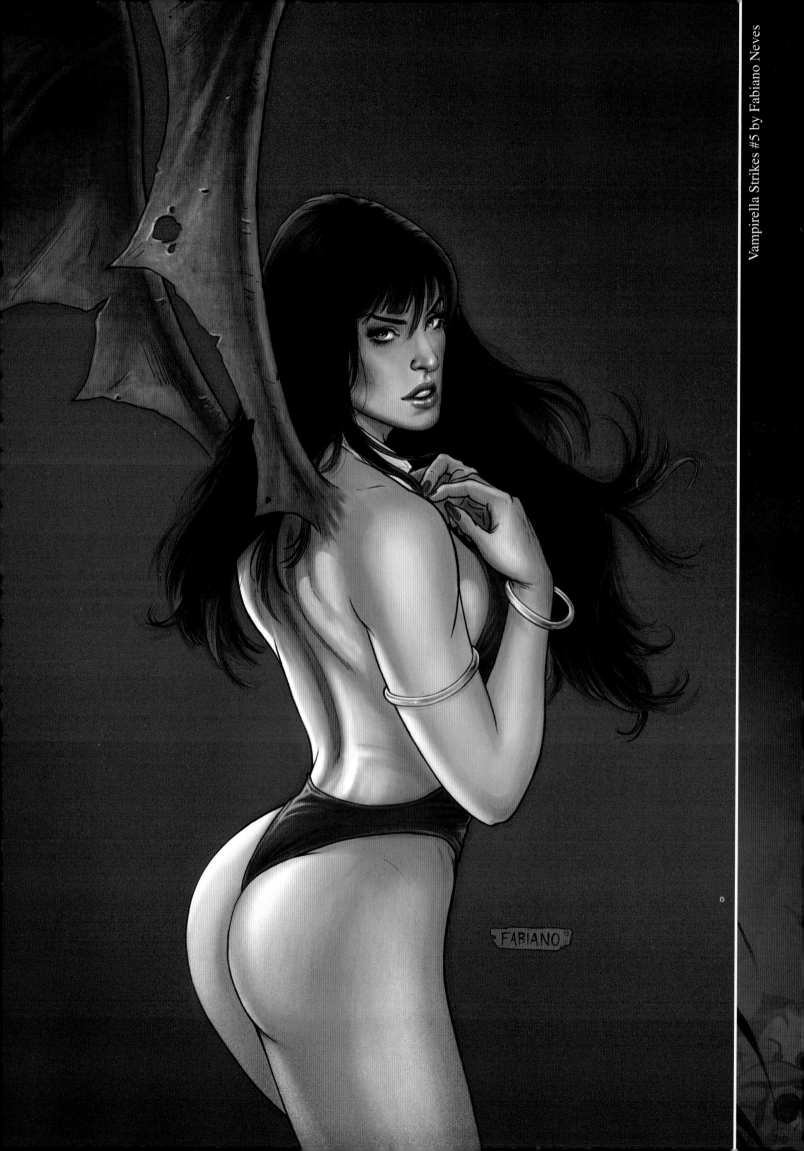

Vinicius Andrade JOHNNY.D. 13

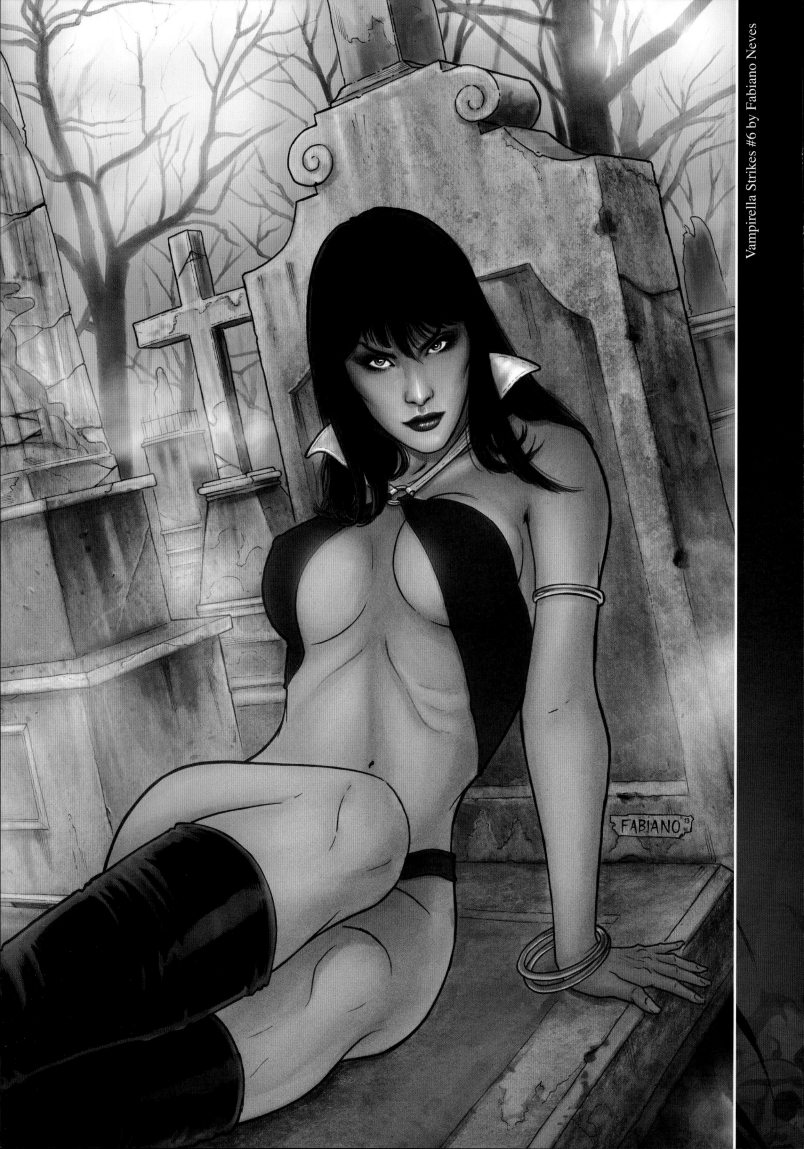

Vampirella Strikes #6 by Johnny Desjardins

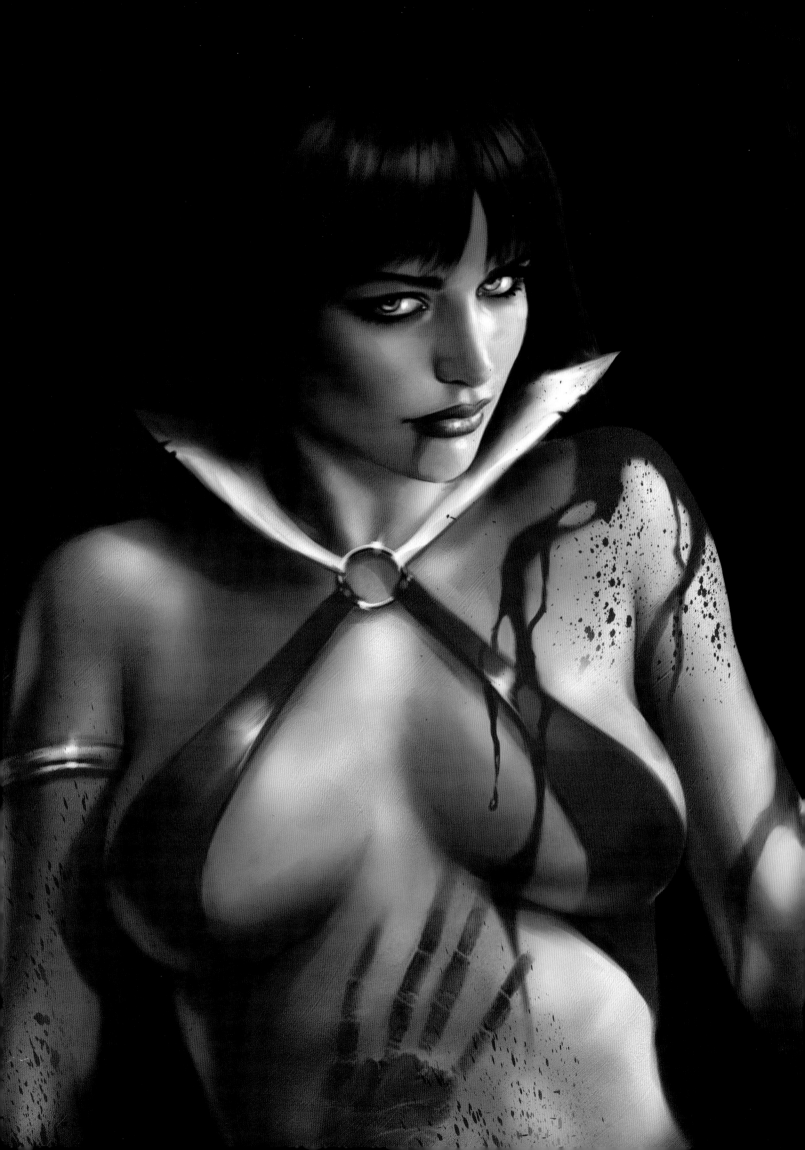

AFTERWORD

BY BRANDON JERWA

SOMETHING LIKE THE FINAL WORD ON THIS SUBJECT

Here's the truth: I'm writing this afterword on the night before it's due.

Okay, okay…to be fair, I'm finishing this afterword, but I also had to pretty much scrap the two pages I'd already written because they had an extended riff on writers wishing they could be artists. If you didn't skip Eric Trautmann's introduction, you'll understand why I had to go back to the well. Credit where it's due: Eric made almost exactly the same points, and probably articulated them better than I would have.

This is why being a writer is easier, at least in theory. The art you see in this book can't be produced overnight, and I wouldn't be surprised if some of the best pieces took months to complete. All I have to do is share a few semi-coherent thoughts, and present them in a readable fashion. At the end of the day, it's all just words on a screen. No one's going to complain about the coloring, or say that my anatomical proportions are completely wrong (let's not kid ourselves; the latter point could still find its way onto a message board, but it would probably be a personal attack).

Eric and I are frequent collaborators, and practically idiot twin brothers. We've worked together many times, and I am proud to note that we are the first two writers of Dynamite's monthly *Vampirella* series. Our good pal Mark Rahner wrote the second series annual (and some great one-shots and mini-series) so at least we kept it in the family.

Personally, I never thought I'd write a Vampirella comic.

Obviously, I wasn't unwilling. We all have our wish lists, and if you work in comics long enough, you get some ideas about other characters that aren't on those lists. I just don't think Vampirella ever crossed my mind, even though I'd already written some action-horror stuff.

Hell, I was surprised when Eric was called in to launch the series because it seemed like an odd fit for him as well. I seem to recall that our first exchange about it went something like this:

Eric: "So, I'm writing *Vampirella* for Dynamite."

Me: "Really? That's weird. Why would they do that?"

I know that sounds mean, but he was just as confused as me. It didn't take long to figure out that Dynamite was serious about taking the character in a fresh direction, and our editor Joe Rybandt knew full well that Eric would take that ball and run all the way across the yard with it. A few months later, the vampire space princess returned to the comic marketplace with a new job, big guns, and an Armani pantsuit.

Several months into the process, I was asked to write a fill-in issue, because Eric's writing slate was full-to-bursting, and we had worked together often enough that I could follow his lead without it being too

jarring for the readers. That theory held very well, and I was immediately given a follow-up gig writing the first series annual. Even then, I figured this was a random exercise that wouldn't lead anywhere.

I can see now that Vampirella had already seduced me. Like a schoolboy with a crush, I started thinking about more adventures with that dark lady, and I secretly hoped I'd be reunited with her again someday. When the fateful e-mail finally arrived, I was ready to go.

I took over with issue 21, and wrote her adventures through issue 38, the last installment of the first volume. Sure, I did my own thing, but I also made sure that Eric's stories were not forgotten or disavowed. I like to think that Dynamite's first Vampirella outing is the kind of series that can be read from beginning to end as a single story, which is something that I find to be a rare commodity in modern comics.

Of course, you didn't buy this book to hear from the writers. The art is taking center stage here and rightfully so. Eric did a swell job of playing "gallery guide" for the art fans, so that leaves me with the task of closing down the museum with some final thoughts.

Vampirella is an iconic character, the kind that transcends story and stands tall as a figure of modern pop art. We can argue about pants all day (and trust me, Eric's heard it all) but the image of the raven-haired woman in the revealing red swimsuit is one that has persevered for almost a half-century, and I don't suspect it will go gently into any night, good or bad.

Yes, she's sexy.

Yes, she's a horror legend.

Yes, she's weird and wonderful.

I note these attributes primarily because they're all on full display here. You can see a wide variety of interpretations from a fantastic group of artists in this book, proving that Vampirella is very much a character whose appeal is in the eye of the beholder. I tend to scoff at multiple covers, but there's something to be said for taking a book that attracts different readers for different reasons, making sure that the covers speak to those fans, and hopefully bringing in some new blood in the process.

I'd like to take a moment to acknowledge the work of Heubert Khan Michael, my collaborator on damn near every issue of "my" Vampirella. Heubert is a fantastic artist to work with, and we developed a real creative bond during our time on the book. His style is distinct, and his love for the stories and characters is obvious in each and every panel he drew. If you're a collector who only bought our issues for the cover art, do yourself a favor and check out what's happening on the inside of the book, too. You won't be disappointed.

Vampirella is an amazing woman, and I'm sure that the people who draw her have fallen in love with her just as I have. It almost seems like a necessary part of the process, and I believe you can see that in almost every image that depicts the Daughter of Drakulon. If the artist and writer are seduced, you can only hope that the readers will be, too.

Brandon Jerwa
Seattle, WA
March, 2014

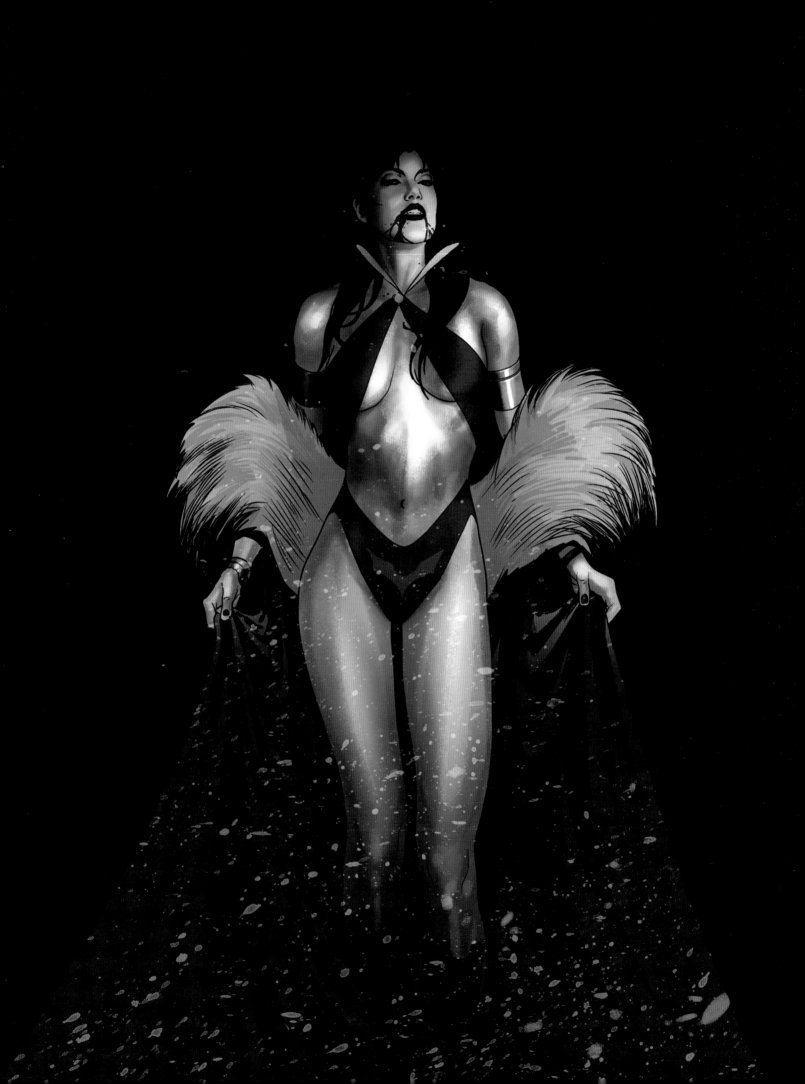

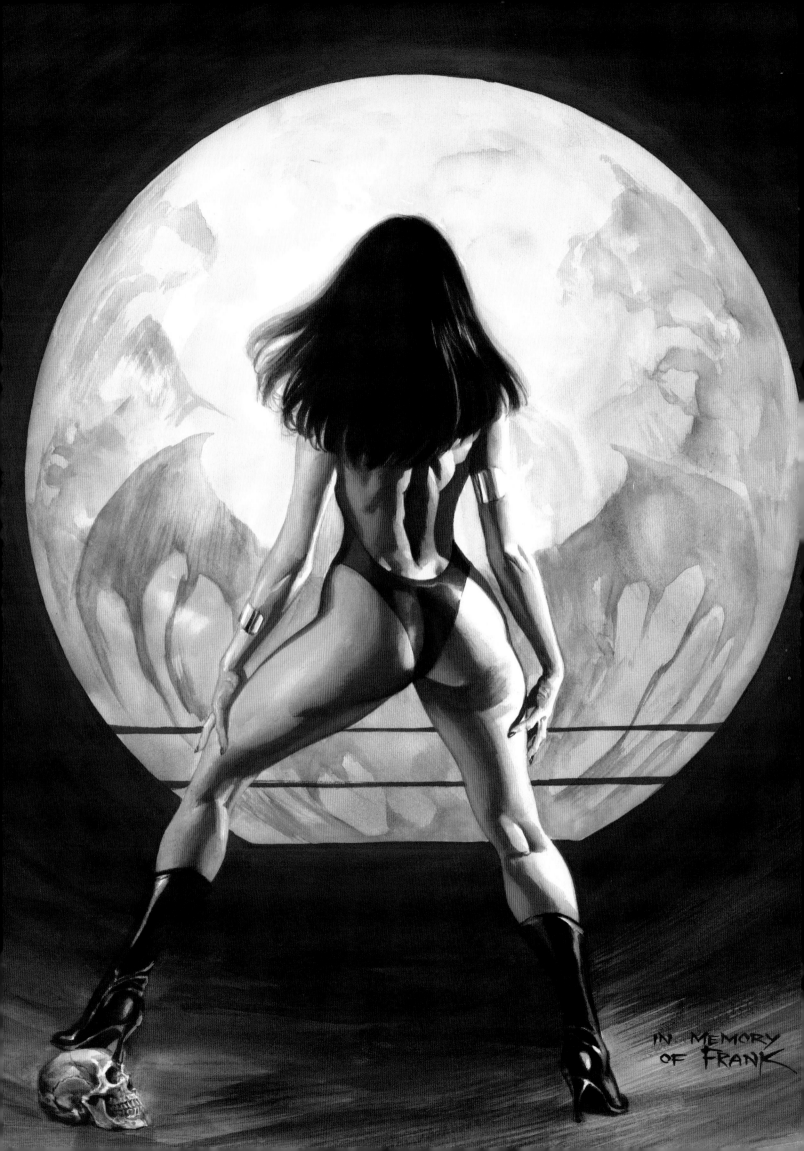

IN MEMORY
OF FRANK